BIG MUDDY
Amid the flooded streets
of New Orleans, the memory
of good times past is obscured

Saving America's Soul Kitchen

How to bring this country together? Listen to the message of New Orleans

By Wynton Marsalis

Now the levee breaches have been fixed. The people have been evacuated. Army Corps of Engineers magicians have pumped the city dry, and the slow (but quicker than we think) job of rebuilding will begin. The 24-hour news coverage is over. The spin doctors' narrative will create a wall of illusion thicker than the new levees. The job of turning our national disaster into sound-bite-size commercials with somber string music will be left to TV. The story will be sanitized as our nation's politicians congratulate themselves on a job well done. Americans of all stripes will demonstrate saintly concern for one another. It's what we do in a crisis.

This tragedy, however, should make us take an account of ourselves. We should not allow the mythic significance of this moment to pass without proper consideration. Let us assess the size of this cataclysm in cultural terms, not in dollars and cents or politics. Americans are far less successful at doing that because we have never understood how our core beliefs are manifest in culture—and how culture should guide political and economic realities. That's what the city of New Orleans can now teach the nation again as we are all forced by circumstance to literally come closer to one another.

I say teach us again, because New Orleans is a true American melting pot: the soul of America. A place freer than the rest of the country, where elegance met an indefinable wildness to encourage the flowering of creative intelligence. Whites, Creoles and Negroes were strained, steamed and stewed in

Daniel Root—Retna Ltd.

Wynton Marsalis

The jazz trumpeter is the artistic director of New York City's Jazz at Lincoln Center. Born and raised in New Orleans, he is one of 17 members of the Bring Back New Orleans Commission, charged by Mayor C. Ray Nagin with creating a vision to rebuild the city.

a thick, sticky, below-sea-level bowl of musky gumbo. These people produced an original cuisine, an original architecture, vibrant communal ceremonies and an original art form: jazz.

Their music exploded irrepressibly from the forced integration of these castes to sweep the world as the definitive American art form. New Orleans, the Crescent City, the Big Easy—home of Mardi Gras, the second-line parade, the po' boy sandwich, the shotgun house—is so many people's favorite city. But not favorite enough to embrace the integrated superiority of its culture as a national objective. Not favorite enough to digest the gift of supersized soul internationally embodied by the great Louis Armstrong.

Over time, New Orleans became known as the national center for frat-party-type decadence and (yeah, boy) great food. The genuine greatness of Armstrong is reduced to his good nature; his artistic triumphs are unknown to all but a handful. So it's time to consider, as we rebuild this great American city, exactly what this bayou metropolis symbolizes for the U.S.

New Orleans has a habit of tweaking the national consciousness at pivotal times. The last foreign invasion on U.S. soil was repelled in the Crescent City in 1815. The Union had an important early victory over the South with the capture of the Big Easy in 1862. Homer Plessy, a black New Orleanian, fought for racial equality in 1896, although it took our Supreme Court 58 years to agree with him and, with *Brown v. Board of Education,* to declare segregation unequal. Martin Luther King's Southern Christian Leadership Conference was formally organized in New Orleans in 1957. The problem is that we, all us Americans, have a tendency to rise in that moment of need, but when that moment passes, we fall back again.

The images of a ruined city make clear that we need to rebuild New Orleans. The images of people stranded, in shock, indicate that we need to rebuild a community. The images of all sorts of Americans aiding these victims speak of the size of our hearts. But this time we need to look a little deeper. Let's use the resurrection of the city to reacquaint the country with the gift of New Orleans: a multicultural community invigorated by the arts.

Forget about tolerance. What about embracing? This tragedy implores us to re-examine the soul of America. Our democracy from its very beginnings has been challenged by the shackles of slavery. The parade of black folks across our TV screens in the days after Katrina struck, asking, as if ghosts, "Have you seen my father, mother, sister, brother?" reconnects us all to the still unfulfilled goals of the Reconstruction era. We always back away from fixing our nation's racial problems. Not fixing the city's levees before Katrina struck will now cost us untold billions. Not resolving the nation's issues of race and class has and will cost us so much more. ∎

HORNING IN
Left, students put a little rhythm into a walk from school

INTO THE MIST
Below, in New Orleans, even funerals are conducted to the sound of jazz

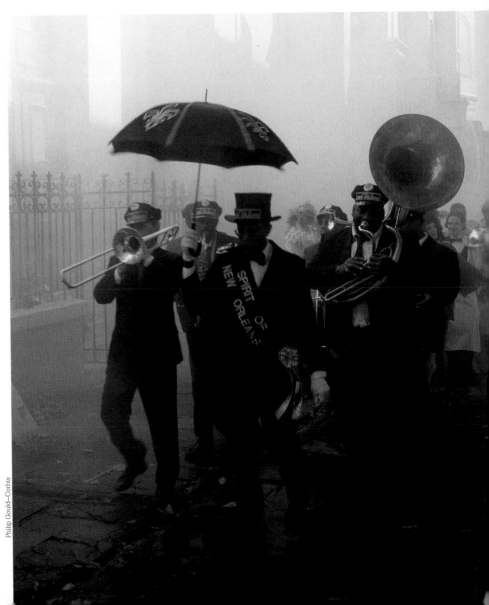

Jeff Greenberg–Agefotostock

Philip Gould–Corbis

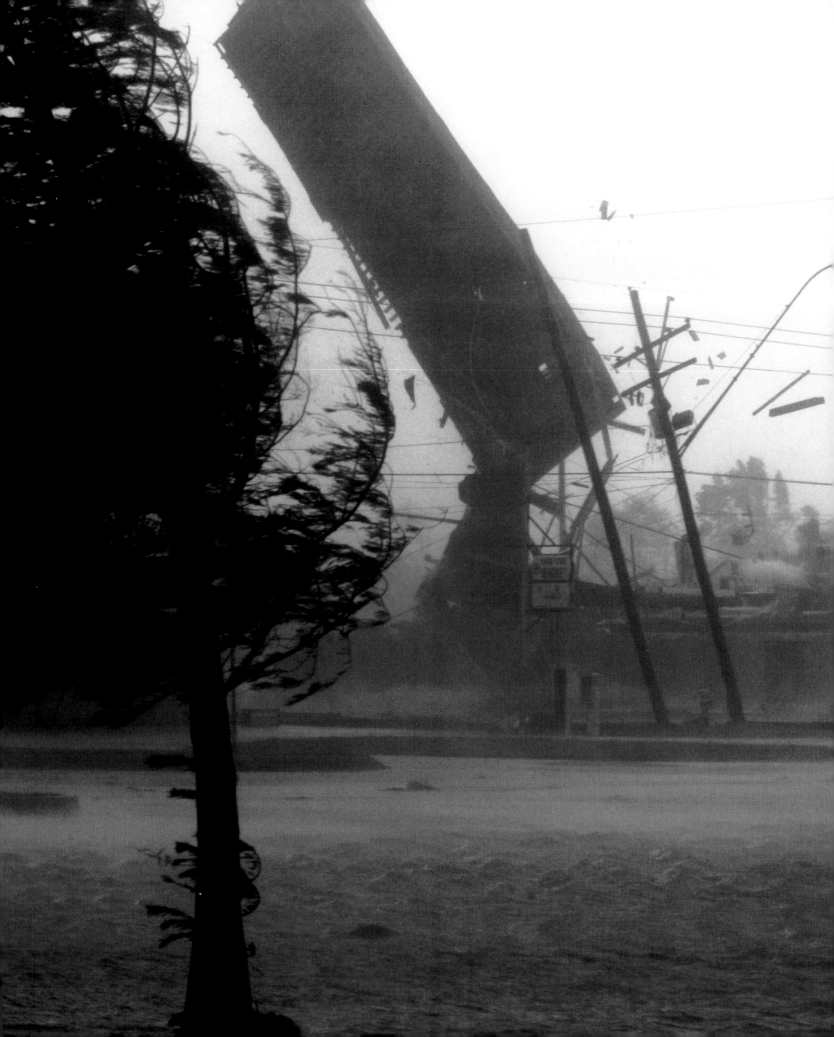

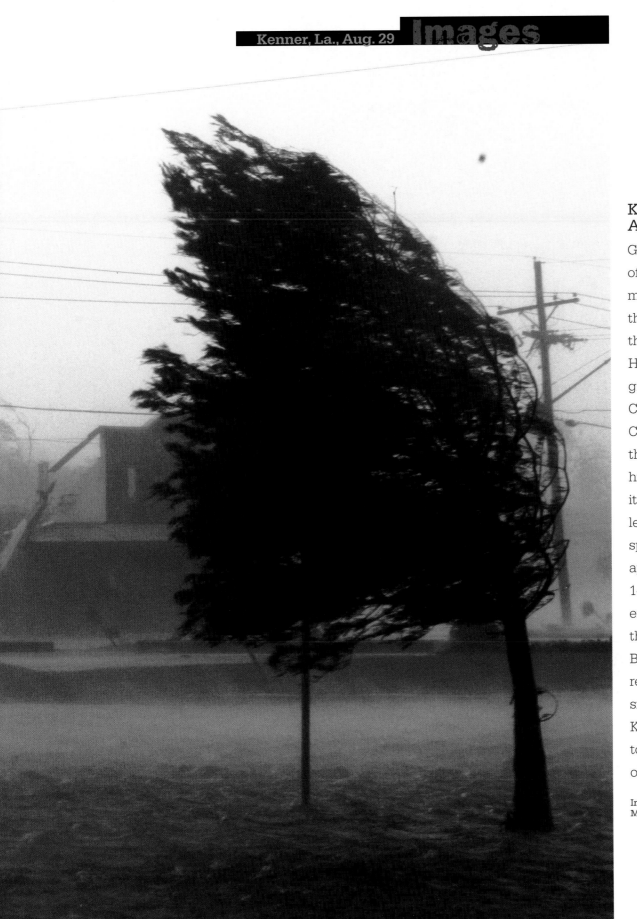

Katrina Comes Ashore

Gathering a head of steam as it moved west across the Florida Keys, then turned north, Hurricane Katrina grew from a Category 3 to a Category 5 storm in three days. When it hit the Gulf Coast, it was at Category 4 level, with wind speeds reaching approximately 140 m.p.h.—strong enough to rip the roof off the Backyard Barbecue restaurant in a single piece in Kenner, a small town 10 miles west of New Orleans.

Irwin Thompson—Dallas Morning News/Corbis

Island in the Torrent

As Katrina roared ashore along the Gulf Coast, and residents fled before her driving winds, many people were trapped along evacuation routes. Among them were members of the Taylor family, who abandoned the cabin of their SUV and huddled on its roof as the waters rose along Route 90 leading out of Bay St. Louis. Above, volunteers from the Bay St. Louis Emergency

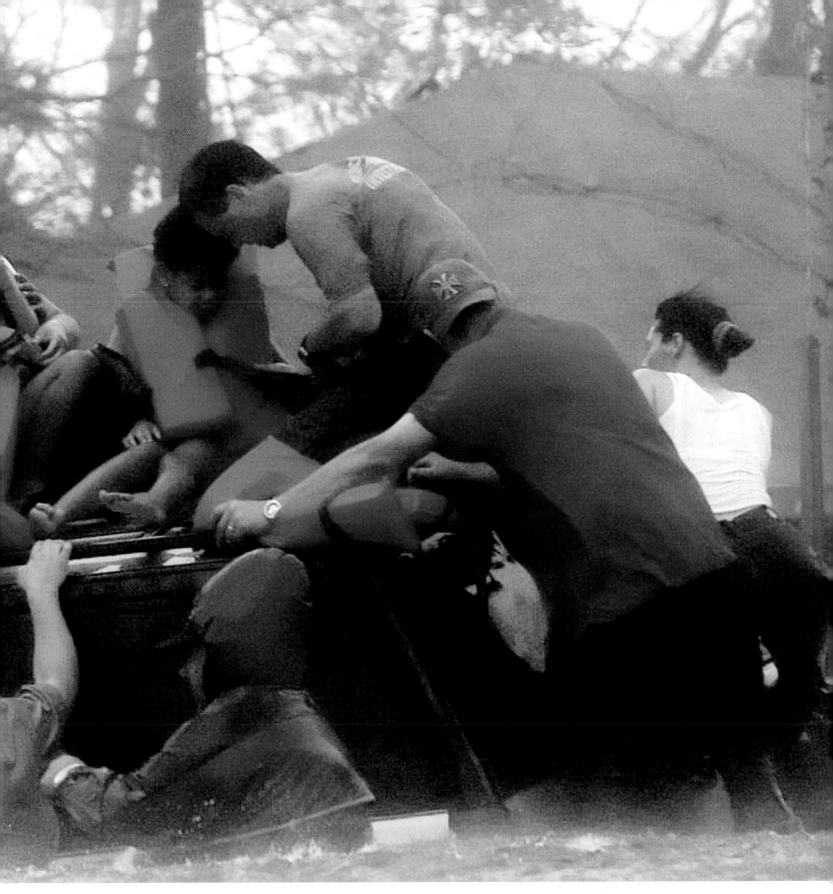

Management Agency rescue the family members. In the first hectic days of the disaster, volunteers working both as individuals and as organized teams provided far more effective relief to storm victims than did faltering federal, state and local agencies.

Ben Sklar—AP/Wide World

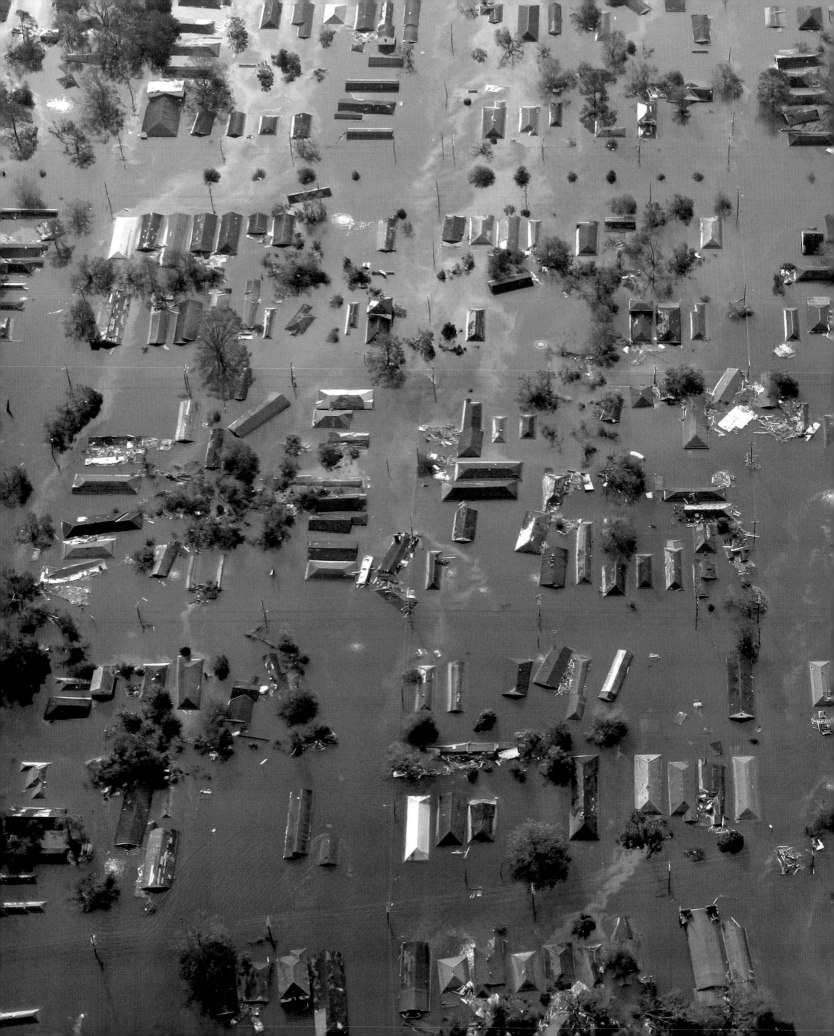

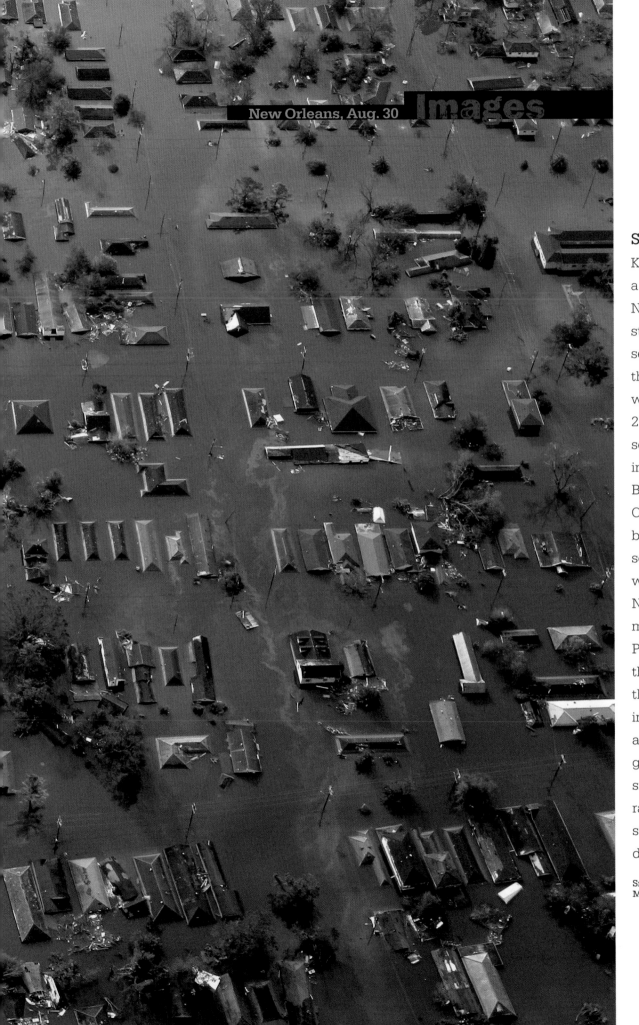

Swamped

Katrina delivered a one-two punch to New Orleans. The storm's high winds sent waters surging through the streets when it hit on Aug. 29, yet damage seemed light in many areas. But the Crescent City's levees had been breached, and soon 80% of the city was flooded; New Orleans had merged with Lake Ponchartrain. Over the next few days, the waters became incredibly foul, a vile brew of gasoline, sludge, snakes and canal rats, stinking of sewage and decaying bodies.

Smiley N. Pool—Dallas Morning News/Corbis

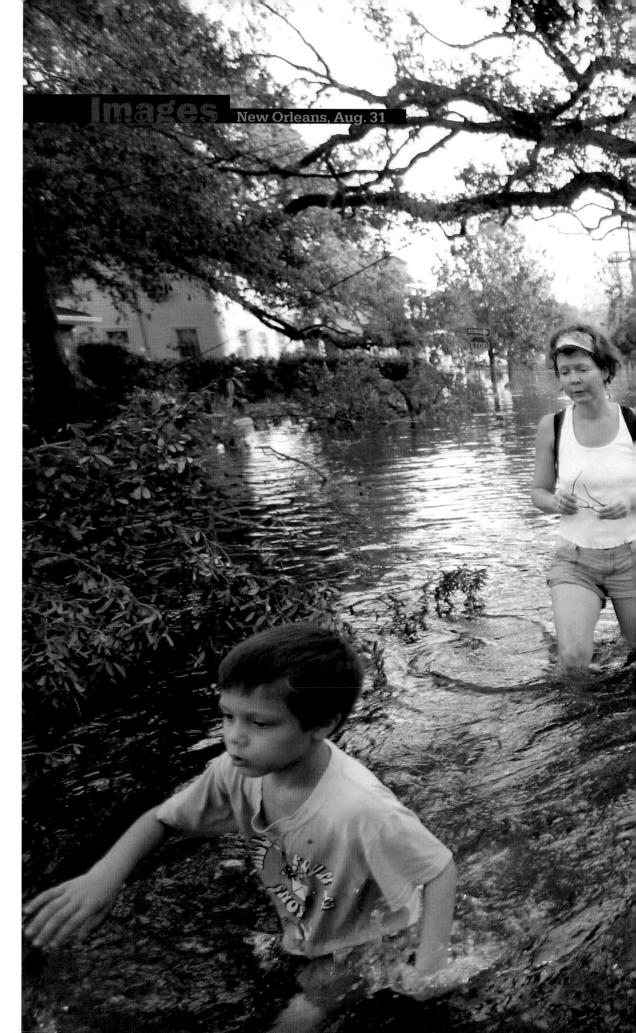

Taking Flight

David Keifer, right, leads his sister Molly and his son William across the flooded landscape of uptown New Orleans two days after Katrina passed through. The three rode out the storm's initial assault without evacuating, but as the floodwaters continued to rise, they were forced to flee. Officials estimate that some 20% of the city's 500,000 citizens did not leave the city before Katrina struck and were then trapped without power, food or drinking water.

Dave Martin— AP/Wide World

Irresistible Force, "Immovable" Object

Katrina's storm surge hijacked the *Chemul*, a 13,000-ton Mexican oil rig sitting in drydock at Mobile's Bender Shipyard, and sent it surfing a mile upstream—against the normal current of the Mobile River—until it slammed into the Cochrane-Africatown USA Bridge. Towboat and shipyard workers John and Michelle Welborn and Robert Rischel, left to right, walk away from the scene in disbelief.

Paul J. Richards—AFP/Getty Images

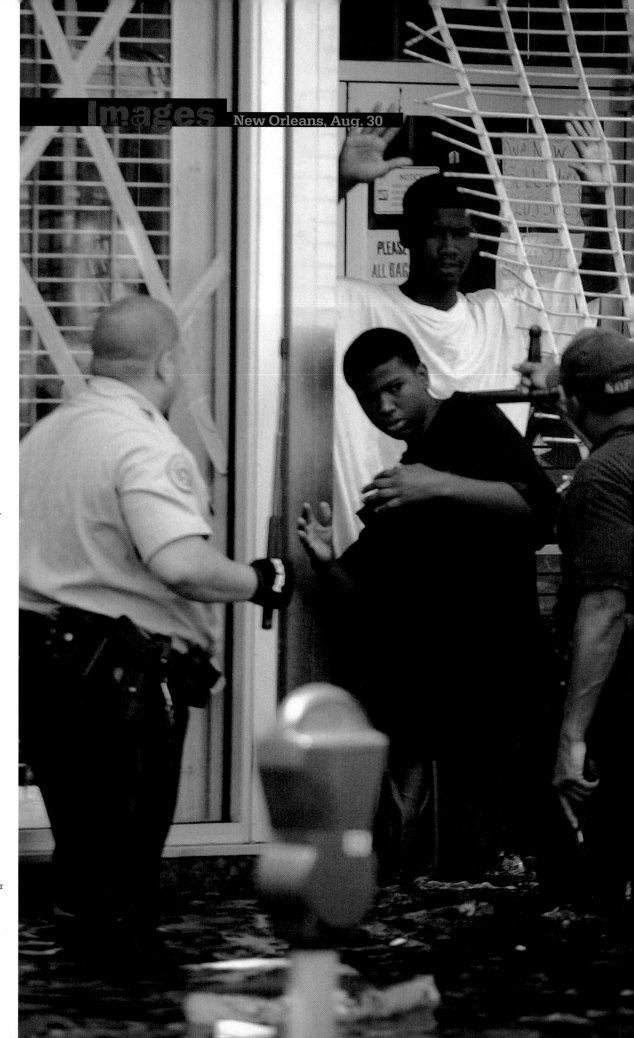

Confrontation

New Orleans cops arrest suspected looters. As the bonds of civil society broke down, the flooded streets became canals of crime. An estimated one-third of New Orleans police officers fled the city in the first few days after the storm; their absence was a key factor in the breakdown of public safety. Some looters were opportunists caught stealing; others stole out of desperation, simply to survive and help others survive.

Khamphia Bouaphanh—
Fort Worth Star Telegram/
Distributed by Knight Ridder

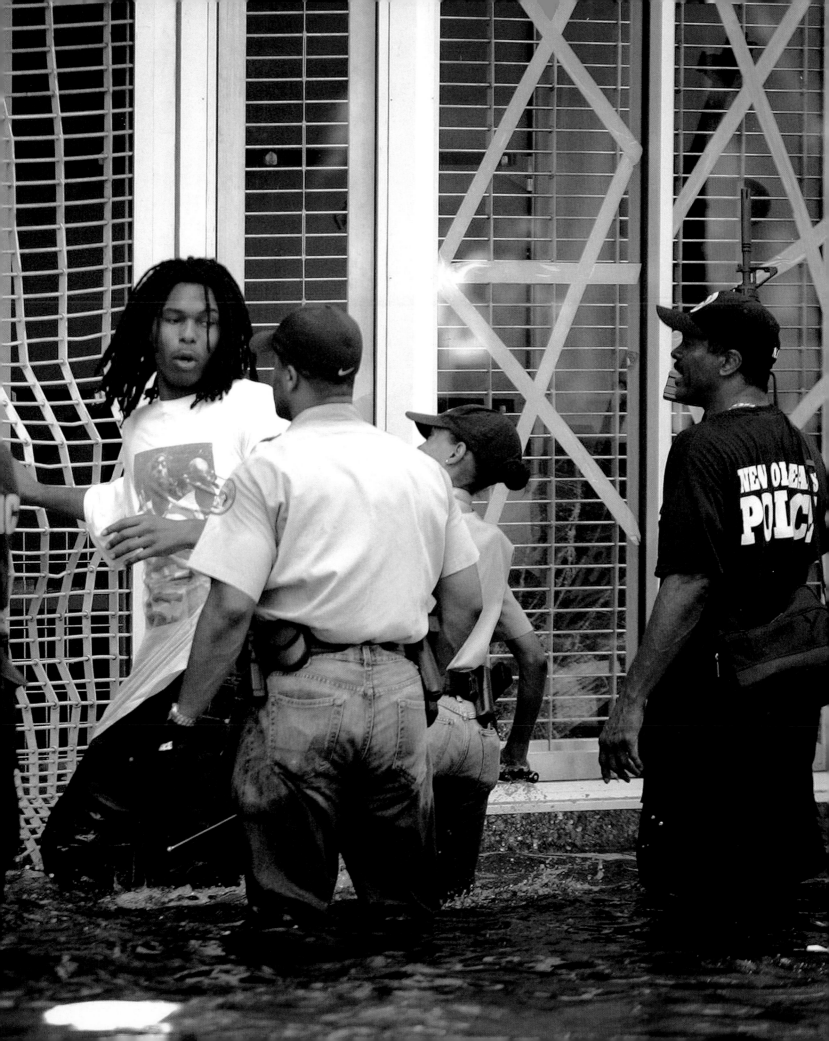

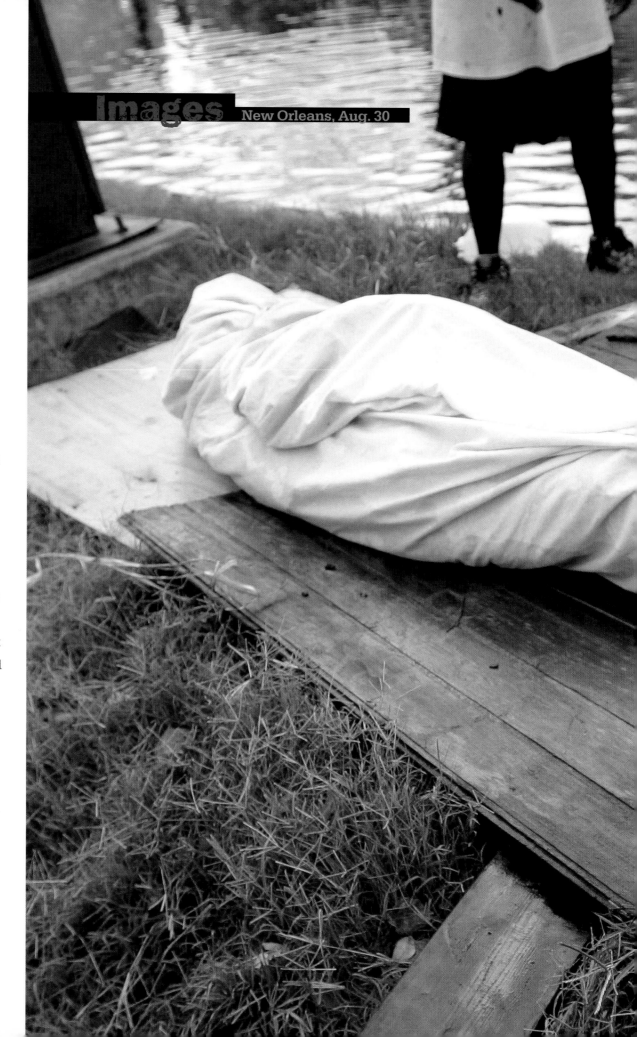

Out of Breath, Out of Time

Evelyn Turner weeps alongside the body of her common-law husband Xavier Bowie. Turner and Bowie, with no means of leaving New Orleans, had hoped to ride out the storm. Bowie suffered from lung cancer and relied on an oxygen tank to breathe; he died when his supply of oxygen ran out and the couple were unable to replace it.

Eric Gay—AP/Wide World

14

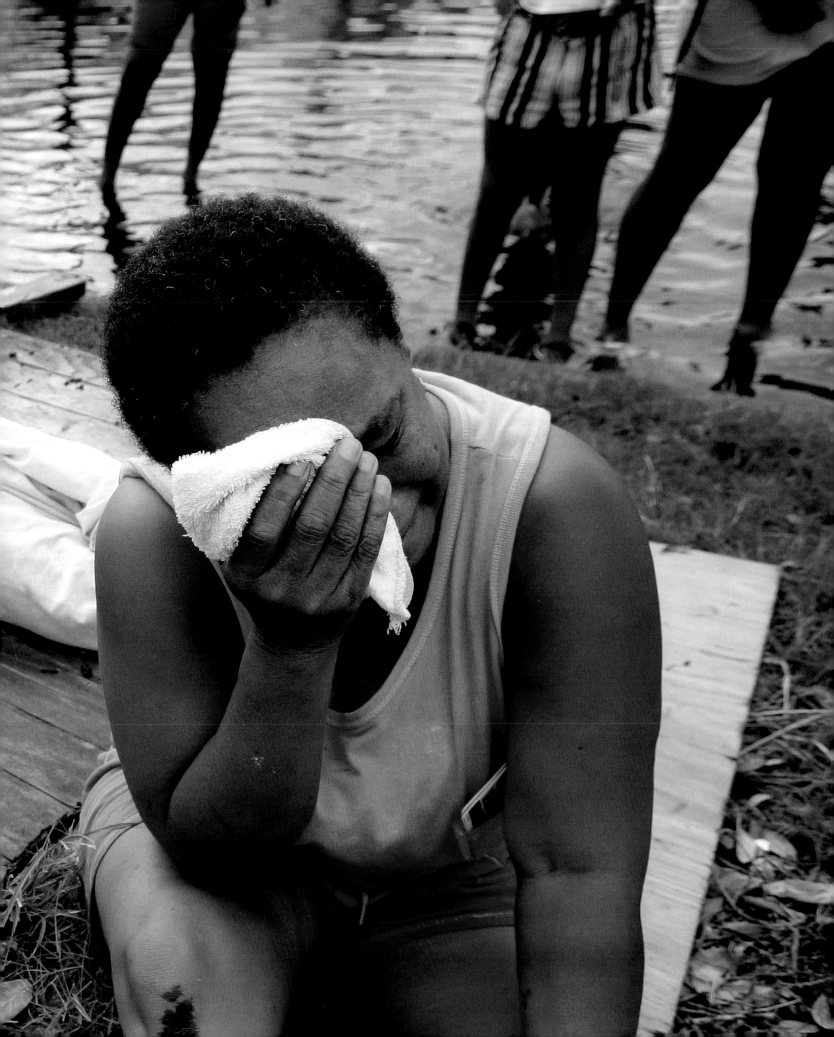

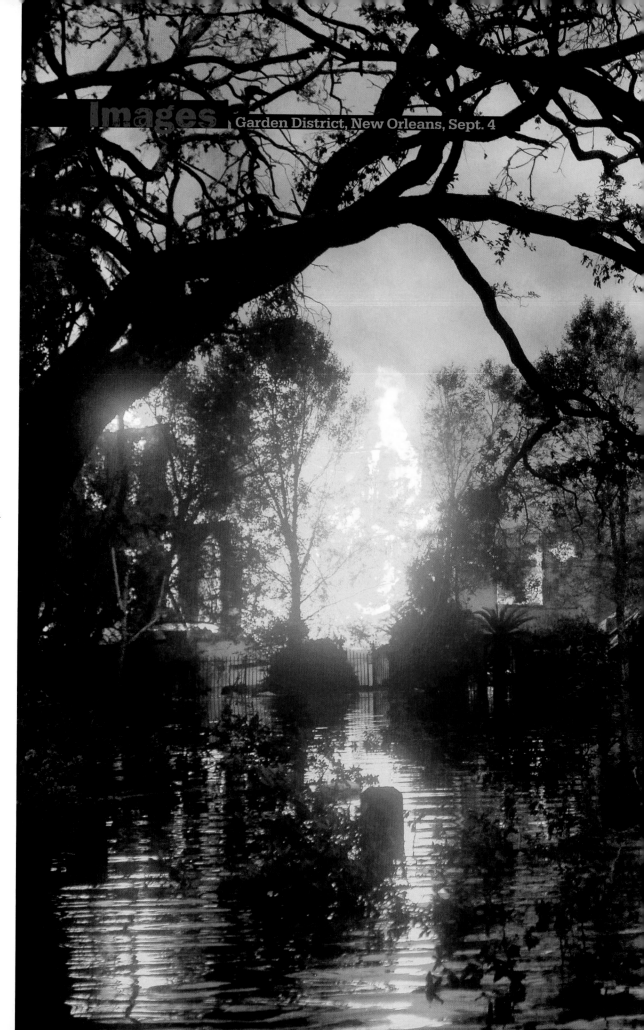

Arson Most Foul?

On Sunday, Sept. 4—almost a full week after Katrina struck—New Orleans remained a zone of anarchy, despite President Bush's call for "zero tolerance" of lawbreakers. These house fires in the city's most beautiful district were believed to have been set by arsonist-looters traveling by boat.

Thomas Dworzak— Magnum Photos for TIME

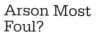

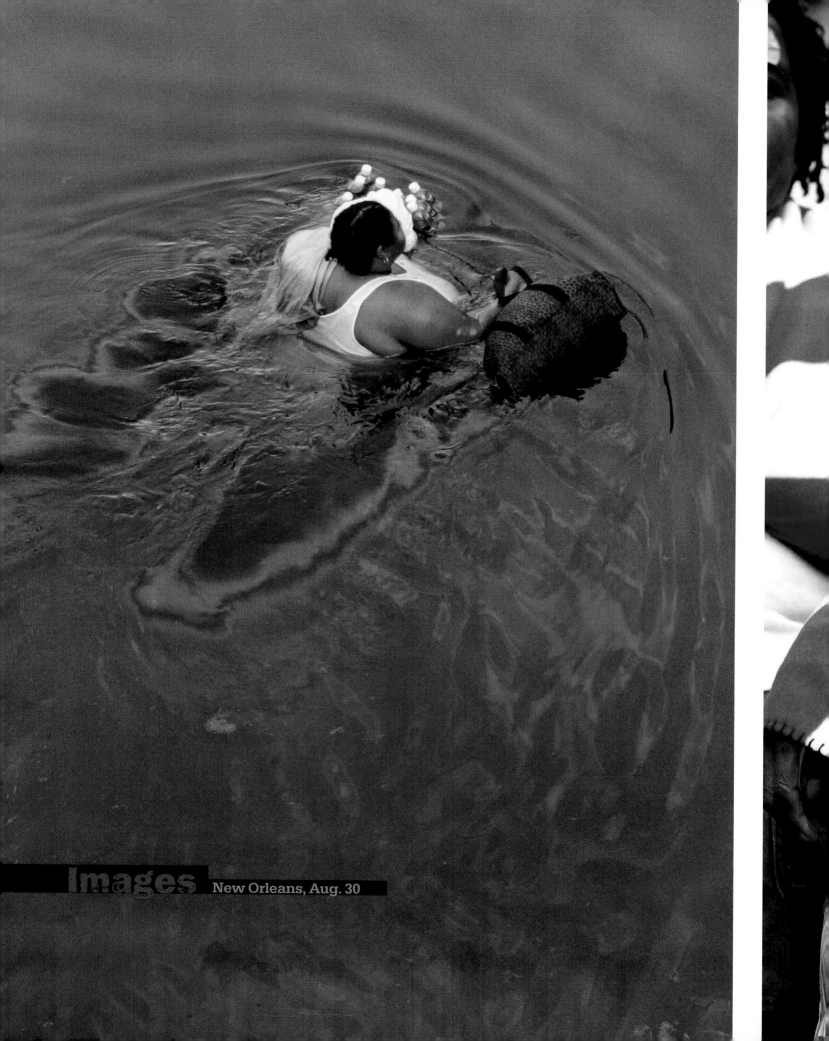

Images New Orleans, Aug. 30

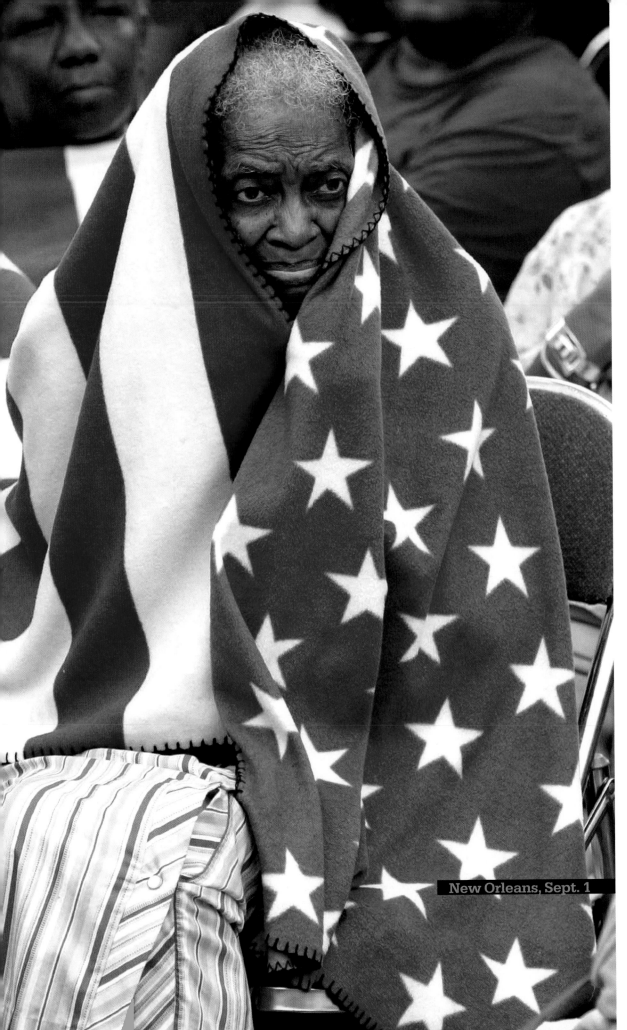

New Orleans, Sept. 1

Orphans of The Storm

Unmoored from their homes, many New Orleans residents became human flotsam, adrift and alone, seeking shelter. Yet even when displaced persons reached such designated refuges as the Superdome and the city's Convention Center, they found themselves trapped for days in intolerable conditions. At left, a woman wades through oil-slicked waters toward higher ground. At right, Milvertha Hendricks, 84, waits in the rain with other flood victims outside the Convention Center. Three days after the hurricane struck, no relief was in sight.

Left: Bill Haber—AP/Wide World. Right: Eric Gay—AP/Wide World

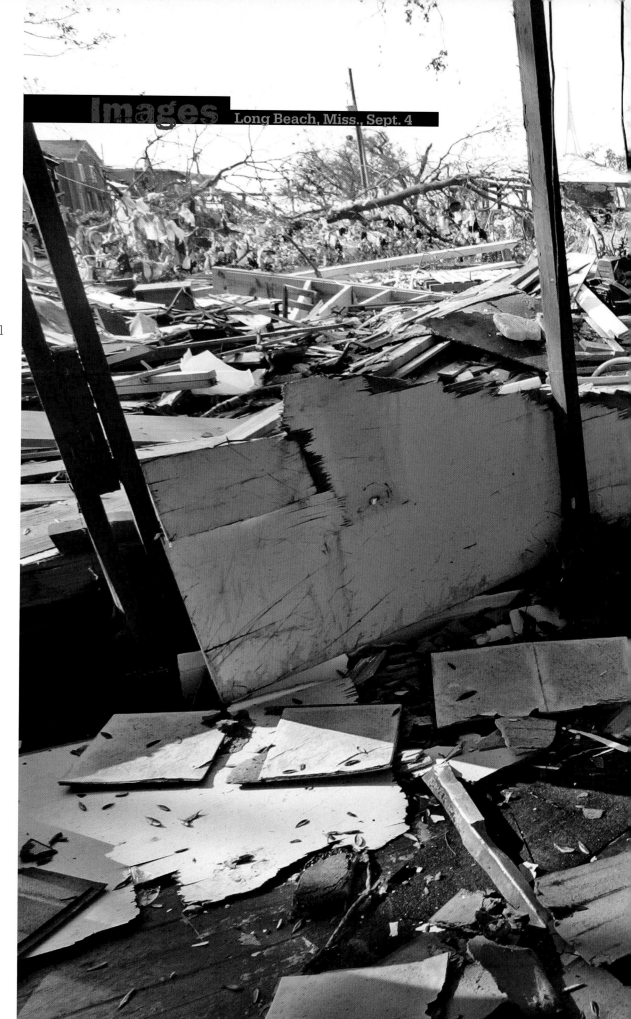

Images Long Beach, Miss., Sept. 4

Homecoming

Leona Watts waited almost a full week after Katrina blew through the Gulf Coast before she returned to her home of 61 years. This is the scene she encountered. As Katrina came ashore, it spawned tornadoes that chewed up houses and spit out splinters and shards. Storm surges as high as 25 ft. then carried the flotsam deep inland. "It was like the houses were playing bumper cars around here," Biloxi fisherman Alan Layne told TIME.

Marcio Jose Sanchez—
AP/Wide World

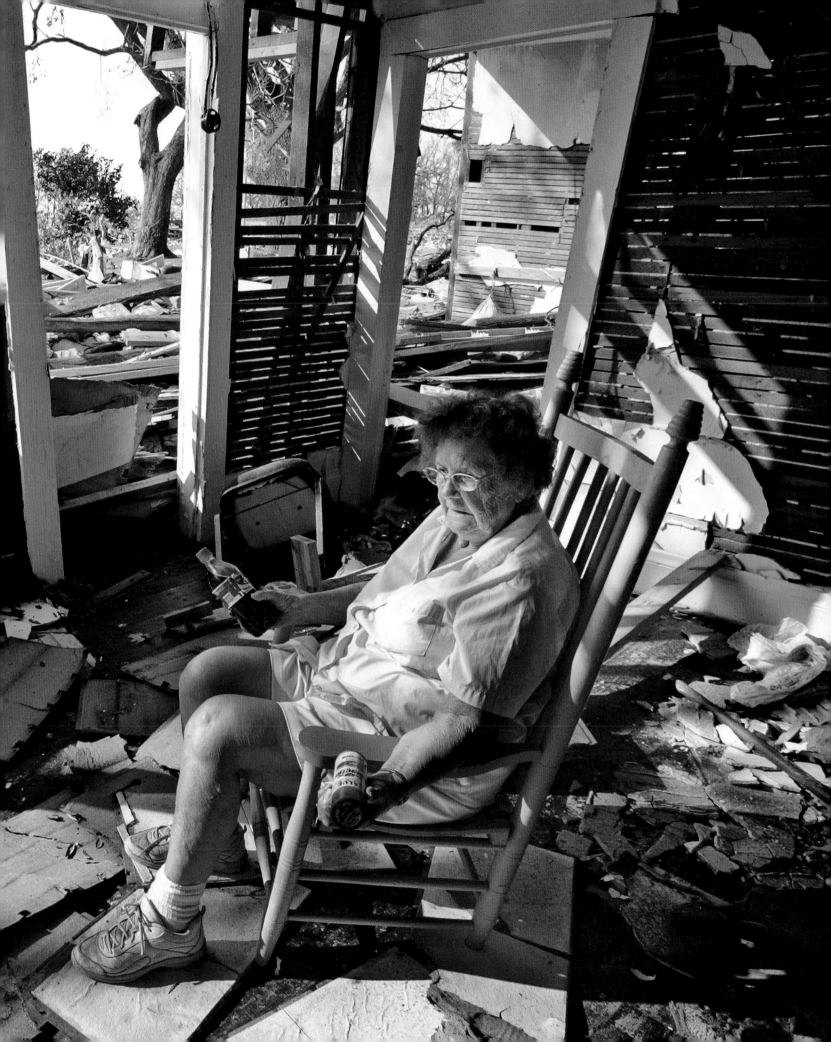

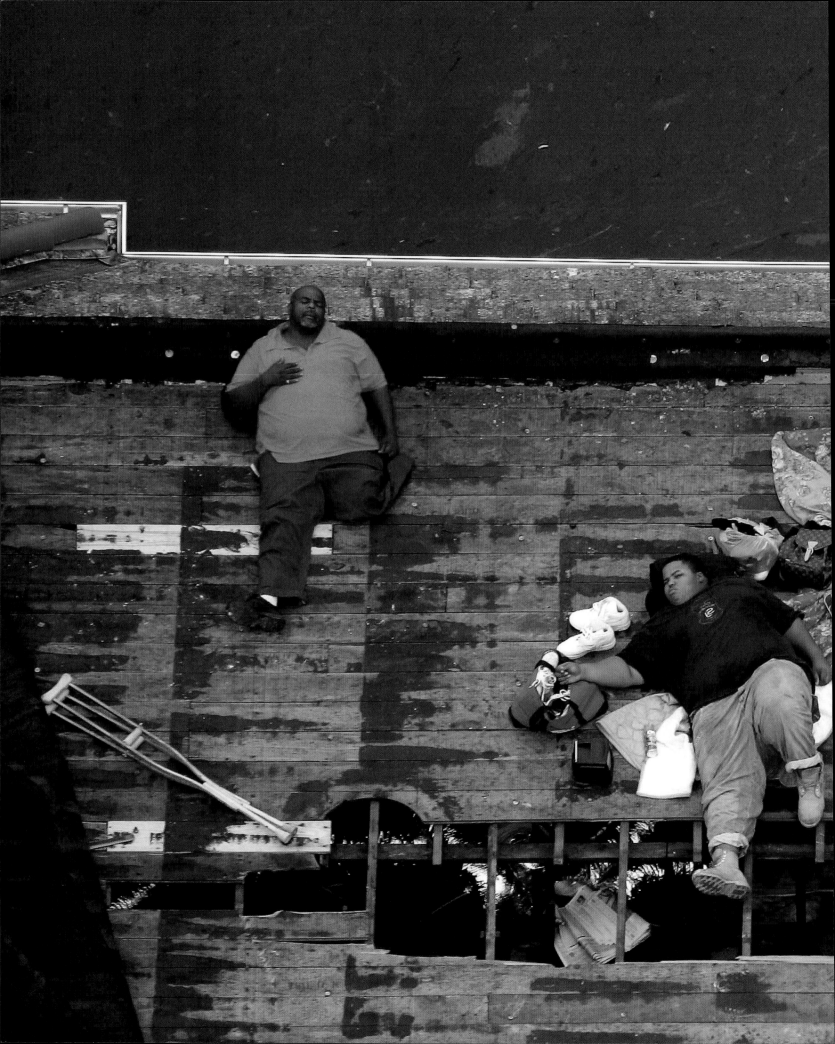

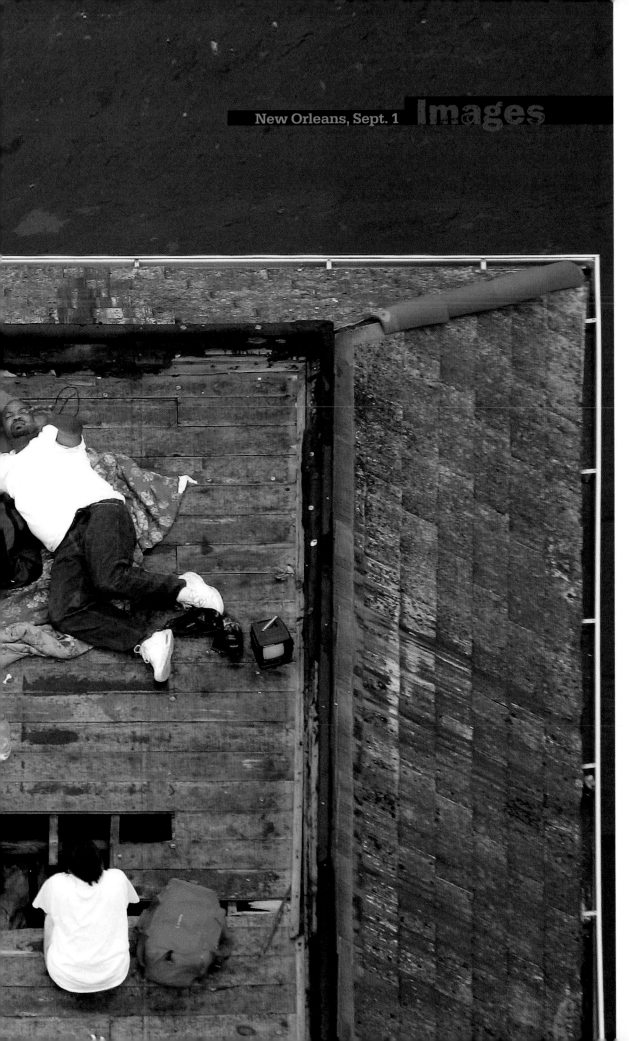

Stranded

Having broken through the roof of a home surrounded by floodwaters, four exhausted survivors await rescue. Incredibly, they were among the lucky ones. In some cases, rescue workers could hear people trapped in attics with no means of escape pounding on roofs from the inside, as the waters kept rising.

David J. Phillip—Reuters

23

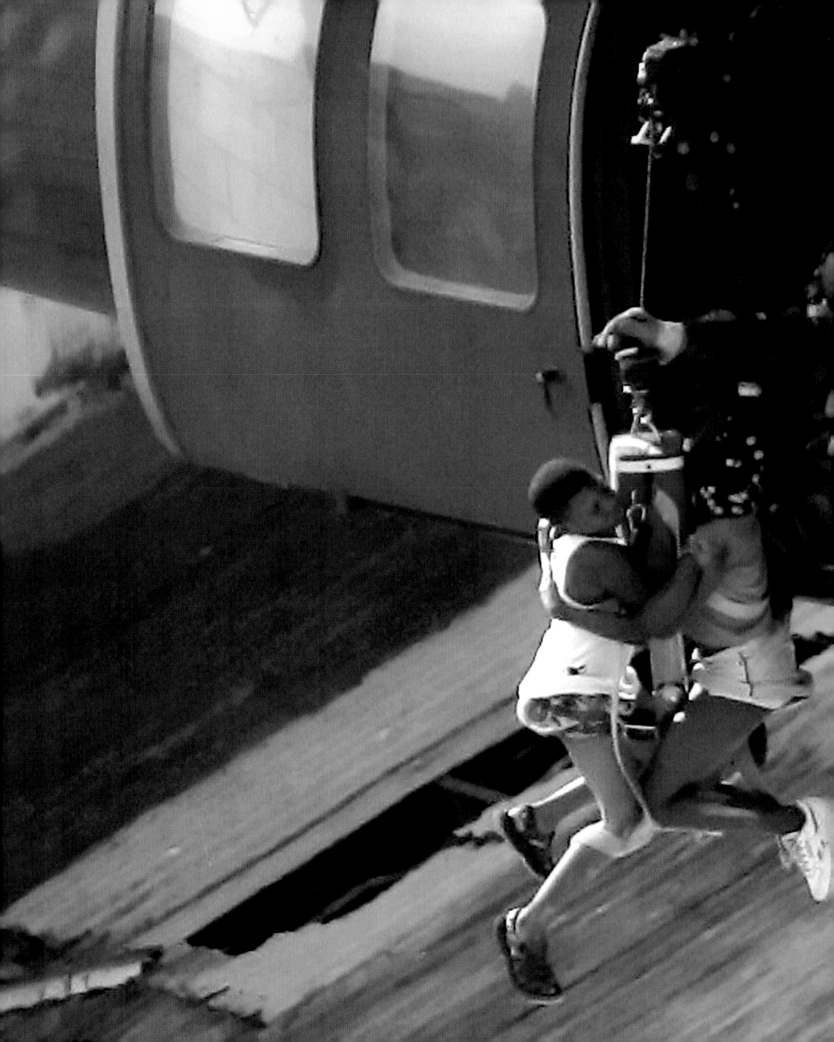

Deus ex Machina

Two children trapped in the rising waters are brought aboard a rescue helicopter. In the frantic first days after the city flooded, helicopters were at a premium: many choppers that could have been used to drop sandbags to help plug the gaps in the city's breached levees were diverted to rescue duty. Eventually, more choppers reached the scene and filled the skies over the swamped city. "It's like *Apocalypse Now*," Army Corps of Engineers spokes- woman Susan Jean Jackson told TIME.

David J. Phillip— AP/Wide World

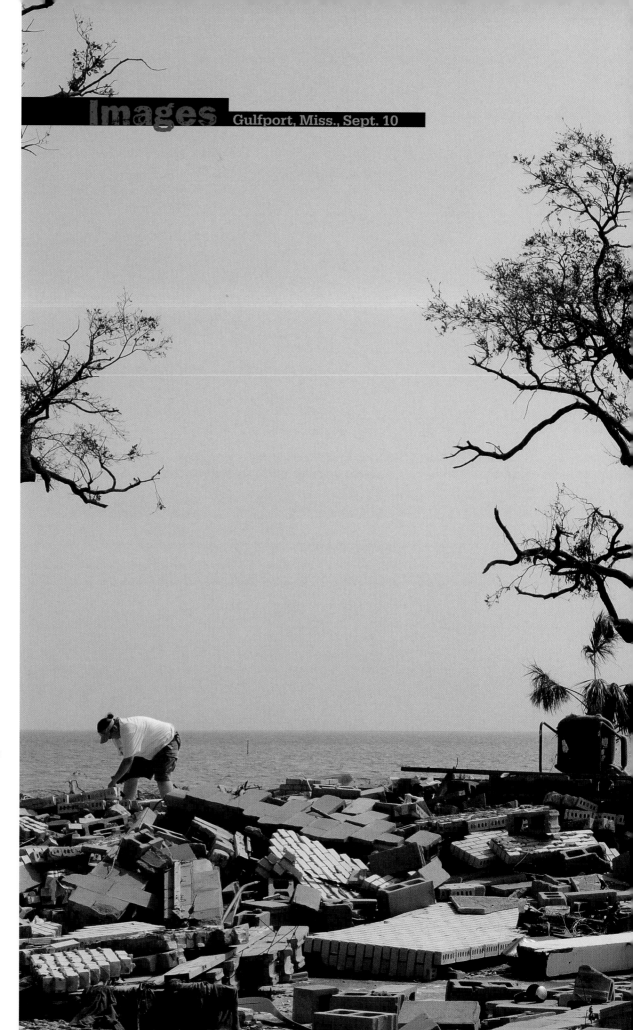

The Searchers

Twelve days after Katrina devastated the Gulf Coast of Mississippi, Lauren Naulett and Kacey Moore search through the wreckage of their adoptive grand-parents' home for any items they can salvage. Their grandfather Ben Wilkes had no insurance on the home and has terminal cancer. The pair told photographer Chris Usher that Wilkes could not bear to visit the site and had asked them to make the journey for him.

Chris Usher for TIME

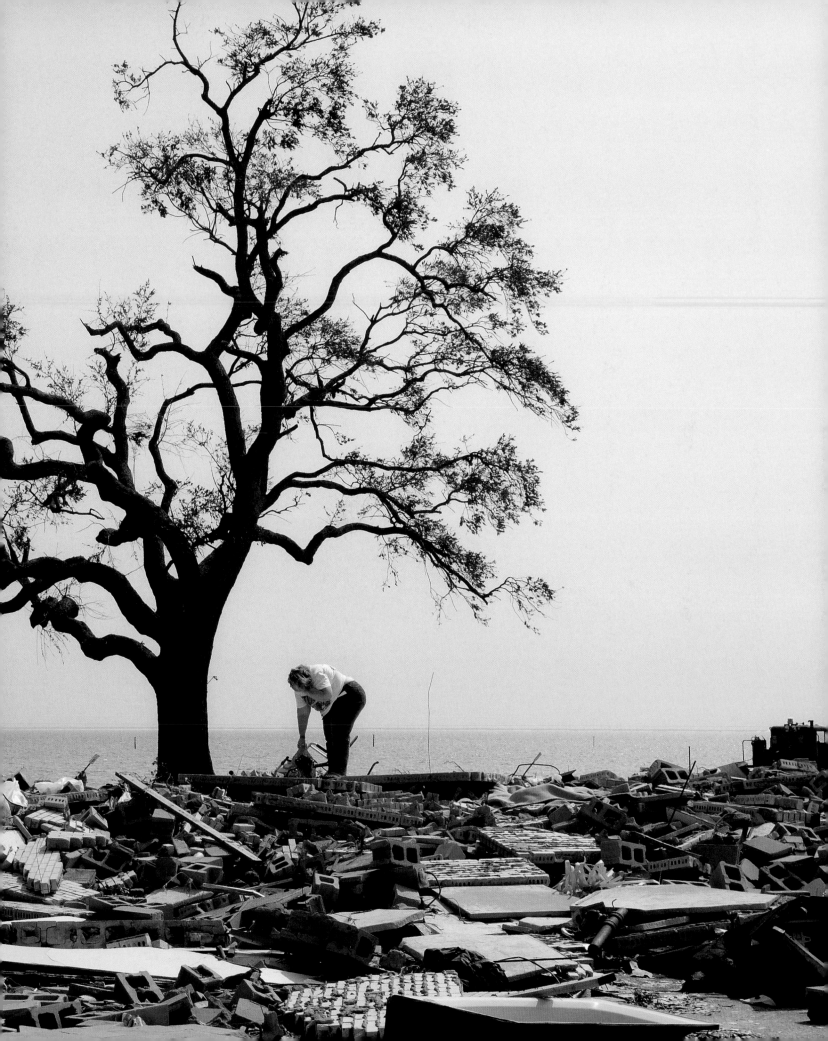

New Orleans

Inside

Hard Times in the Big Easy

New Orleans is Louis Armstrong, his cheeks swelling up as he plays, his horn tilting toward heaven, the instrument a seemingly inexhaustible source of melody and percussion and swing. Armstrong carried the joyful sound of jazz—a music born of the crazy-quilt, shotgun marriage of races and heritages that make up his native city—around the world, and the world fell in love with it. And to fall in love with jazz or its bastard child, rock 'n' roll, is to fall in love with New Orleans.

Huey Long is New Orleans. The "Kingfish" was a populist, a con artist, a peddler of dreams, a savant of illusions. Full of beans—red beans and rice, to be specific—the Tulane Law School graduate became the state's Governor in the 1920s and a U.S. Senator in the '30s. He was—or claimed to be—a Robin Hood in a roadster. He also embodied the city's darker side, the political corruption that flourishes in a town that sanctions license. That corruption lives on: "Half of

New Orleans

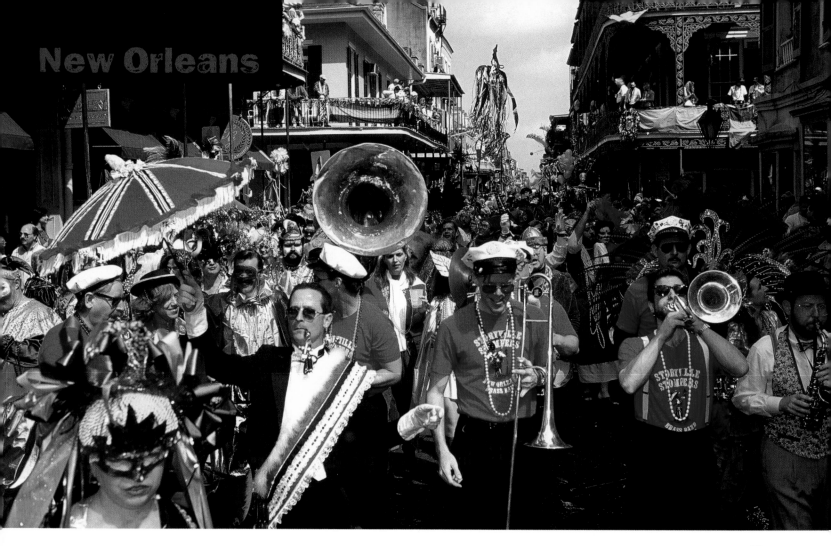

Louisiana is under water, and the other half is under indictment," said the modern-day Pelican State lawmaker Billy Tauzin.

Emeril Lagasse is New Orleans. A "come-here" not a "from-here," the Massachusetts native opened his first restaurant in the Big Easy in 1990, and his gift for spicing up every dish with a dash of essence—*Bam!*—reminds us that New Orleans has been the spice in America's pantry for more than two centuries. For long decades, visitors have come here to kick their lives up a notch. Long before Las Vegas was a glimmer in a mobster's eye, the City That Care Forgot was this nation's sanctioned adult playground, for what happened in New Orleans stayed in New Orleans. And while Las Vegas may have outstripped its model in many ways, it will never capture the casual ambiance of the Big Easy, which seems to drift in on a careless breeze from the Gulf, fresh from Haiti and Jamaica and Trinidad.

Perhaps above all, New Orleans is Blanche DuBois. Like the city, the fading temptress of Tennessee Williams' *A Streetcar Named Desire* is an anachro-

MARDI GRAS The annual pre-Lenten party was adapted from an ancient French Catholic tradition. Although the revelry is synonymous with the city, the feast is also celebrated in other cities along the Gulf Coast

Where the Livin' Was Easy

Founded by the French in 1718 at one of the world's great natural strategic and trade locations, at the mouth of the Mississippi River, New Orleans has played a distinctive role in U.S. history. Ceded to Spain in 1763, it absorbed Hispanic influences still evident in its oldest architecture. The city returned to French control in 1801 and Napoleon sold it to President Thomas Jefferson as part of the Louisiana Purchase in 1803. A principal port of the slave trade, it was also the home of many free blacks. Its polyglot racial heritage also reflects the influence of refugees from Haiti. Louisiana joined the Confederacy in 1861, but Union forces controlled the city from early in the Civil War. The city has always been known for its devotion to joy: Let the good times roll!

Bettmann Corbis

Andrew Jackson "Old Hickory" won glory by beating the British at the Battle of New Orleans in January 1815 (after the War of 1812 was officially over). He rode the tide to the presidency.

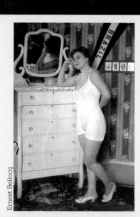

Ernest Bellocq

Storyville Back in the day, every big city in America had its red-light district, but no other compared with this celebrated quarter of sin. And in what other city would courtesans pose for the camera of Ernest Bellocq so unashamedly?

nism, a black-and-white belle in a Kodachrome world, lost in reveries of a storied past, when armies of gentlemen callers laid siege to her front porch. She depends on the kindness of strangers, just as New Orleans came to depend on the dollars of tourists.

There is no other city in America like New Orleans; there is no other city in the world like New Orleans. Only the 35th largest city in the U.S., the city packs a cultural wallop far beyond its size. *Bam!* New Orleans gave us Mardi Gras and Bourbon Street. *Bam!* Professor Longhair and Allan Toussaint. *Bam!* Jambalaya and crawfish étouffée with a Sazerac chaser. *Bam!* Antoine's and the St. James Infirmary, the Neville Brothers and Jazz Fest. *Bam!* Don't you want to be in that number, when the saints go marchin' in?

The city is so inimitable that even its fictionalized doppelgänger, the ethereal New Orleans of novels and plays and songs, is populated with unforgettable characters. Take a ride on the streetcar named Desire and watch the parade. Anne Rice's Vampire Lestat slips past Stanley Kowalski on the street; he's buying a hot dog from Ignatius J. Reilly, the obese, slothful antihero of John Kennedy Toole's *A Cofederacy of Dunces*. Nearby, Randy Newman's mother instructs him in the niceties of the city's racial spectrum, as the songwriter recalled in *New Orleans Wins the War*:

> Momma used to wheel me past an ice
> cream wagon
> One side for White and one side for Colored …
> She said, "Here comes a white boy, there goes
> a black one, that one's an octoroon"

Down the street, a ragged clown follows a jangling figure, hurling skipping reels of rhyme into evening's empire—a young Bob Dylan came to Mardi Gras in

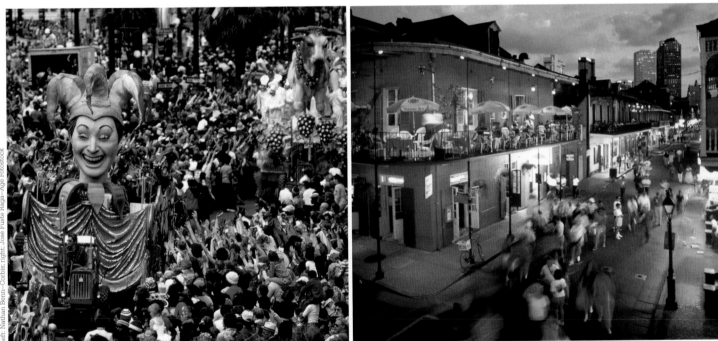

Left: Nathan Benn–Corbis; right: José Fuste Raga–Age Fotostock

Dennis Stock–Magnum Photos

Cradle of Jazz The improvised music, often called America's only indigenous art form, was born in the mingling of European melodies, Afro-Caribbean rhythms and the sheer exuberance of the balmy city on the Gulf. The term jazz is said to be local slang for sex.

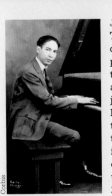

Corbis

Jelly Roll Morton The arranger, composer and pianist liked to think of himself as the father of jazz. At the least, he helped turn the élite syncopations of ragtime into the more complex, more upbeat sound of 20th century jazz.

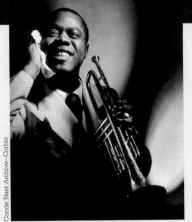

Conde Nast Archive–Corbis

Louis Armstrong The foremost exponent of "hot jazz," Armstrong exploded on the American scene in the late 1920s; his horn put the roar in that roaring era. His raspy rumble, scat singing and wide smile made him a beloved star for five decades.

New Orleans

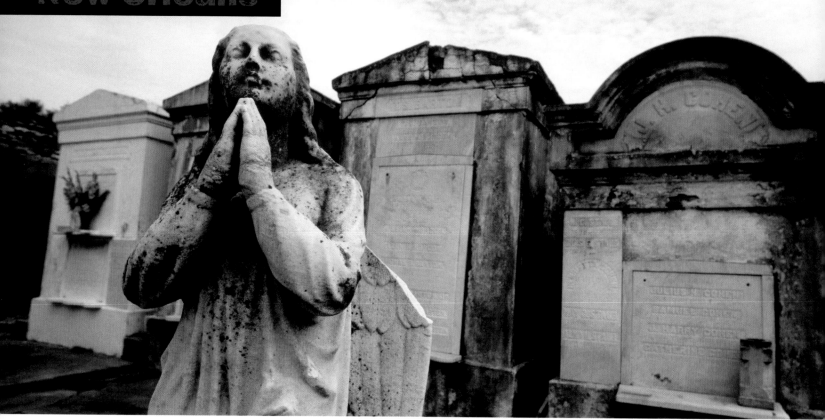

1964 and emerged with *Mr. Tambourine Man*.

New Orleans is a slice of the 19th century in a wireless world, a last, unlikely remnant of French Catholicism in a nation of Baptists and Presbyterians. The city's inimitable joie de vivre is founded on an acceptance of humanity's frailties and darker longings that sterner minds prefer to ignore or condemn. Here the pirate Jean Lafitte struck a hard bargain with Andrew Jackson, joined his cause and helped "Old Hickory" trounce the British. Here Creole belles waltzed with riverboat cardsharks. Here celebrated courtesans plied their trade in Storyville, the red-light district whose name could well suit the entire city.

The racial and social history of New Orleans is elaborately nuanced. As all the world learned in the bitter days after its streets flooded, today's city is segregated along racial and economic lines that can be traced back to the days of slavery; the Lower Ninth Ward, where the waters rose highest, is 98% black. Yet at the same time the city is, in Wynton Marsalis' phrase, America's soul kitchen, an authentic melting pot whose cultural sum is far greater than its parts.

So when Hurricane Katrina came to the city of Fat Tuesday on a stormy Monday morning, it attacked not just a landscape, not just homes and buildings: it also attacked an idea of a city that is deeply rooted in

IN THE SAME BOAT Cemeteries in New Orleans have become tourist attractions; they consist of mausoleums placed aboveground, owing to the city's location below sea level and the instability of the marshy soil upon which it is built

Where the Livin' Was Easy

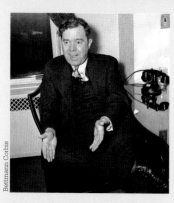

Bettmann-Corbis

Huey Long The "Kingfish," a populist demagogue, cultivated a role as defender of the poor and foe of the wealthy. As Governor in the late 1920s, he ran Louisiana in dictatorial fashion, taxing the rich to build vast public works projects and putting the state into debt. Elected to the Senate in 1930, he hoped to run against Franklin Roosevelt but was killed by an assassin.

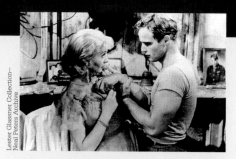

Lester Glassner Collection—
Neal Peters Archive

A Streetcar Named Desire Marlon Brando played Stanley Kowalski and Vivien Leigh was Blanche DuBois in the 1951 movie, based on Tennessee Williams' 1947 play. The streetcar line leading to Desire Street was eliminated decades ago.

Fats Domino One of the great pioneers of rock 'n' roll, the singer and pianist still resides in the Ninth Ward of the city. Age 77 in 2005, he was initially reported missing but survived the floods of Katrina.

Neal Preston—Corbis

America's history and culture. Like Venice, another city defined by its topography, the character of this metropolis is indelible, precious, irreplaceable—even to those who have never walked its streets. After Katrina struck, television viewers around the world who had never savored a hot beignet at the Café du Monde, never eyed with envy the jalousies on a French Quarter balcony, never staggered down Bourbon Street clutching a "go-cup," watched the city descend into anarchy and helplessness and felt that a personal friend had just been mugged.

Katrina's devastating one-two-three punch—the storm, the flooding and the disgracefully bungled official response to them—tore the chemise off this great, yearning, aging courtesan of a city, revealing its unsightly, hidden infirmities for all to see. Sadly,

among the victims of the storm was the city's reputation as a place where the good times always roll. Some of the police deserted; sometimes the mayor dithered; looters plagued its streets. In the fog of the crisis, rumors and fears were widely repeated as truth, even by civic leaders who should have known better. And it's a truism of today's hasty news cycles that exaggerated initial claims make headlines, whereas sober, later retractions are relegated to the inside pages of the newspaper.

Standing in Jackson Square on Sept. 15, President George W. Bush declared, "There is no way to imagine America without New Orleans, and this great city will rise again." The words rang true, but it is troubling to think that the city's promised renaissance may depend on the kindness of strangers. ■

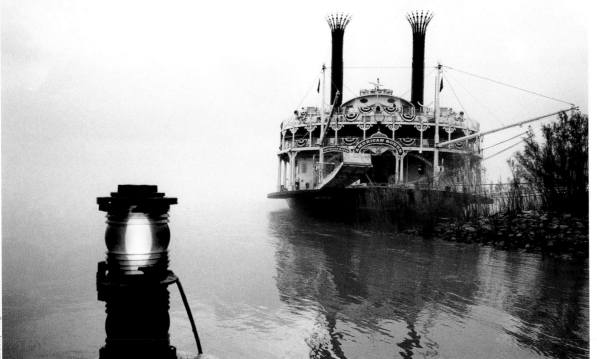

Ian Berry—Magnum Photos

Jay Blakesberg—Retna Ltd

Neville Brothers
From sweet soul to rhythm and blues, the four siblings have been the first family of New Orleans music since they began playing as a group in 1978. The angelic-voiced Aaron Neville, left, also pursues a highly successful solo career.

John Atashian—Corbis

Dr. John Mac Rebennack was in the right place at the right time to craft hits out of the city's jazzy second-line rhythms.

Paul Prudhomme
The proprietor of K-Paul's Louisiana Kitchen brought such exotic treats as blackened redfish to everyone's kitchen. Along with Emeril Lagasse, he is the modern face of a cuisine known for for its flair with spices and fresh seafood from the Gulf.

Owen Franken—Corbis

WHEN THE LEVEE BREAKS

New Orleans is surrounded by a 350-mile (563 km) system of levees that hold back the waters of the Mississippi River and Lake Pontchartrain. When three levees failed, the city filled like a bathtub

① OVERTOPPING

Floodwaters may have risen past the tops of the levees. The city's pumping system, designed to handle smaller storms, lost power and failed

② BREACHING

Because the flooding didn't begin until after the hurricane, some suspect the levees may have leaked from within. The water pressure would have turned tiny cracks into gaping holes

③ REPAIR

Crews have been trying to plug the collapsed levees with giant sandbags and concrete barriers. Once the levees are sealed, the challenge of draining the city begins. That job could take months

TIME Graphic by
Ed Gabel and
Lon Tweeten;
text by Kristina Dell

Sources: Dean Gesch, U.S. Geological Survey; Army Corps of Engineers; Digital Globe; New Orleans *Times-Picayune*. Inset model of downtown New Orleans "Intelligent 3D Map" provided by ITspatial, imagery provided by Sanborn Mapping

New Orleans Unde

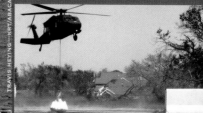

17th STREET CANAL
Helicopters dropped giant sandbags in an effort to seal the initial breach

TRAVIS HEYING—KRT/ABACA

Levee

17th St. Canal breach

Metairie

Lakeview

Orleans Ave. Canal

Interstate 10

17th St. Canal

N E W

Jefferson

Mem Medi Cente

Water-treatment plant

Unive Hospi

Levee

Tulane University

Loyola University

Memorial Medical Center

Audubon Park

St. Cha Hospita

Tulane Hospital

LOUISIANA SUPERDOME
As aid began to trickle into the city, thousands waited for evacuation

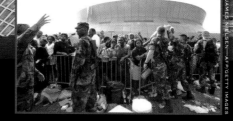

Mississippi River

JAMES NIELSEN—AFP/GETTY IMAGES

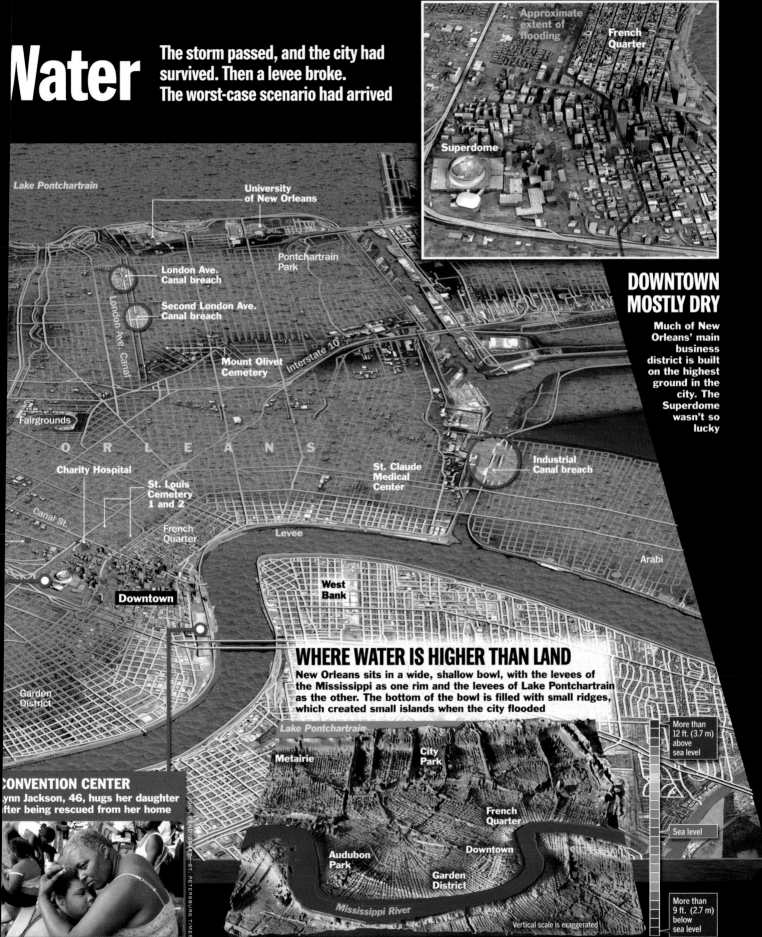

Water

The storm passed, and the city had survived. Then a levee broke. The worst-case scenario had arrived

Approximate extent of flooding

French Quarter

Superdome

DOWNTOWN MOSTLY DRY

Much of New Orleans' main business district is built on the highest ground in the city. The Superdome wasn't so lucky

Lake Pontchartrain

University of New Orleans

London Ave. Canal breach

Second London Ave. Canal breach

Pontchartrain Park

London Ave. Canal

Mount Olivet Cemetery

Interstate 10

O R L E A N S

Fairgrounds

Charity Hospital

St. Louis Cemetery 1 and 2

St. Claude Medical Center

Industrial Canal breach

Canal St.

French Quarter

Levee

Arabi

Downtown

West Bank

WHERE WATER IS HIGHER THAN LAND

New Orleans sits in a wide, shallow bowl, with the levees of the Mississippi as one rim and the levees of Lake Pontchartrain as the other. The bottom of the bowl is filled with small ridges, which created small islands when the city flooded

Garden District

More than 12 ft. (3.7 m) above sea level

CONVENTION CENTER

Lynn Jackson, 46, hugs her daughter after being rescued from her home

Lake Pontchartrain

Metairie

City Park

French Quarter

Audubon Park

Downtown

Garden District

Sea level

Mississippi River

Vertical scale is exaggerated

More than 9 ft. (2.7 m) below sea level

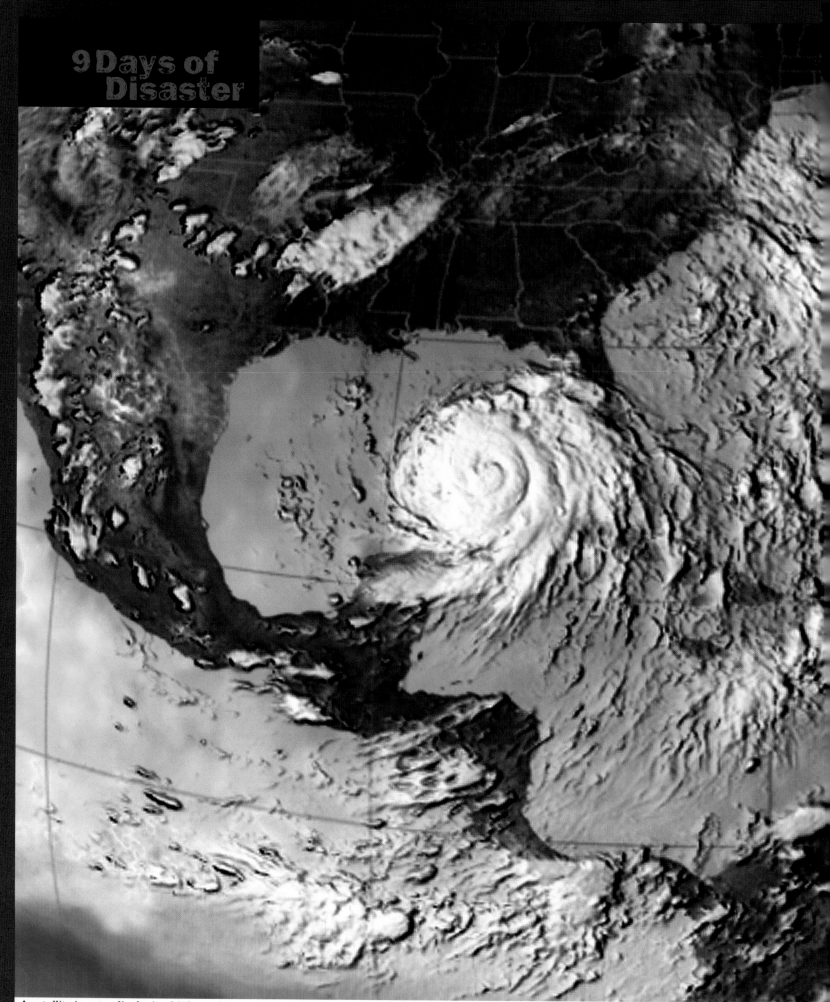

A satellite image—displaying higher wind speeds in red—shows Katrina heading for New Orleans on Aug. 27; the storm stayed on course on Aug. 28

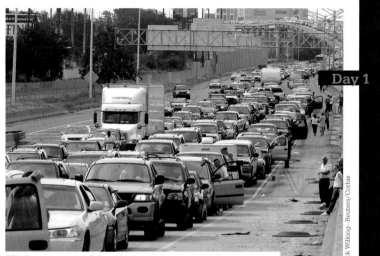

Highways out of the city are jammed with evacuees

Spirits remain high as the evacuation begins

Well-to-do residents protect Garden District homes

By afternoon, the French Quarter is almost deserted

Day 1

Sunday, Aug. 28

Hurricane Katrina heads straight for New Orleans, with winds reaching 175 m.p.h. Some 80% of its 484,000 residents flee—stranding those unable to leave, who are disproportionately old, black and poor

8 a.m.
The National Hurricane Center (NHC) in Miami upgrades Katrina to Category 5, the highest rating on the Saffir-Simpson scale

9 a.m.
President George W. Bush calls Louisiana Governor Kathleen Blanco and encourages an evacuation of New Orleans

9:30 a.m.
Mayor Ray Nagin and Gov. Blanco urge residents to leave New Orleans. "We're facing the storm most of us have feared," Nagin says

11 a.m.
As FEMA director Michael Brown and Homeland Security Secretary Michael Chertoff prepare FEMA's daily briefing for Bush, NHC officials warn that "Katrina's storm surge could overtop New Orleans' levees"

Noon (approx.)
The Regional Transit Authority sends buses to 12 New Orleans locations to transport people to the Superdome, one of 10 city shelters. About 550 members of the Louisiana National Guard are assigned to provide security and distribute food and water in the giant arena

1 p.m.
Traffic congestion and weather delays turn the standard 2-hr. drive from New Orleans to Baton Rouge into a 10-hour ordeal

Afternoon
Governor Blanco activates about 3,500 of the 6,000 National Guard troops under her command. Some 35% to 40% of the state's National Guard troops are serving in Iraq

Afternoon
The Louisiana National Guard requests 700 buses from FEMA to assist coastal evacuation. Only 100 arrive, for reasons still unclear

Afternoon
Bush declares federal states of emergency for Mississippi and Alabama and declares a major disaster in Louisiana. Blanco asks him to boost emergency financial aid from $9 million to $130 million

9 p.m.
Some 20,000 people have gathered at the Superdome. The National Guard has stocked the arena with three trucks of water and seven truckloads of meals ready to eat (MREs), sufficient for 15,000 people for three days, a Guard spokesman says

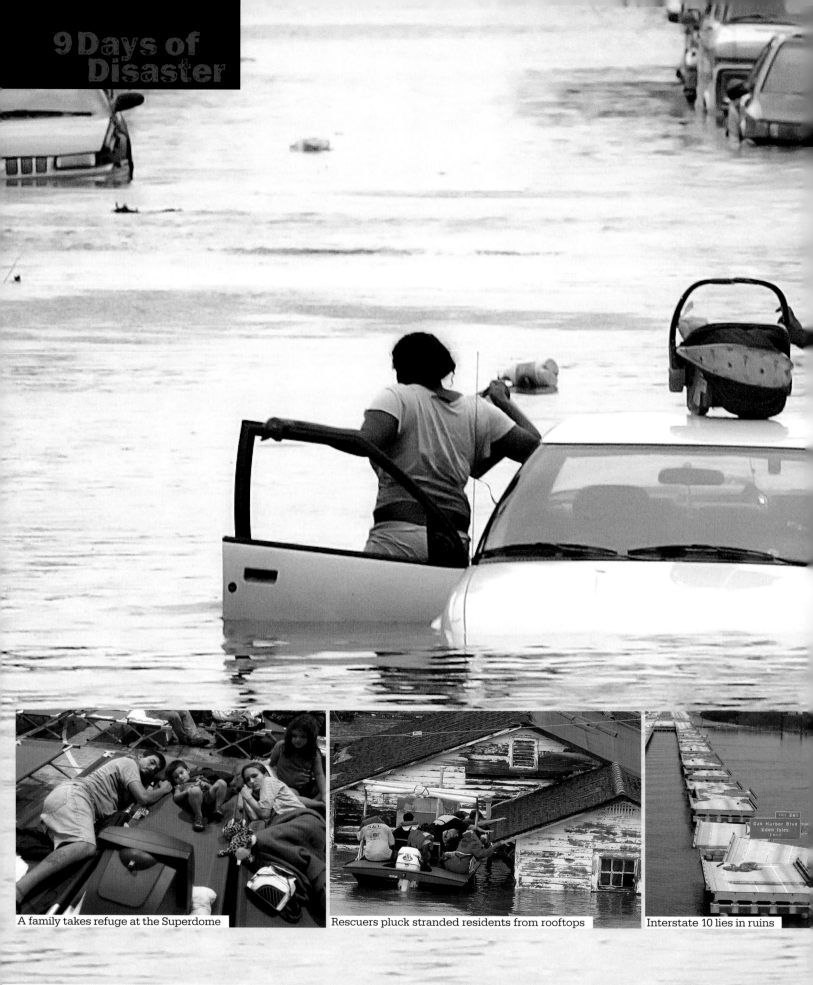

A family takes refuge at the Superdome

Rescuers pluck stranded residents from rooftops

Interstate 10 lies in ruins

Residents of the city's east side, where flooding is heaviest, abandon a swamped vehicle

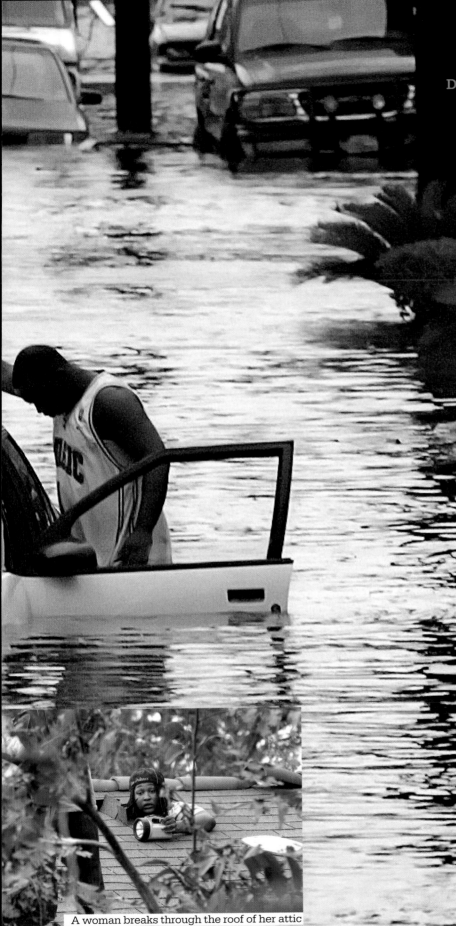

A woman breaks through the roof of her attic

The hurricane makes landfall, and New Orleans initially seems to have dodged major damage. But Katrina's storm surges overtop, then breach, the city's levees, and waters from higher Lake Pontchartrain begin flooding the city

6 a.m.
Katrina, previously heading toward New Orleans, veers to the east, and its winds slow to 145 m.p.h. The storm makes landfall at Buras, La., a bayou town 70 miles southeast of New Orleans; the first photos from Buras show it has been completely destroyed

Dawn
The Superdome, where 20,000 people have now taken shelter, loses electricity and begins running on generator power, with lighting reduced and no air conditioning

8:14 a.m.
The Industrial Canal levee, which holds back Lake Pontchartrain from the Ninth Ward and St. Bernard Parish on the city's east side, is breached. Eight to 10 ft. of flooding is expected

9 a.m.
Katrina's eye passes over the Mississippi coast, moving at 15 m.p.h. Wind speeds of 135 m.p.h. and storm surges wreak destruction

9:30 a.m.
Two pieces of metal planking tear loose from the Superdome's roof and rain pours in

Noon
Electrical and phone systems in New Orleans begin to go offline. Floodwaters rise to more than 6 ft. in Orleans and St. Bernard parishes

1 p.m.
The breach in the Industrial Canal widens: St. Bernard Parish posts a bulletin in red on its website: ESTIMATED 40,000 HOMES ARE FLOODED

2 p.m.
City officials confirm that the levee along the 17th Street Canal on the northwest side of the city has failed; the city is filling like a bowl

4 p.m.
Two levees along the London Avenue Canal fail. They are the last barriers to be breached

4:30 p.m.
Damage to the city is called far lighter than expected by early news reports that focus on the city's well-known Garden District and French Quarter. Built on higher ground, these tourist haunts are not heavily flooded

5:30 p.m.
The breach in the 17th Street Canal levee is widening; it will reach 200 ft. Most of New Orleans will be underwater within 12 hours

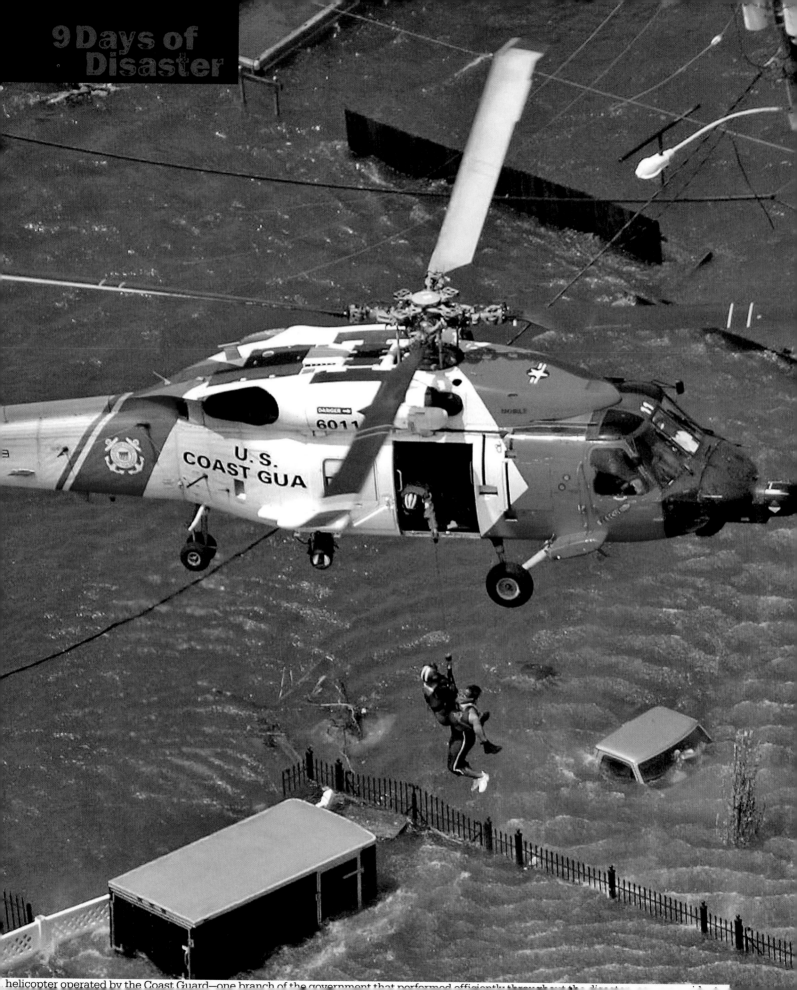

helicopter operated by the Coast Guard—one branch of the government that performed efficiently throughout the disaster

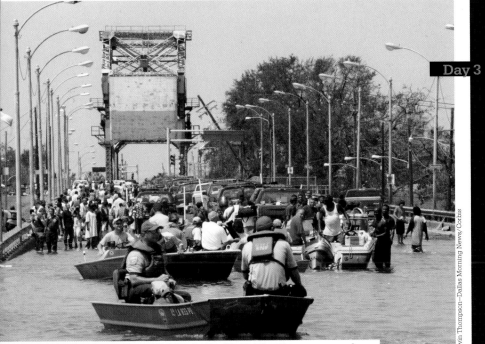

The foot of the St. Claude Street Bridge in the Ninth Ward becomes a refuge

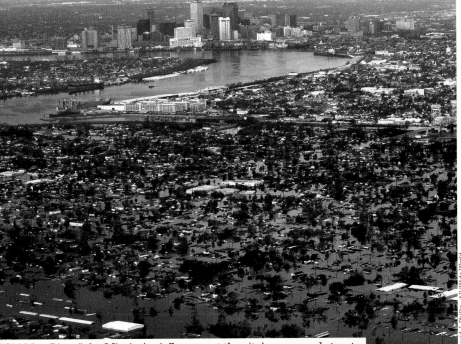

"Old Man River," the Mississippi, flows past the city's swamped streets

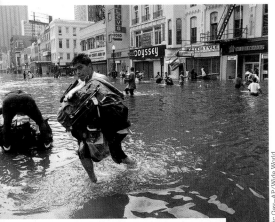

Caught in the act, a looter eyes the camera

Michael Chertoff, on the spot

Blue skies reveal a city rapidly flooding; by day's end New Orleans will be 80% under water. Civil society begins to break down, as looting and arson start to rock the city. Thousands are stranded at the Superdome —where rumors of crime spread unchecked

5 a.m. (Pacific time)
President Bush, in San Diego for a V-J day anniversary celebration, is briefed on the flooding of New Orleans and decides to cut short the last week of his Texas vacation and return to Washington to address the crisis

9 a.m.
DHS Secretary Chertoff is told that there is no quick fix for New Orleans' multiple levee breaches. Rapid flooding continues

Noon
Fires break out around the city, some of them believed to be the result of arson. Looting also begins, with few police to halt it

Afternoon
Governor Blanco visits the Superdome and is shocked at the conditions there. Louisiana and FEMA officials argue over who should be supplying buses to evacuate the displaced

Late afternoon
The city's water supply system fails, depriving stranded residents of potable water

6:30 p.m.
Mayor Nagin tells a local radio station that the Army Corps of Engineers' efforts to mend the city's levees have failed. At a press conference minutes later, he estimates that 80% of the city is underwater, and he warns that some areas now dry may also soon flood

Evening
The population within the Superdome has swelled; estimates of the number present range up to 25,000, and no evacuation plan for the stranded is in effect. Sanitary conditions are rapidly deteriorating, food and water are scarce, and rumors of violence spread fear

Evening
To relieve crowding at the Superdome, local officials open the Ernest N. Morial Memorial Convention Center and advise residents to take shelter there. But no plans exist for using this facility to accommodate large numbers of people, and conditions there soon mirror those within the Superdome

Evening
Large numbers of evacuees gather beneath an overpass of Interstate 10, where rescue helicopters are dropping people plucked from rooftops. The displaced are left in the open for days without shelter, food, sanitary facilities, medical aid or official supervision

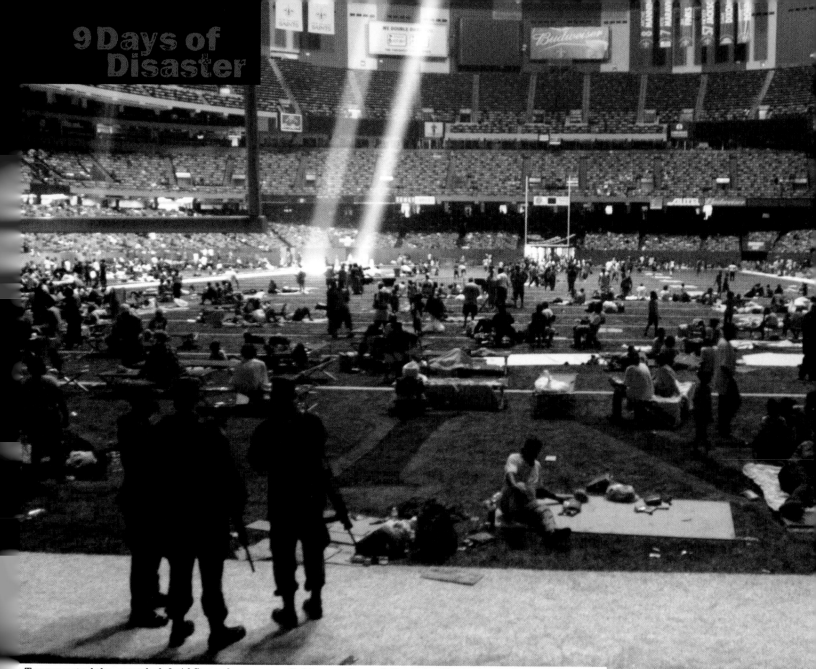

Troops patrol the crowded, fetid Superdome, as sunlight pours through the holes Katrina's winds tore in its roof

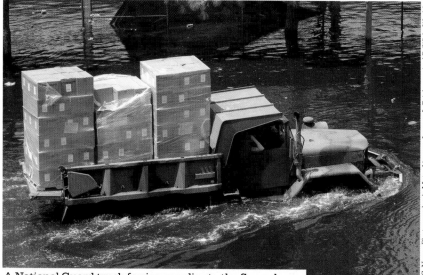

A National Guard truck ferries supplies to the Superdome

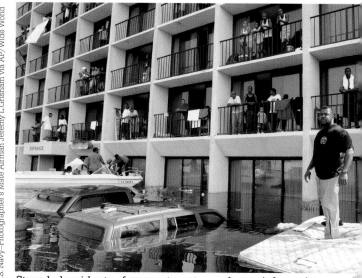

Stranded residents of an apartment complex wait for assistance

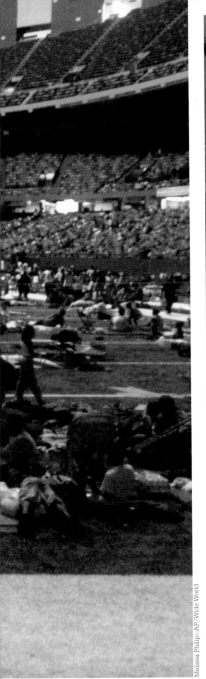

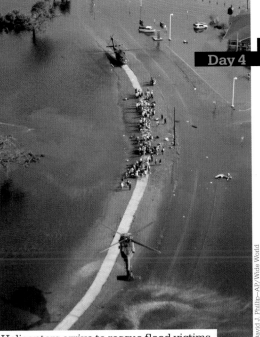

Helicopters arrive to rescue flood victims

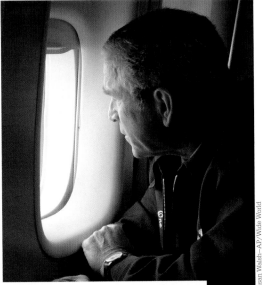

President Bush flies over New Orleans

Swamped park, no amusement

Day 4 ## Wednesday, Aug. 31

Conditions within New Orleans continue to deteriorate; this will rank as one of the worst days of the calamity, as local, state and federal agencies are unable to aid crowds in the Superdome and Convention Center, where food, water and patience are in short supply

8 a.m.
Emergency generators at University and Charity hospitals run out of fuel, leaving some 350 patients and 1,000 staff in the dark

Morning
As conditions within the Superdome worsen, sanitary conditions are foul, and multiple rapes, homicides and a suicide are reported; most of the accounts are unfounded rumors

10 a.m.
FEMA and Governor Blanco announce a new evacuation plan for the displaced: a convoy of buses will take evacuees stranded in the Superdome to the Houston Astrodome

Noon
President Bush surveys New Orleans through the window of Air Force One as he cuts short his vacation to return to Washington. White House sources later say photos of the moment, showing a disengaged Bush, contribute to public disapproval of his response

Noon
The Army Corps of Engineers declares that water levels in the city and Lake Pontchartrain have equalized, effectively making low-lying New Orleans part of the lake

1 p.m.
Corps of Engineers' efforts to plug the 17th Street Canal levee are hindered by a lack of slings, the fabric bags used to hold rocks and sand dumped into the breaches by helicopter

4:11 p.m.
After a Cabinet meeting, Bush confirms the scale of the disaster. "The vast majority of New Orleans … is under water. Tens of thousands of homes and businesses are beyond repair. A lot of the Mississippi Gulf Coast has been completely destroyed. Mobile is flooded. We are dealing with one of the worst natural disasters in our nation's history"

Late afternoon
Mayor Nagin orders almost all of the city's 1,500 police officers off search-and-rescue duty to control looting and arson. In these first days of the disaster, some one-sixth of the city's policemen do not report for duty

Evening
Crowds at the Convention Center swell to more than 3,000. Local officials say the facility has food for the hungry and buses to evacuate victims. Both statements are incorrect

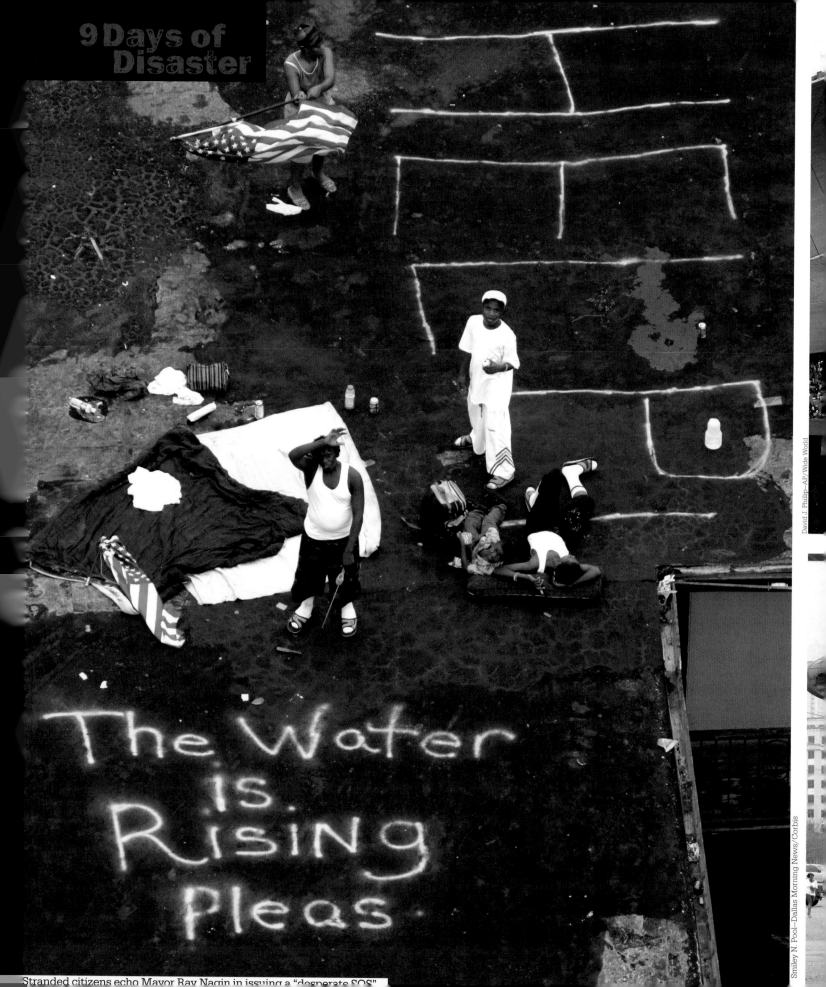

The Water is Rising Pleas

Stranded citizens echo Mayor Ray Nagin in issuing a "desperate SOS"

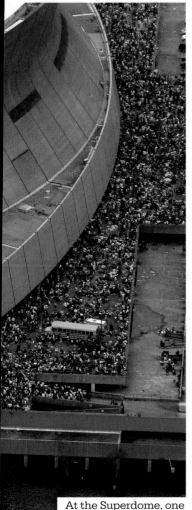

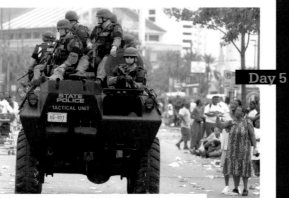
A Louisiana state SWAT team moves in

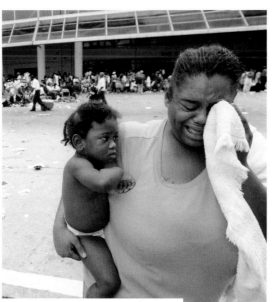

At the Superdome, one bus and 20,000 riders

Misery at the Convention Center

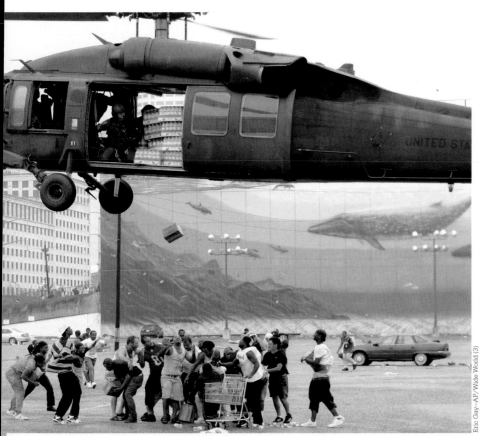
U.S. military helicopters drop food and water to those stranded at the Convention Center

Flood victims are still trapped on rooftops. Evacuation begins, slowly, at the Superdome. Federal officials claim to be ignorant of the desperate situation at the Convention Center, which most Americans have been following closely through extensive live media reports

8 a.m.
As many as 20,000 people are stranded at the Convention Center, amid turmoil. A reporter counts seven unburied bodies outside it

Morning
Some 300 Louisiana National Guardsmen arrive at the Superdome and begin bus and helicopter evacuation. It is suspended within an hour owing to rioting outside the facility and reports of snipers firing at rescuers

Morning
Police Chief Eddie Compass sends 88 officers to establish security at the Convention Center, but they cannot control the crowds

Noon
In a press conference, DHS Director Chertoff claims his agency has New Orleans under control and that the Superdome is secure

Noon
Live on CNN, Mayor Nagin sends out "a desperate SOS ... I keep hearing [help] is coming. This is coming. That is coming. My answer to that today is, 'B.S.: Where's the beef?' ... They're spinning and people are dying down here."

Afternoon
Dennis Hastert, Speaker of the U.S. House of Representatives, says of New Orleans to an Illinois newspaper, "It looks like a lot of that place could be bulldozed." He later apologizes

Afternoon
Attempts to evacuate the Charity and L.S.U. hospitals are halted by sniper fire

Afternoon
General Strock of the Corps of Engineers admits his agency can't assess the breached levees because all available helicopters are working search-and-rescue missions

Late afternoon
In an interview with NPR, Chertoff dismisses the idea that there are large numbers of people starving at the Convention Center

Evening
The first busloads of evacuees from the Superdome arrive at the Astrodome in Houston

Late evening
On ABC's *Nightline,* FEMA chief Brown says he learned about the havoc at the Convention Center only hours before. Anchor Ted Koppel asks, "Don't you guys watch television?"

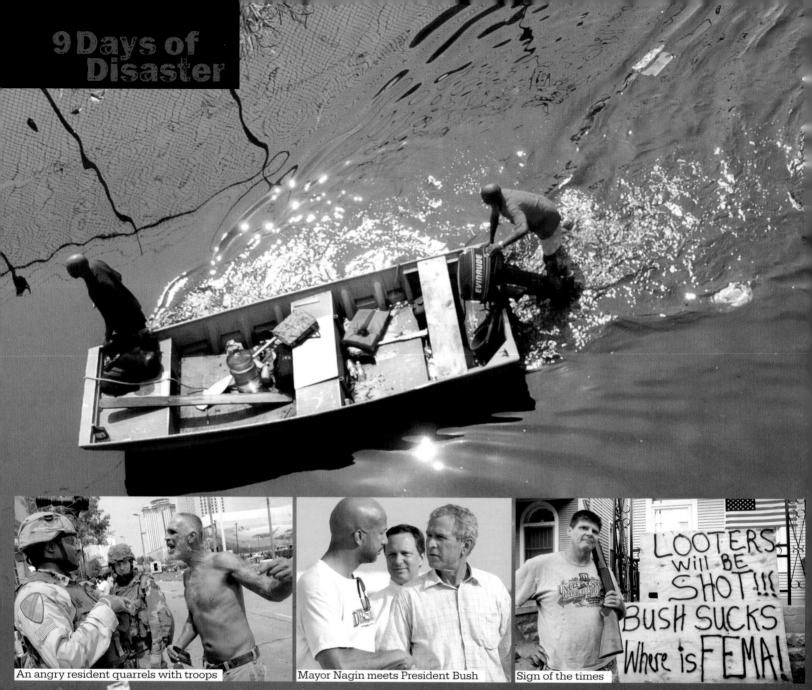

An angry resident quarrels with troops

Mayor Nagin meets President Bush

Sign of the times

LOOTERS will BE SHOT!!! BUSH SUCKS Where is FEMA!

Near the Superdome, residents bring a boat to help rescue stranded flood victims, ignoring a floating corpse

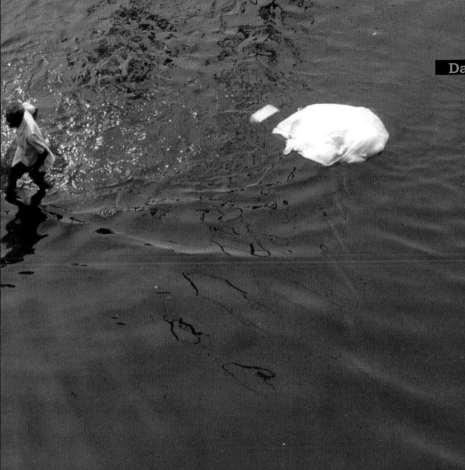

This day is the turning point. More National Guard troops arrive, evacuation continues at the Superdome and concludes at hospitals, and the Convention Center is secured. Amid popular disapproval of federal aid efforts, the President arrives in the Gulf for the first time

4:35 a.m.
New Orleans is rocked by a series of large explosions at a chemical storage facility

7:05 a.m.
Before leaving Washington for a six-hour air tour of devastated coastal areas, President Bush, speaking of federal relief efforts, tells reporters, "The results are not acceptable"

Morning
In a heated meeting aboard Air Force One at the New Orleans airport, Governor Blanco and Mayor Nagin assail the federal response to Katrina. Bush asks Blanco to relinquish control of local law enforcement and National Guard troops. She asks for time to consider the request and later refuses it

10:35 a.m.
At the Mobile (Ala.) Regional Airport, Bush praises FEMA Director Michael Brown, saying, "Brownie, you're doing a heck of a job"

Noon
A force of 1,000 National Guard troops and New Orleans police officers arrives at the Convention Center to provide security and offer food and water to a crowd now estimated at more than 20,000. But the Guard has no buses to speed evacuation from there

1 p.m.
Evacuation of the Superdome resumes, with an estimated 8,000 to 10,000 people standing in 100°-plus heat and wading through knee-deep trash to board buses

2 p.m.
More than 600 people, including 110 patients, are evacuated from University Hospital; 2,200 people, including 363 patients, are evacuated from Charity Hospital

4 p.m.
Remaining staff and patients at three more hospitals—Tulane University, Methodist and Kindred—are evacuated

Afternoon
Houston Mayor Bill White reports that, with 15,000 evacuees inside, the Astrodome is full. He opens the Reliant Center, an indoor convention hall, which can hold another 11,000

Late afternoon
Bush and Louisiana Senator Mary Landrieu visit the 17th Street Canal levee, where sheet piling has temporarily patched the breach

Hospital workers evacuate

More police return to duty, quelling looting

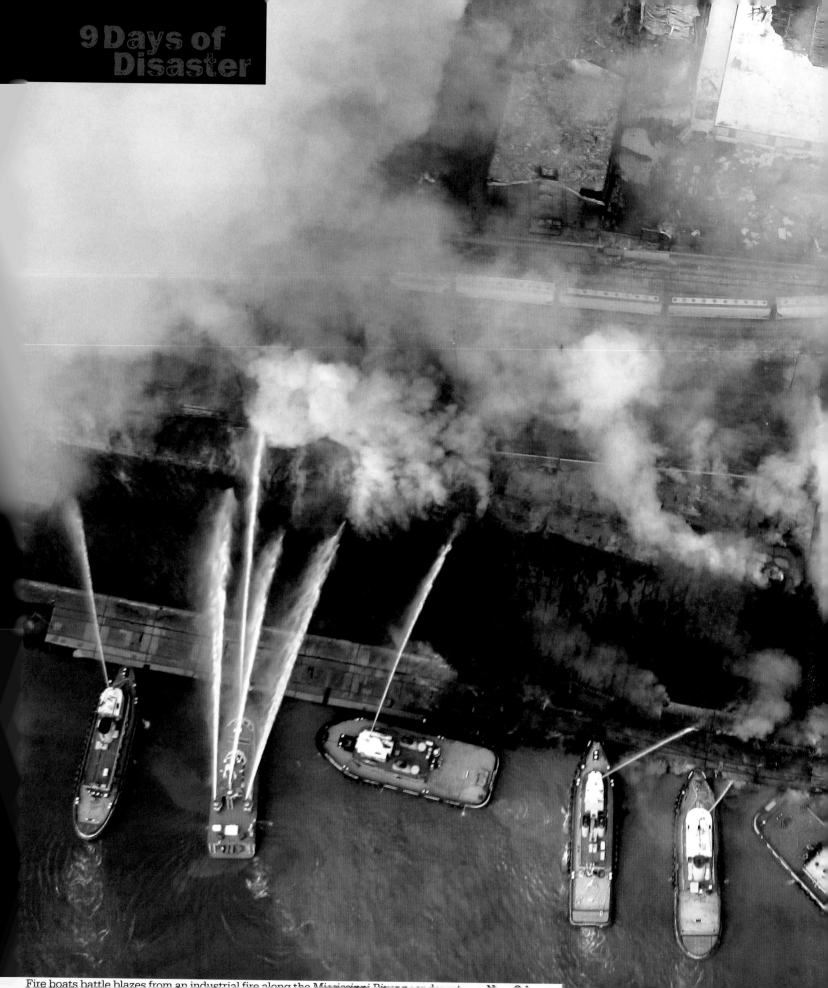

9 Days of Disaster

Fire boats battle blazes from an industrial fire along the Mississippi River near downtown New Orleans

Saturday, Sept. 3

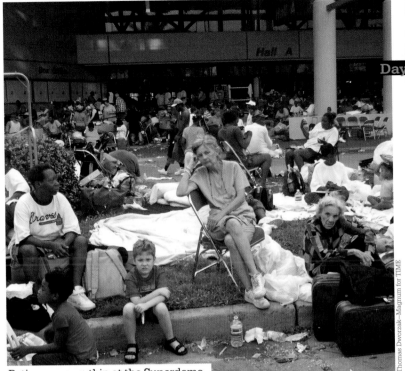

Patience wears thin at the Superdome

Thomas Dworzak—Magnum for TIME

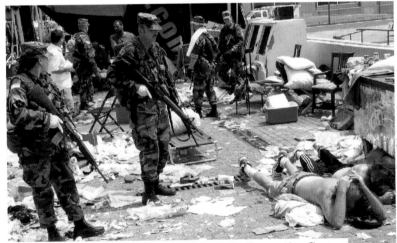

National Guard troops stop a knife fight at the Convention Center

Jessica Leigh—Shreveport Times/Polaris

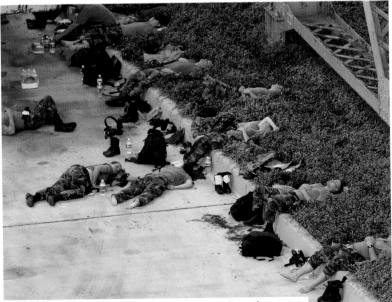

Exhausted National Guardsmen take a break on the street

David J. Phillip—Reuters/Corbis

Brent Coomer—Houston Chronicle/WPN

Slowly, New Orleanians stranded for days in intolerable conditions are being evacuated from the city. Looting is under control, but the city remains crippled, its streets flooded and power out, as fires continue to break out in both industrial and residential areas

Early morning
Evacuation of the Superdome nears an end; some 2,000 to 5,000 evacuees remain. Efforts to relieve the Convention Center have barely started; more than 25,000 people are believed to be at the site. Buses freed from duty at the Superdome are redirected to this facility

9 a.m.
In his weekly radio address, President Bush says he will send more than 7,000 military personnel to the Gulf over the next 72 hours, in addition to the more than 4,000 active-duty U.S. troops already there

Late morning
The Department of Defense announces separately that 10,000 more National Guard troops are being sent to the region, in addition to the 30,000 already there or en route

Noon
Members of the Texas National Guard, who have been helping evacuate the Superdome, cheer as the last person departs. But more people arrive later, and the exodus resumes

Early afternoon
U.S. Army Colonel John Smart, chief operations officer for Joint Task Force Katrina West, reports that 42,000 people have now been evacuated from the Superdome and Convention Center

Afternoon
Rosalie Guidry Daste, a 100-year-old woman who had been stuck in her flooded nursing home for days, dies moments after she is rescued from the facility

Afternoon
Army Corps of Engineers officials realize that the pumps used to drain New Orleans have not been manufactured for years; replacement parts will have to be designed and made from scratch, delaying the removal of floodwater

Afternoon
Governor Blanco announces she has hired former FEMA director James Lee Witt, a Clinton appointee, to head the state recovery effort

Evening
American Airlines dispatches three aircraft manned by volunteer crews to New Orleans and flies Katrina refugees to Lackland Air Force Base in San Antonio, Texas. Several other airlines follow suit; more than 50 of these missions are flown over the next five days

A natural-gas fire burns through the flooded streets of the city's Lakeview district

Senate Majority Leader Bill Frist, a doctor, helps at the airport

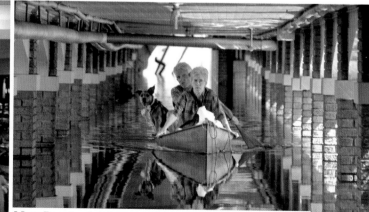

Mary Rossiter is taken to safety via a flooded breezeway

Patience runs out

The most pressing problem in the city—the urgent need to evacuate those stranded at the two main shelters and city hospitals—has now been solved. As the rescue process ends, emergency personnel turn, at last, to recovering the bodies of the dead

8 a.m.
The last stragglers have been evacuated from the Superdome and Convention Center. In the past week, 24 people died in and around the Convention Center. Four bodies have been recovered from inside the Superdome and six more in the immediate vicinity

Morning
FEMA announces that all patients from New Orleans' 12 largest hospitals have been evacuated and that cruise ships are being dispatched to the Gulf to serve as temporary housing for evacuees and emergency workers

Morning
Federal officials formally accept several offers of foreign aid, clearing the way for tons of supplies that have been awaiting official clearance to be be airlifted from Germany, Sweden and other countries and flown to the Gulf. European Union officials say the U.S. government requested first-aid kits, blankets, water trucks and 500,000 food rations

11 a.m.
Jefferson Parish president Aaron Broussard appears on NBC's *Meet the Press* with DHS Secretary Chertoff and claims that FEMA prevented aid from reaching his parish. "Bureaucracy has committed murder here in the greater New Orleans area," he charges

Afternoon
Federal officials acknowledge that the massive Navy relief ship U.S.S. *Bataan* has been in the region for almost four days but that no use had been made of the ship's doctors, six operating rooms, 600 hospital beds, food and water supplies—or its ability to produce 100,000 gal. of clean, fresh water a day

4 p.m.
Mayor Nagin estimates for the first time that Katrina's final death toll in New Orleans may approach 10,000; the eventual tally will turn out to be about one-tenth that number

5 p.m.
The Army Corps of Engineers announces that it has succeeded in closing the breaches in the 17th Street Canal

Evening
As the number of Katrina evacuees in Texas approaches 250,000, Governor Rick Perry orders state emergency officials to begin implementing plans to airlift some of them to other states that have offered to help

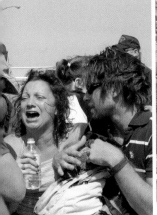

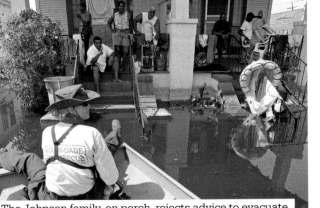

The Johnson family, on porch, rejects advice to evacuate

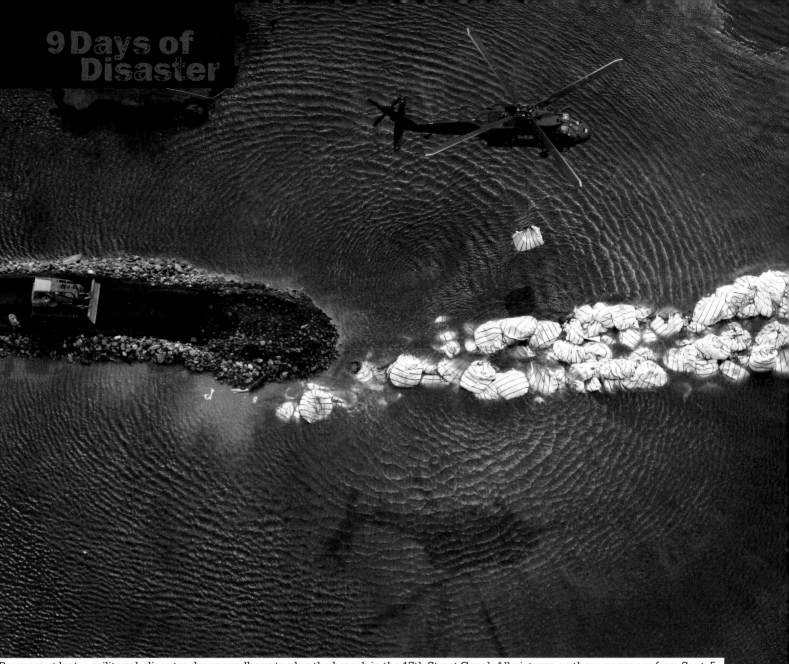

Progress at last: a military helicopter drops sandbags to plug the breach in the 17th Street Canal. All pictures on these pages are from Sept. 5

President Bush and Governor Blanco meet with FEMA staff in Baton Rouge, La.

Kevin Lemarque—Reuters/Landov

In a city with many wooden homes, fire remains a threat

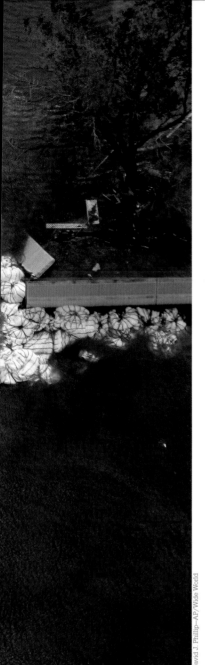

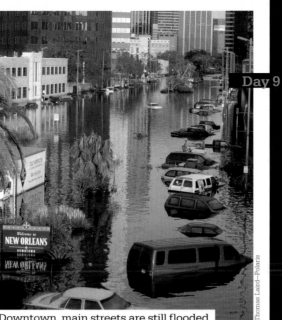

Downtown, main streets are still flooded

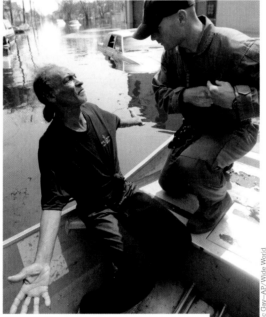

Joseph Gerdes, left, resists evacuation

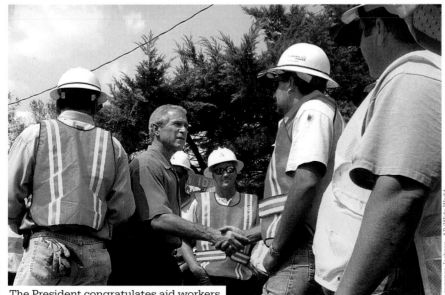

The President congratulates aid workers

Monday, Sept. 5
and the Days That Followed

On Sept. 5, Mayor Nagin issues a mandatory evacuation order for his flooded city, and President Bush, under fire, returns to the region. In the following weeks, the fallout and finger pointing over the local, state and federal responses to the disaster continue

Sept. 5, morning
Stung by ongoing criticism of the tardy federal response to the crisis, President Bush returns to Louisiana. In a sign of the tension between state officials and the White House, Governor Blanco is not informed of the visit in advance, further souring relations

Sept. 5, afternoon
The patching of the 17th Street Canal breach is completed. It reopens and begins pumping water out of the city. The breach in the London Avenue Canal is also closed

Sept. 9, morning
DHS Secretary Chertoff relieves FEMA Director Brown and places Coast Guard Vice Admiral Thad W. Allen in day-to-day command of the Katrina relief effort

Sept. 9, afternoon
FEMA abandons a plan to distribute debit cards worth $2,000 to Katrina victims one day after announcing it, saying it will deposit funds directly in their bank accounts instead

Sept. 12
Michael Brown resigns as head of FEMA

Sept. 13
In a press conference, Bush for the first time admits the failures in the response to Katrina, saying it "exposed serious problems ... at all levels of government. And to the extent that the Federal Government didn't fully do its job right, I take responsibility"

Sept. 15
In a live TV address from New Orleans, Bush asserts "there is no way to imagine America without New Orleans, and this great city will rise again"; he proposes a massive infusion of federal aid to rebuild the city

Sept. 23
Hurricane Rita slams into the coasts of Texas and west Louisiana; New Orleans levees are overtopped, and some districts flood—again

Sept. 26
The New Orleans Times-Picayune publishes a story revealing that media coverage of the Superdome and Convention Center during the crisis severely exaggerated the extent of crimes and deaths at both facilities

Sept. 27
New Orleans police superintendent Eddie Compass abruptly resigns

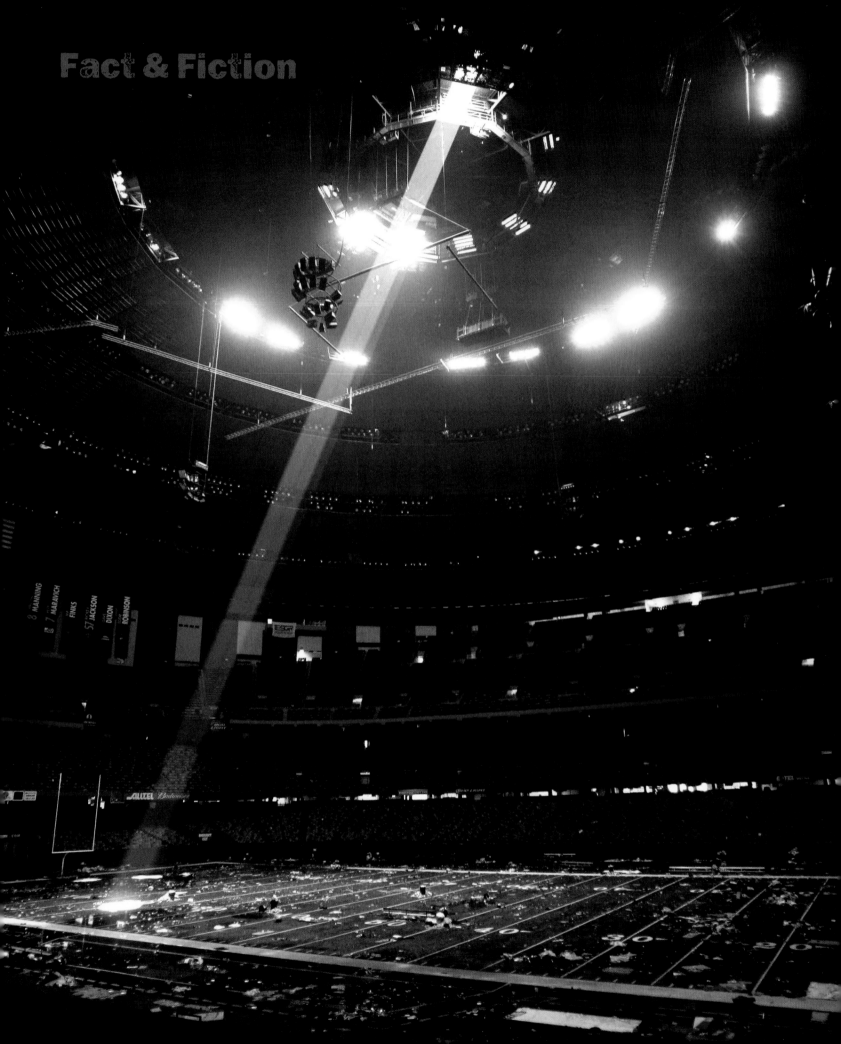

Fact & Fiction

Katrina's Last Casualty: Truth

A flood tide of rumors swamped the facts in New Orleans, further harming the city

In the wake of any disaster, the flow of information becomes polluted with mistakes, myths and half-truths so often repeated they seem to harden into fact. Hurricane Katrina was no exception. Delusion seemed to follow the deluge by a matter of hours, and many of the rumors remained afloat long after the floodwaters had receded. Sadly, the widely reported tales fed the sense of helplessness among those stranded in the city, were often repeated as truth by authorities who should have known better, and sometimes played up false racial stereotypes. Here are some examples:

Myth Dozens of people were raped and killed in the Superdome and at the Convention Center.
Fact After those facilities were clear of evacuees, officials sent in forensic teams, expecting to find as many as 200 corpses. Only 10 bodies were found at the Superdome. Of these, four were apparently brought in from the street outside, and six were believed to have died within (four of natural causes, one of a drug overdose and one of a fall from a balcony that was an apparent suicide). Of four deaths known to have occurred inside the Convention Center, three were from natural causes, and one was an apparent homicide. The bodies of 20 people were found outside the center, but those deaths are not believed to have involved crimes.

Myth Armed bands of looters tried to shoot down rescue helicopters as they attempted to evacuate survivors from New Orleans.
Fact There were numerous confirmed incidents of gunfire on the streets of New Orleans after the hurricane, but separate investigations by the Air Force, Coast Guard, Department of Homeland Security and Louisiana Air National Guard had been unable, as of the first week in October, to confirm a single case of airborne rescue teams taking fire from the ground. Investigators noted that low-flying crews could have heard shots on the ground and might have erroneously assumed they were being targeted.

Myth Louisiana Governor Kathleen Blanco did not formally declare a state of emergency until many days after Katrina struck, creating legal obstacles to the flow of federal aid into her state.
Fact Although this allegation was widely reported, often attributed to unnamed White House sources, it was at the very least a mistake and possibly a case of malicious political spin. Many responsible news outlets, including the Washington *Post,* later published corrections acknowledging that Blanco had, in fact, declared a state of emergency on Aug. 26, three days before Katrina made landfall.

Myth Fully one-third of the roughly 1,600 members of the New Orleans police force deserted in the days following the landfall of Hurricane Katrina.
Fact This figure, based on an estimate quoted by Deputy Police Superintendent Warren Riley at a Sept. 5 news conference, was widely circulated, but later analysis by police officials concluded that no more than 249 officers—about 15% of the force—were absent without permission during the crisis. Further investigation will be required to determine how many of these officers actually deserted, and how many of them had legitimate reasons involving the disaster that kept them from their duty.

Myth There was a wave of suicides among New Orleans police officers after Katrina.
Fact There are two documented cases of New Orleans police officers taking their own lives. Patrolman Lawrence Celestine shot himself on Sept. 3. Sergeant Paul Accardo, a department spokesman, shot himself the next day. The officers are believed to have been close friends.

Myth The floodwaters in New Orleans were infested with sharks, alligators and killer snakes.
Fact There is not a single credible report of a sighting of sharks or alligators in the flooded, polluted streets of the city. Although snakes were occasionally seen, they generally avoided contact with humans. ∎

SHEDDING LIGHT
The interior of the Superdome is finally clear of stranded New Orleans residents on Sept. 5

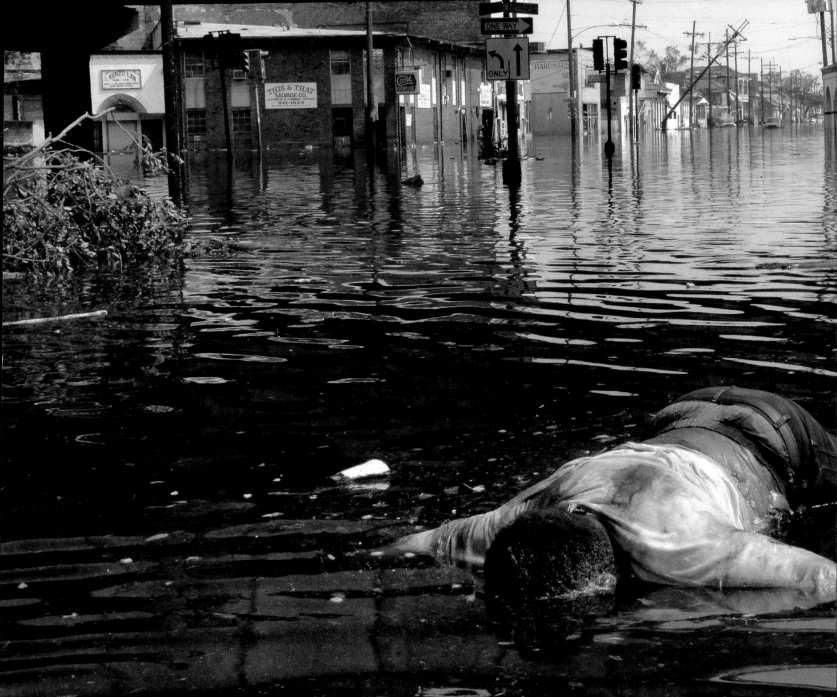

Elysian Fields

Thomas Dworzak believes this photo, taken in the Elysian Fields neighborhood, is the most important picture he took in New Orleans. "This is really not nice. It doesn't look good, it doesn't smell good, and it was horrible. The body should have been taken out of there a long time before. Neighborhood people told me about the corpse. As in war, people were telling me about events they thought should be recorded."

Thomas Dworzak

Born in Germany in 1972,
Thomas Dworzak works in the
tradition of such great photojour-
nalists as Robert Capa, Carl
Mydans, Larry Burrows, James
Nachtwey and Christopher
Morris: he travels to the world's
combat zones to record war
and turmoil. His experiences in
covering the post-9/11 wars
in Afghanistan and Iraq, as well
as conflicts in Kosovo, Chechnya
and other hot spots, served him
well when he was asked by TIME
to photograph Hurricane Katrina.
 In the storm's wake, Americn
photographers found both heart-
break and heroism through their
lenses. Dworzak's pictures seem
darker, perhaps because he
approached the storm's after-
math from the perspective
of an outsider.

❝ [This body] was one of many not recovered. Yes, there are floods
and hurricanes … it's a normal thing … you can't blame anybody.
The most shocking thing is, nobody picked up the bodies. **❞**

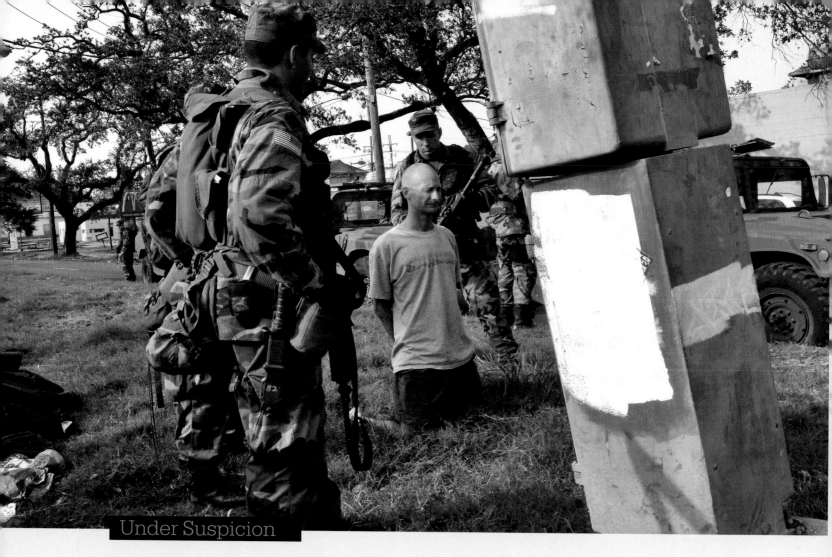

Under Suspicion

In the fog of war, certainty is hard to establish. Dworzak: "The Oklahoma National Guard arrested a man they said they had seen from a helicopter in the act of looting. He was kneeling down, pledging his innocence. He had a printed card saying he was part of a rescue mission from Virginia. He had a pair of rubber boots and a sleeping bag they said he had stolen. It was strange ... had he come all the way from Virginia to loot rubber boots?"

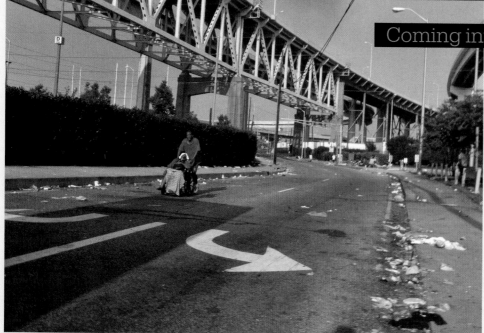

Coming into Focus

Dworzak: "I saw this man pushing a person from a distance, and I didn't really look too closely, I just started taking pictures. But the man pushing started yelling at me to stop. I tried to make a cheesy argument about wanting to show people helping each other. Then he said, 'How would you feel if you were pushing your dead mother down a highway in a wheelchair and somebody took a picture?' I apologized and took no more shots."

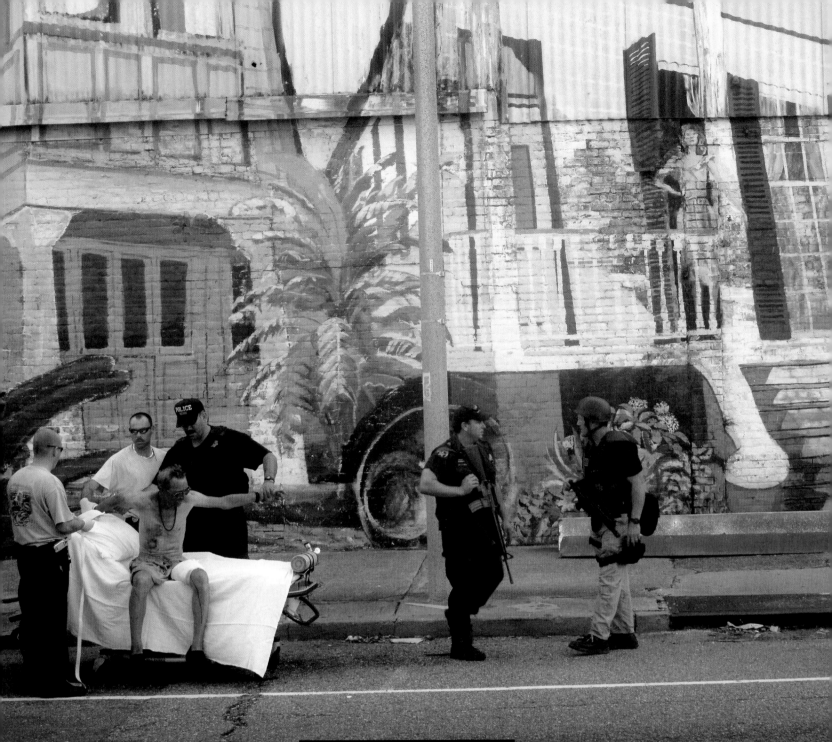

Criminal—or Crazy?

As police began to take back control of the streets, it became difficult to distinguish between the law abiding and the lawless. Dworzak captured the confusing scene above on Sept. 5. "The police arrested this man," he recalls. "At first they had him in handcuffs, but he was injured or slightly hurt during the arrest, so they changed his handcuffs to white bandages and tied him on the stretcher. I asked one cop what was happening. 'I've seen this man for 10 years now,' the policeman said. 'He's always drifting around the neighborhood.' " Dworzak inquired, "Was he looting?" "Well, he was found inside an art gallery, so we're taking him to a hospital, but under arrest," the officer replied.

"There's a geography of racism here ... the city is built with the white, rich quarters above sea level, and the black, poor quarters below sea level. So when the waters come, it floods the black guys, and the white guys stand on the bridge."

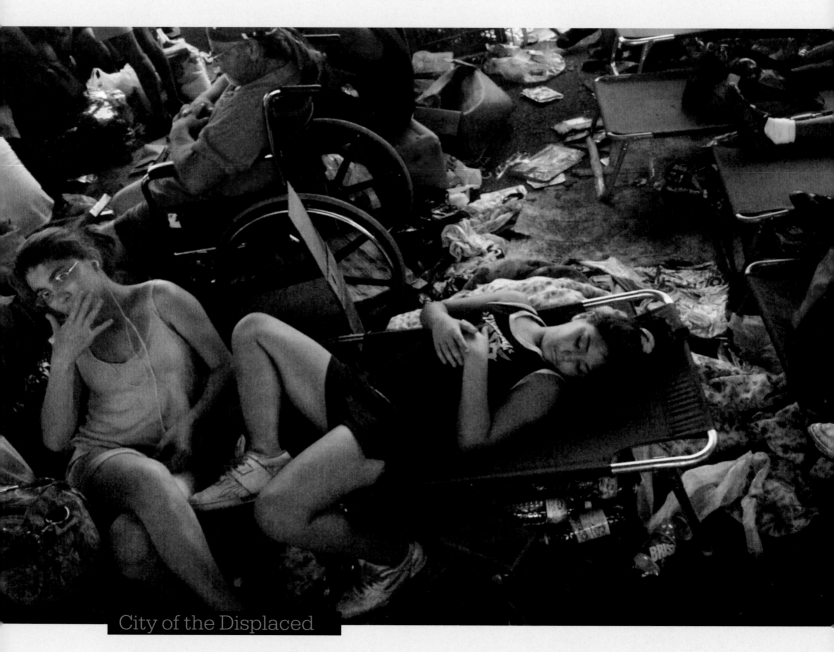

City of the Displaced

On Sept. 2, Dworzak came upon a huge encampment of displaced people who had taken shelter and created a city of sorts beneath an underpass on Interstate 10 outside New Orleans. "It was a bad place," he says, "thousands of people living under a highway for three days in the heat and the dirt. These weren't drug addicts or crazy people—they were just normal people who couldn't get out."

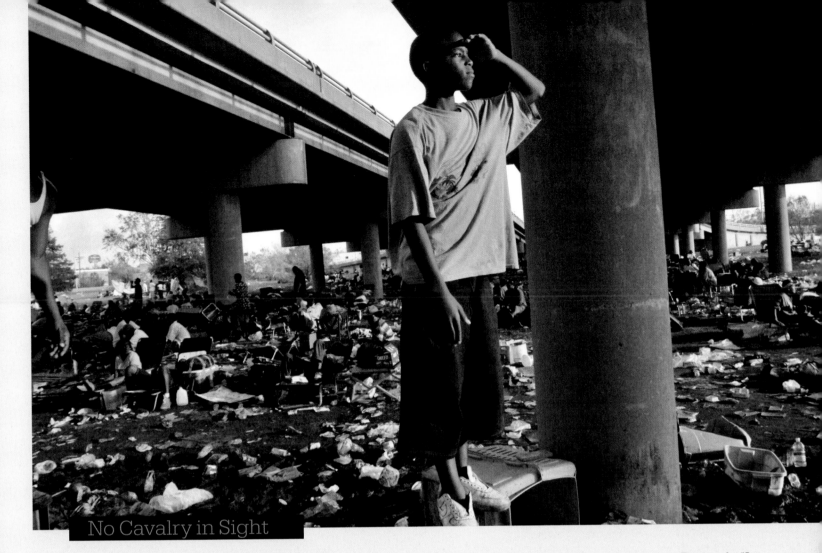

No Cavalry in Sight

A boy camping out under the highway scans the horizon for aid on Sept. 2, without success. Says Dworzak: "I can't understand how I could fly to Dallas, fly to Baton Rouge, rent a car, drive down a highway, pass through one checkpoint—where the authorities took a quick look at my passport—and drive right into this scene. And there was no danger; nobody shot at me. So why couldn't the National Guard find its way down there?"

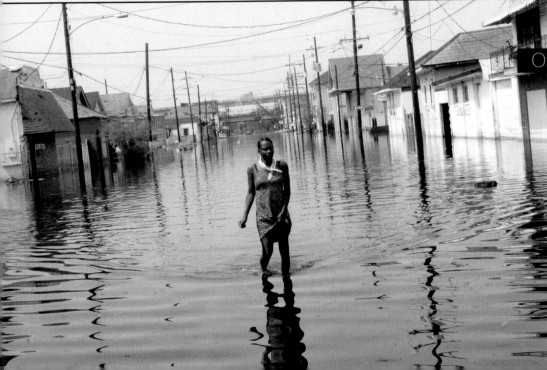

Out for a Stroll

On Sept. 2, his first day on the scene, Dworzak decided to seek out residents who were still living in a flooded New Orleans. He came upon this woman in the Elysian Fields neighborhood and found her to be, "strangely enough, pretty cheerful. She laughed and said that at least the water wasn't too cold."

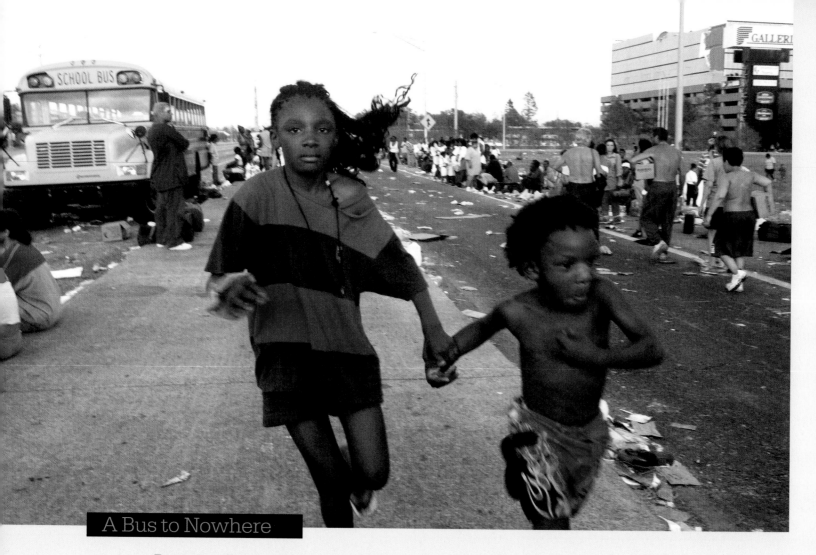

A Bus to Nowhere

Evacuation efforts began to take hold on Sept. 2 and 3, and although order was being established, rumors were flying. These children, among those camping under a highway, are running to catch a bus they heard was going to Houston. The rumor proved false. Says Dworzak: "There was all this confusion; people were running around. It was getting more active, but the process was still really, really slow. Yet the people were peaceful."

Out of Context

Dworzak: "Right in the middle of the road I came across this coffin, with no cemetery in sight anywhere. A sign on the casket dated it to 1993. Local people told me that they had always scared their children with tales of coffins floating out of the city's aboveground cemeteries during a flood."

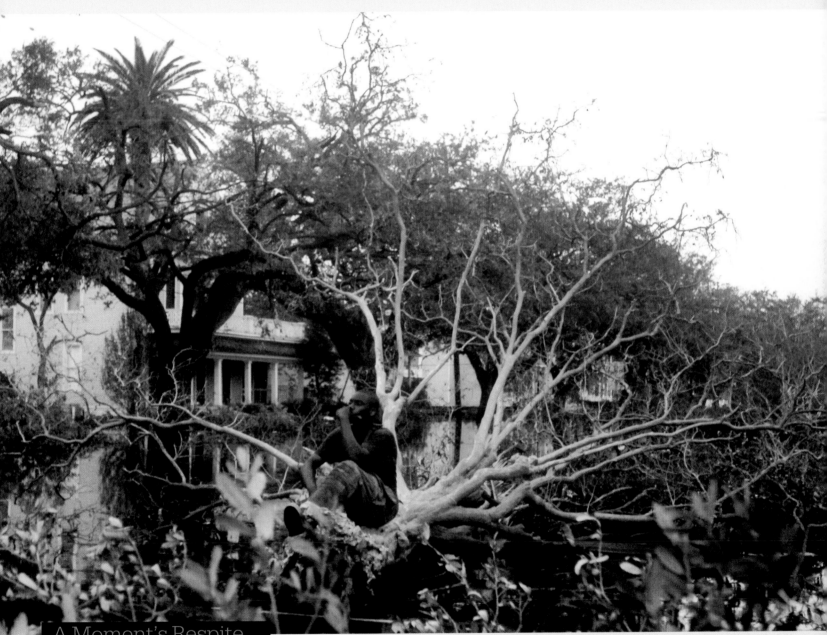

A Moment's Respite

A toppled oak tree in the Garden District becomes a roost for a fire fighter who needs a break. The French Quarter and the Garden District, occupying higher ground, flooded less severely than most of the districts of New Orleans, which lie below sea level. Even so, throughout the Garden District in the days after the storm, power lines were down, cars had flat tires—or the tires had been stolen—and massive, decades-old Spanish oaks like the one above blocked the streets.

Catastrophe Along the Coast

On path for a direct hit on New Orleans, Hurricane Katrina veers east at the last minute and wreaks horrifying damage on a necklace of historic, graceful Mississippi towns that face the Gulf of Mexico

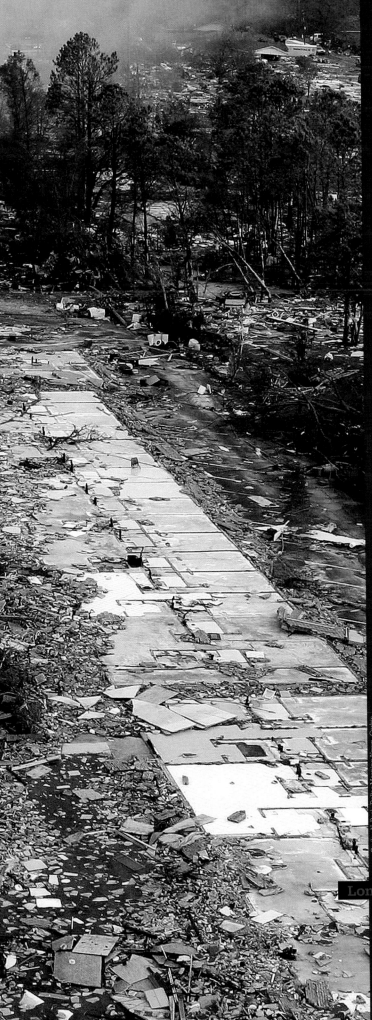

Smiley N. Pool–Dallas Morning News–Corbis

"Extremely dangerous Hurricane Katrina continues to approach the Mississippi River Delta. Devastating damage expected."

So read the headline of Katrina Advisory No. 25, issued by the National Hurricane Center in Miami at 4:31 p.m. on Aug. 28, 2005. It was the fourth advisory issued on the storm that day and each one was worse. When Katrina made landfall on the Gulf Coast about 6 the next morning, it seemed to follow the script written by the forecasters in Miami to the letter—as the following pages demonstrate in excruciating detail. Among the other predictions of Advisory No. 25:

Most of the area will be uninhabitable for weeks, perhaps longer. At least one half of well-constructed homes will have roof and wall failure ... The majority of industrial buildings will become nonfunctional. Partial to complete wall and roof failure expected. All wood-framed low-rising apartment buildings will be destroyed. Concrete block low-rise apartments will sustain major damage, including some wall and roof failure. High-rise office and apartment buildings will sway dangerously, a few to the point of total collapse ... Airborne debris will be widespread and may include heavy items such as household appliances and even light vehicles. Sport utility vehicles and light trucks will be moved. ... Persons, pets and livestock exposed to the winds will face certain death if struck ... Power outages will last for weeks, as most power poles will be down and transformers destroyed. Water shortages will make human suffering incredible by modern standards.

Long Beach, Miss., Aug. 31

On Wednesday morning, 48 hours after Katrina passed through the town of Long Beach, fires are still burning at an apartment complex that has been leveled by winds that reached 145 m.p.h.

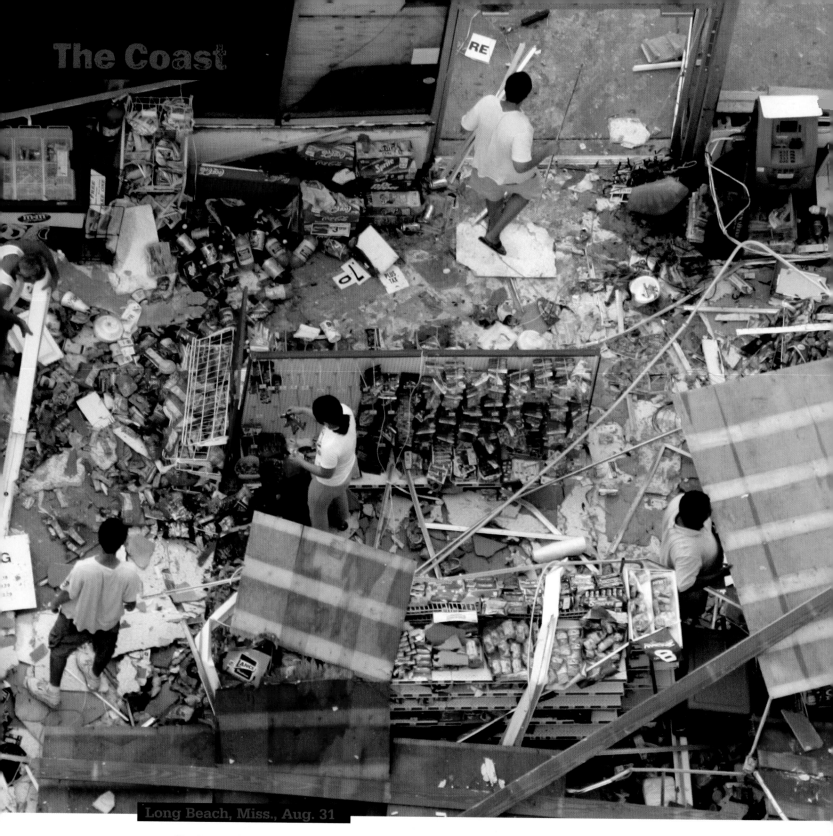

The Coast

RE

Long Beach, Miss., Aug. 31

Katrina made off with the roof and scattered the goods, but a convenience-store owner in Long Beach found plenty of friends—black and white—willing to help clean up. The tardy and ineffectual response to the storm by some government agencies obscured the heroic efforts of many residents of the Gulf Coast, who pitched in to weather the storm, help shelter their neighbors and, once Katrina passed, begin the process of rebuilding their lives.

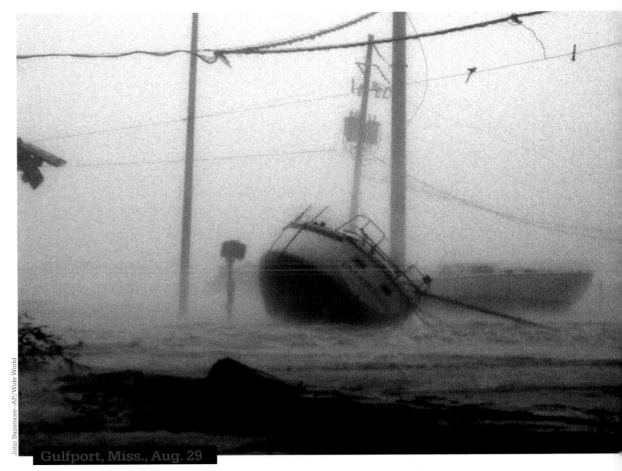

Gulfport, Miss., Aug. 29

At the height of Katrina's assault on the coast, a storm surge lifts a boat and hurls it onto U.S. Route 90, which runs parallel to Mississippi Sound. Katrina had been aiming directly at New Orleans on Aug. 28, but it hooked east as it approached land and caused its greatest physical destruction in a string of graceful old towns along the Mississippi coast, including Waveland, Bay St. Louis, Pass Christian, Long Beach, Gulfport and Biloxi.

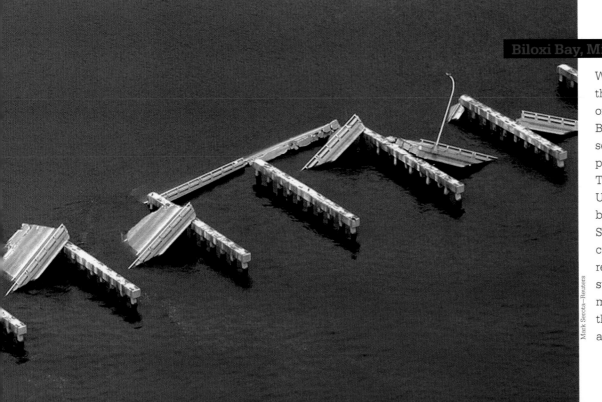

Biloxi Bay, Miss., Aug. 30

When Katrina slammed into the coast, it tore the roadway off the Ocean Springs–Biloxi Bridge, ripped it into segments and scattered the pieces across Biloxi Bay. The 1.6-mile bridge, part of U.S. Route 90 that spans the bay, was built in 1961. In mid-September, a $300 million contract was awarded to rebuild the bridge The new structure will be higher, by as much as 30 ft.: every span of the old bridge less than 23 ft. above water was destroyed.

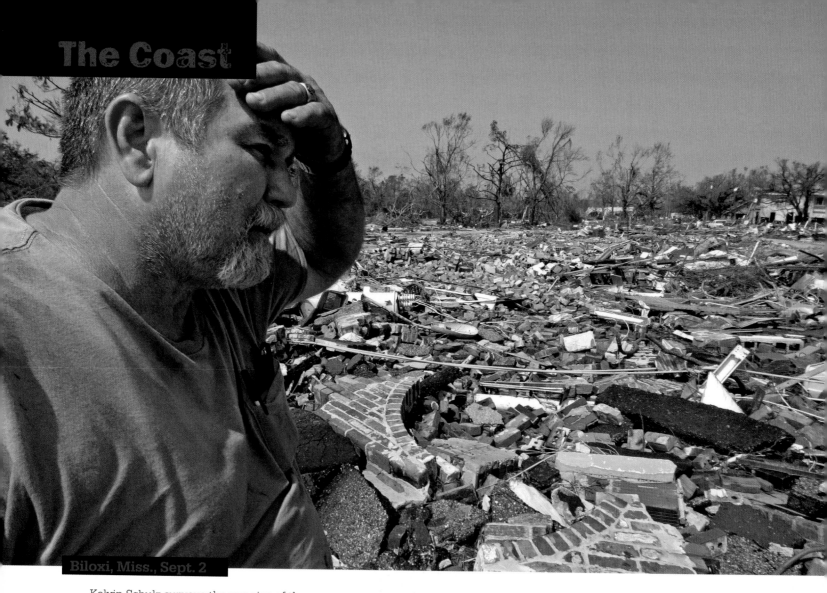

Biloxi, Miss., Sept. 2

Kelvin Schulz surveys the remains of the
Star Theater, a 137-year-old building that
was his family's home. With Katrina's high
winds buffeting the building and water
rising around it on Sept. 29, Schulz, his
wife, three children and 80-year-old
mother-in-law, Jane Mollere, retreated
to the building's roof. As he and the
children climbed to the roof, Schulz tried to
assist his mother-in-law: "I told her, 'Come
on, let's go. She told me, 'Kelvin, I'm too old
for this.'" As he turned around to pull her
up, a wall collapsed on top of her. She did
not survive. "After what we went through,"
Schulz said later, "if I died right now and
went to hell, I think I'd have it made."

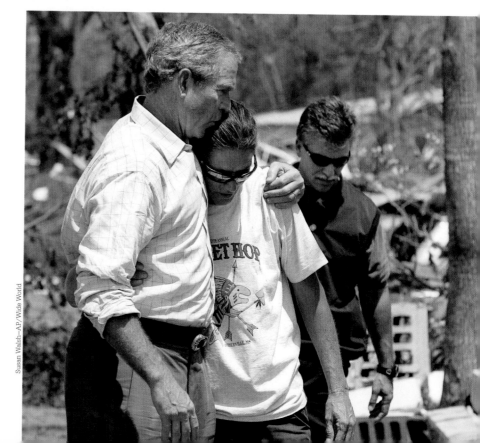

Susan Walsh—AP/Wide World

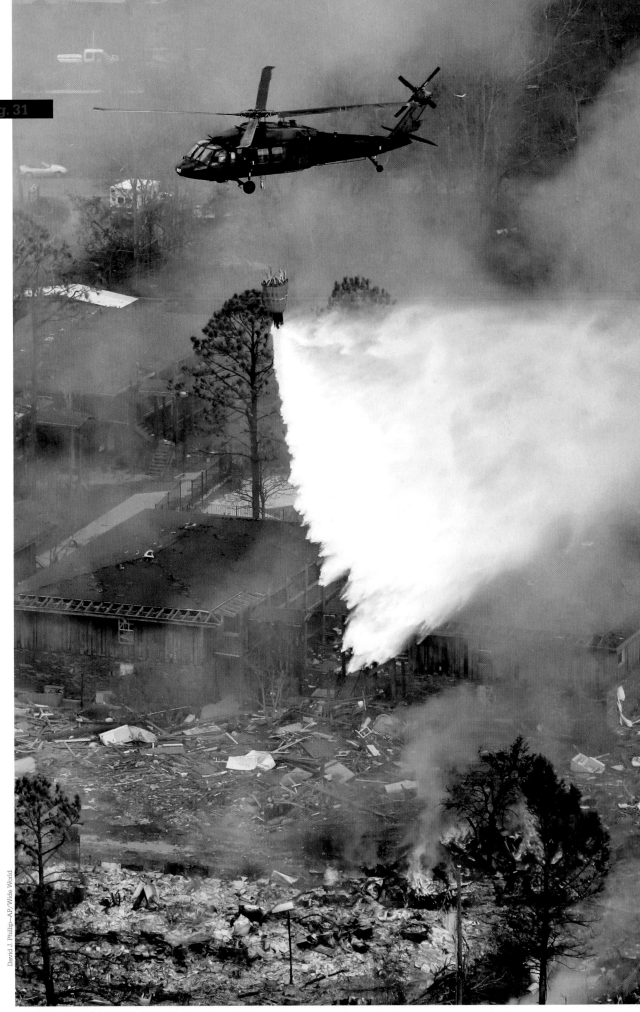

Long Beach, Miss., Aug. 31

Two days after Katrina struck the coastal town, fire fighters were still struggling to control the blazes it caused. "It's mind boggling," said Gene Taylor, who represents Mississippi's Fourth Congressional District in the U.S House of Representatives. "I'm guessing tens of thousands of homes are gone." The structures that did survive were crippled: as of Sunday, Sept. 11, six days after the storm, an estimated 131,000 homes and businesses in Mississippi were still without power.

Biloxi, Miss., Sept. 2

President George W. Bush comforts resident Ella Glavan during his first visit to the region, four days after the storm. Upon viewing the scene, he said, "I understand the devastation requires more than one day's attention. It's going to require the attention of this country for a long period of time."

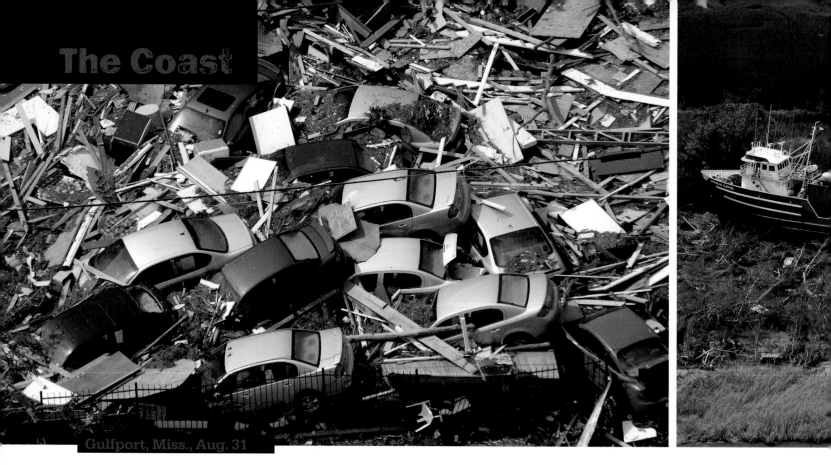

Gulfport, Miss., Aug. 31

Americans have seen plenty of hurricane damage over the years, but Katrina's high winds and storm surges created scenes of havoc that boggled the mind. Autos were shaken up like beads of glass in a kaleidoscope; large cargo boats were carried far inland, then left high and dry when the surging waves receded. Colonel Joe Spraggins, director of the Gulfport Emergency Management Agency, said, in the first hours after the storm, "Right now, downtown [Gulfport] is like Nagasaki." Biloxi Mayor A.J.

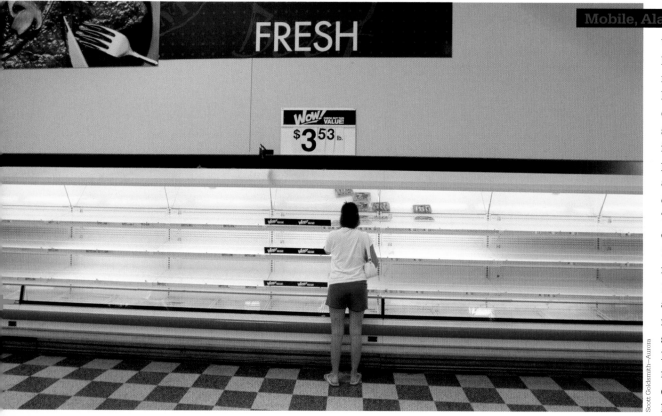

Mobile, Ala., Aug. 31

FRESH

WOW! CHECK OUT THIS VALUE!
$3 53 lb.

When this shopper went looking for dinner in the meat department at a local Wal-Mart, the cupboard was bare: the store had discarded all its perishable food after power failed. In Mobile, at the storm's eastern end, sustained winds of 74 m.p.h. tore the roofs off houses, while an 11-ft. storm surge matched a record set in 1917. Power failed all across Alabama, and many lights in Mobile stayed off for a week. But floodwaters receded rapidly, and a dusk-to-dawn curfew kept looting to a minimum.

Scott Goldsmith–Aurora

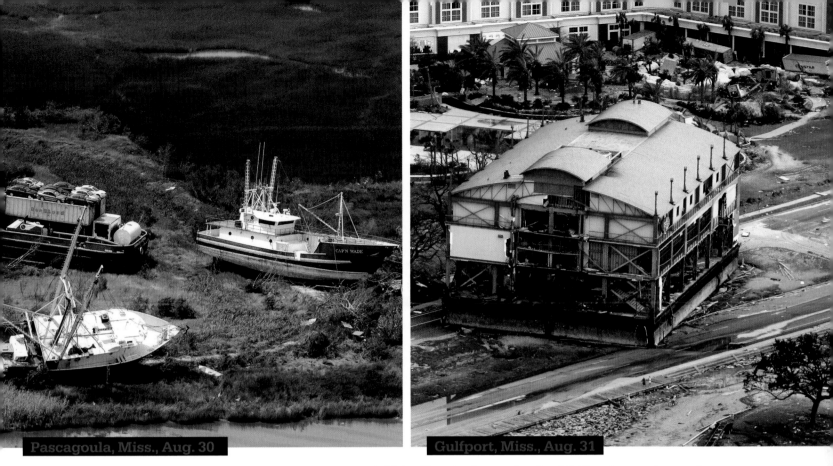

Pascagoula, Miss., Aug. 30

Gulfport, Miss., Aug. 31

Holloway used another analogy. "This is our tsunami," he said. Of the 13 casino barges that lined Gulfport's waterfront, only one may be repairable. Several of the barges were carried ashore, including the Harrah's Grand Casino, above, which was deposited on Route 90 in front of the Harrah's Hotel. On Sept. 22 the Harrison County board of supervisors unanimously agreed to adopt a resolution asking the Mississippi legislature to amend state law and allow the casinos to be relocated on land.

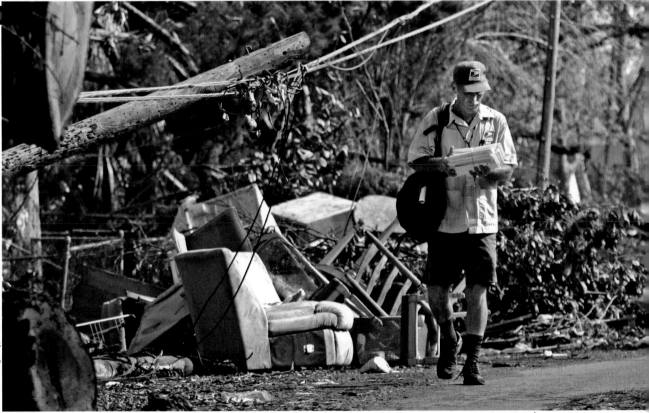

Biloxi, Miss., Sept. 10

Wendell Pruitt, president of the local National Association of Letter Carriers, delivers mail through Katrina's debris. "I could cover only about a third of my route," he told TIME. "Another third was either underwater or blocked by impassable wreckage. And the last third just didn't exist anymore." Pruitt's own home survived, but he was separated from his family for 36 hours by the storm. "My wife almost broke three of my ribs, hugging me, when we finally reconnected," he said.

Darron Cummings–Ap/Wide World

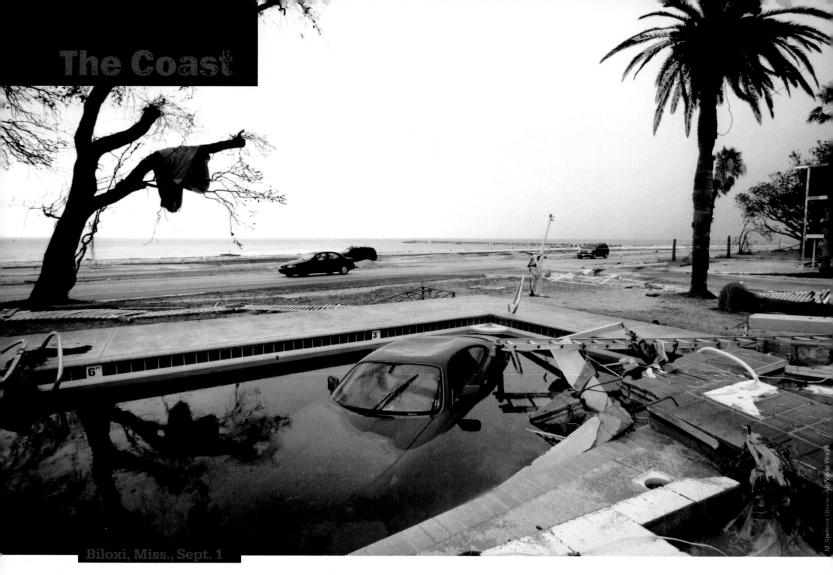

Biloxi, Miss., Sept. 1

Katrina displaced cars, boats, barges and people—including.many longtime residents of the coast who had survived earlier hurricanes but ignored orders to evacuate as Katrina approached. "The weatherman said it's going to be badder than Camille, but no one believed it. No one expected it to be that bad," said Alex Jordan, a 30-year resident of Waveland, Miss., who stayed behind and ended up providing shelter to 25 people in his home. All of them ended up stranded on his roof and had to be rescued.

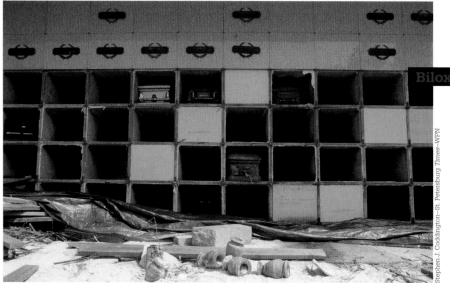

Biloxi, Miss., Sept. 3

Respecting neither the dead nor the living, Katrina's winds ripped apart the aboveground mausoleums at Southern Memorial Gardens, above, mixing the remains of the interred with the detritus of the storm. At least 50 caskets were displaced. Even as searchers sought the remains, Kim Powers, a partner in a Tennessee mortuary service who was aiding the recovery effort, told the local *Clarion-Ledger* newspaper, "The reality is, [some] could have been swept into the Gulf,"

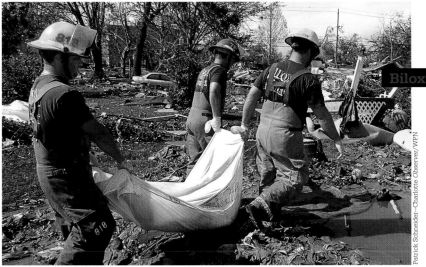

Biloxi, Miss., Aug. 30

Members of the city's fire department recover a dead body from Biloxi's east side. The storm placed unusual demands on civic workers. Gulfport, Miss., Mayor Brent Warr ordered his police officers to commandeer residents' cars and gas supplies after most of the city's police fleet was destroyed. He also ordered police to break into a locked restaurant and take a stove needed to prepare meals for relief workers. "When you send your law enforcement out to steal things, that's when you know you're in a different situation," Warr said.

Bay St. Louis, Miss., Sept. 5

Jimmy Goodman, foreground, tunes into a small radio in hopes of getting news about relief efforts. Goodman, his brother Eric, rear, and mother Joanna Dubreuil, left, were camping out in the remnants of a room at a heavily damaged motel after their home in Waveland was destroyed. Communication flowed in unusual ways when power went down around the region: ham radio operators found themselves in sudden demand. One local radio station, WMSI, managed to stay on air; and its call-in show host Rick Adams spent 13-hour days relaying updates from listeners as to where food, gas and shelter were available in the area.

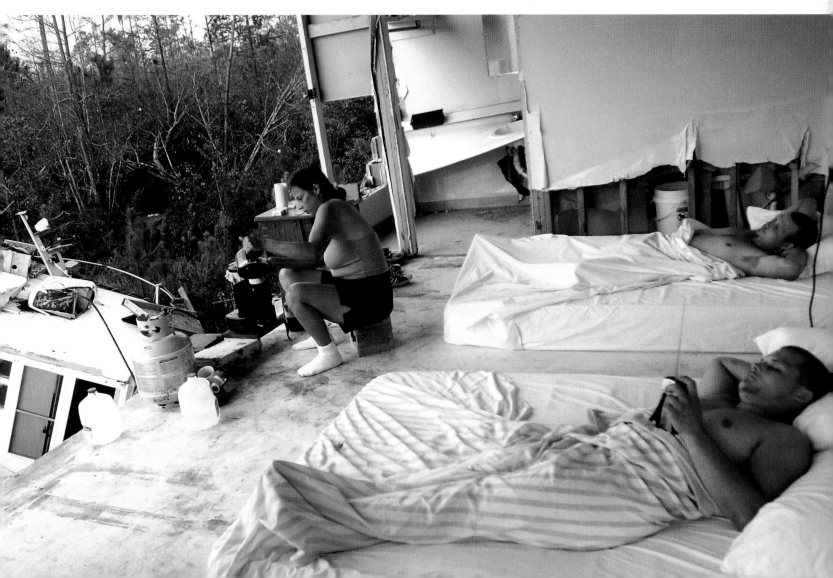

Area of main map

LOUISIANA

Slidell
Marina area is virtually destroyed. Sections of the 8-mile-long Interstate 10 bridge collapse into Lake Pontchartrain

Baton Rouge

Lake Charles

Lafayette

New Iberia

Lake Maurepas

Lake Pontchartrain

New Orleans

Atchafalaya River

Mississippi River

Vermilion Bay

Morgan City

Houma

A Calamity Waiting to Happen

Offshore oil facilities

Approximate coastline in 1975

Approximate extent of hurricane-force winds

Isles Dernieres

Louis Offsh Oil Po

Gulf of Mexico

AMERICA'S SOFT UNDERBELLY ...

The heart of the U.S. oil industry happens to be a magnet for hurricanes. Katrina tore right through it, slowing production and sending prices soaring

■ **Nine oil refineries** that produce about 12% of U.S. gasoline remain closed

■ About **500 Gulf oil rigs** are out of service, some suffering major damage

■ **Natural gas production**— about 20% of the U.S. total—also comes to a halt

■ **Two major pipelines** have been reopened, though at reduced capacity

The Gulf Coast ravaged by Hurricane Katrina is one of the most delicate ecosystems on earth— and one of the most economically important areas in the U.S. Can those two realities coexist?

Sources: National Oceanic and Atmospheric Administration; Army Corps of Engineers; Louisiana State University Hurricane Center; *Scientific American*; AP; National Hurricane Center; Energy Department; Platts Power Maps

Satellite photo from MDA Federal Inc./EarthSat

TIME Graphic by Jackson Dykman, Lon Tweeten, Missy Adams and Kristina Dell

1911-1940
20 storms
Category 3 or higher

The **Okeechobee hurricane** kills 2,500 to 3,000 people

IS THE WORST STILL TO COME?

Some scientists think we may have entered a new cycle of heavy hurricane activity after relative calm over the previous 30 years

Major natural disasters in the U.S.

• 1885 • • • '90 • • • '95 • • • '05 • • • '10 • • • '15 • • • '20 • • • '25 • • '30 • • • •

The **Great Plains Schoolhouse blizzard** in January and a **New England blizzard** in March kill more than 600 people

The **Johnstown flood** kills more than 2,200 people in Pennsylvania

The **Galveston hurricane of 1900** kills 8,000 to 12,000 people—the **deadliest disaster in U.S. history**

The **San Francisco earthquake and fire** destroy much of the city. Estimates of the death toll range from 700 to more than 3,000

The **Great Mississip Flood** kills as many as 1,000 people and leaves thousands more homeless

M I S S I S S I P P I A L A B A M A F L O R I D A

Approximate extent of hurricane-force winds

Bay St. Louis
Highway 90 bridge across Bay St. Louis is destroyed. Beachfront homes are washed away

Gulfport
Hospital suffers extensive damage. Hurricane winds rip the roofs off eight schools serving as shelters

Fort Walton Beach

10 A.M. AUG. 29

Chandeleur Islands

Waveland
Storm surge swamps town of 7,000 people. Most houses are destroyed; hundreds of cars are submerged

Biloxi
Massive floating casinos are destroyed or hurled hundreds of feet; dozens are reported killed in one apartment complex

Mobile
Downtown Mobile is severely flooded. An oil-drilling platform floats away from a shipyard and strikes the bridge over the Mobile River

Pensacola
Water sweeps over two barrier islands, causing downtown flooding

Breton Sound

Port Sulphur

River flow

Flooding

Sinking ground

Levee Silt

Silt

Mississippi Delta

Garden Island Bay

STORM CENTER AT 4 A.M. AUG. 29

Path of Katrina's eye

30 miles
48 km

Approximate size of the hurricane's eye

... GETS MORE VULNERABLE EVERY YEAR
The shriveled Louisiana coastline is dying a slow death at human hands

1 Over the centuries, the Mississippi **flooded** periodically, bringing downstream fresh **silt** that replenished wetlands and water that nourished the plants growing there

2 This flow created a large delta of swamps and barrier islands that absorbed storm surges and protected inland areas

3 When the river is constrained to a channel by levees, the silt is funneled out to sea

4 Without water flow and natural silt replenishment, the land outside the levees **dries and sinks** under its own weight, allowing salt water to intrude and killing plants that fed off the fresh water

5 Drawing drinking water from the land outside the levees only makes matters worse, hastening the sinking

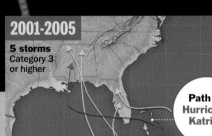

storms
egory 3
higher

1971-2000

14 storms
Category 3 or higher

2001-2005

5 storms
Category 3 or higher

Hurricane Camille pounds the Gulf Coast, killing 256

Hurricane Andrew kills 26, causes $44 billion in damage

Path of Hurricane Katrina

'45 '55 '60 '65 '70 '75 '80 '85 '90 '95 2000

The **Labor Day** hurricane of 1935 kills more than 400 in the Florida Keys

The **New England** hurricane kills more than 600 from New York City to Boston

1950's "Storm of the Century" blizzard kills 383 people in 22 states

Though a relatively weak storm, **Hurricane Agnes** causes $11 billion in damage along the East Coast

Tornadoes sweep across 13 Midwest states, killing 315 people

Hurricane Hugo thrashes South Carolina, causing $12 billion in damage

Photographs for TIME by Chris Usher

"I'm from the Midwest, and I've seen the damage tornadoes can do, carving out a narrow trail of destruction. But Katrina was like a 250-mile-wide tornado that turned the entire Mississippi coast into a wasteland. You could see long, flat vistas of ruin, with personal items strewn all around … bicycles, family photos and, everywhere, Mardi Gras beads glittering in the rubble."

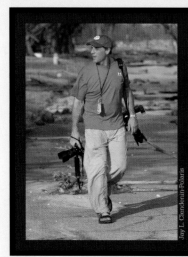

Jay L. Clendenin-Polaris

Chris Usher

The free-lance photojournalist, 43, is based in Washington; he relishes assignments like covering Hurricane Katrina for TIME, which give him an opportunity to escape the capital. Usher spent one day shy of three weeks recording such scenes as the battered shores of Mississippi, a helicopter-rescue mission in New Orleans and the recovery efforts of volunteer fire fighters from Georgia. On his travels, he says, he found that government agencies were often tardy and inept, and their insistence on a rule-book approach was sometimes "unconscionable." Yet volunteers and residents were resilient and, in many cases, heroic. "Everywhere I went in the first few days," reports Usher, "the locals would say, 'Do you have a place to sleep? Why don't you come to our barbecue tonight? We're cookin' up a lot of food … it's all just going to spoil anyway.'"

Miles to Go

On Sept. 29, even as Katrina was hammering the Gulf Coast and moving north, Usher passed long lines of cars evacuating the area as he drove his "war wagon"—a 1985 Toyota LandCruiser—south through the storm. His goal: New Orleans. But every road into the city was closed by authorities, so the photographer drove east, catching up with Katrina's wake along the Mississippi coast. Outside Madisonville, he encountered Josh Thomas and his father Gerry carrying their cat Minnie toward the home they had fled before the storm made landfall, some four miles away. "I try to be a participatory journalist when I can be," says Usher; he told the men, "Hop in!"

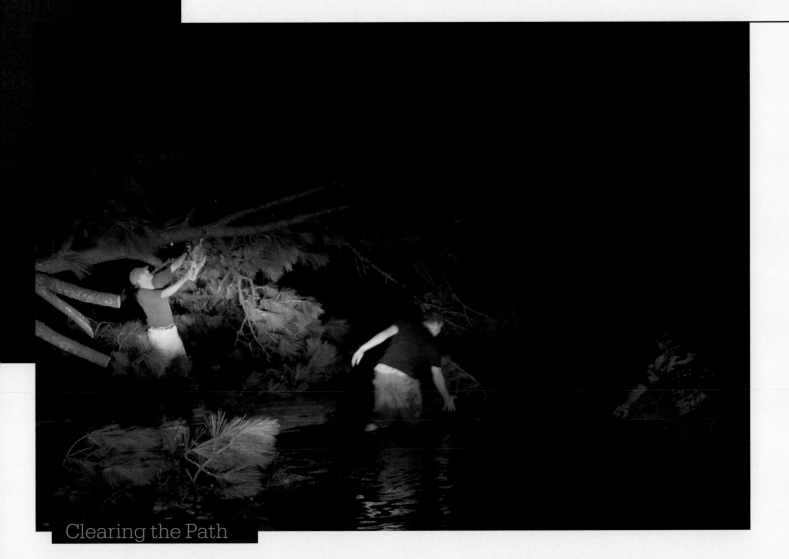

Clearing the Path

Madisonville resident Jerry Thomas works to clear a tree obstructing a flooded Route 22 outside town on the night Katrina made landfall, as his son Josh and another local, Harold Corcoran, remove debris. The lighting is courtesy of the headlights of the photographer's SUV. "Early on, the attitude of the people was remarkably calm and stoic," Chris Usher recalls. "The attitude was, 'O.K., this is a big mess. Let's fix it.'"

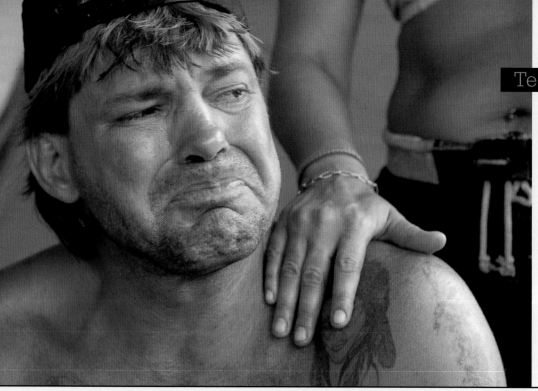

Usher: "In a tent city in Waveland, Miss., locals pointed out a man they called a hero: using a small boat, he had saved 10 people from the flood. When I went to talk to him, Roy Henderson's face wore a look of defiance and anger. But as he told his story of fighting to rescue his neighbors, he grew more and more emotional and finally broke into tears, crying like a 10-year-old, as did the survivors around him who owed him their lives. I stepped back, put down my camera and stopped shooting."

> 66 **When I first walked through the ruins, I was lamenting the loss of giant old trees and antebellum homes. Only later did I realize there were bodies in those ruins … I was walking through a graveyard, and I should have been mourning lost lives.** 99

Home, Sweet Home

Usher encountered Ray and Dorian Kutos on Aug. 30 on the beach at Pass Christian, Miss. The father and son had not evacuated because they feared for the lives of their seven dogs and cats (none of which, Usher noticed, had made it to the beach). As the storm surged, the two had retreated to their attic, but they had to flee the rising waters and finally ended up on the beach. Two days later, Usher returned to the scene and, "It was just as I had left it … no progress had been made. The Kutoses were still living on the beach, so I gave them a ride to a church shelter. At Ray's request, I called his sister to tell her that they were alive."

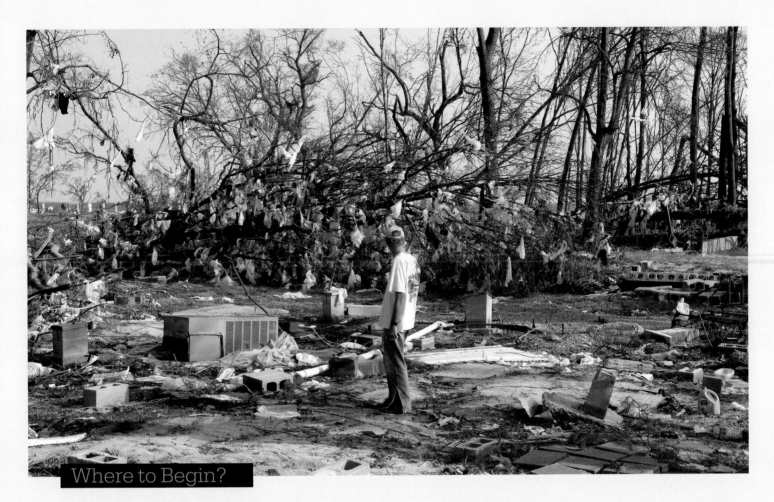

Where to Begin?

On Sept. 9, eleven days after Katrina hit Long Beach, Miss., cleanup efforts were just beginning to get under way. Even as Usher was photographing such scenes, he reports, he came across a number of groups of volunteer fire fighters and emergency workers who had traveled from all around the nation to help out—but had been kept idling on the sidelines for days while various government agencies quarreled over where the volunteers should be dispatched.

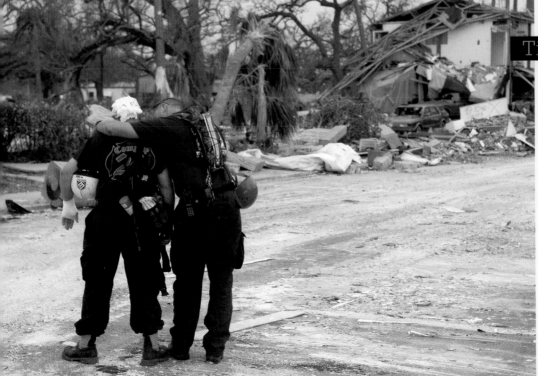

Time Out

Usher defied a FEMA order—"no recovery pictures"—and spent several days near Gulfport, Miss., with the Dekalb County (Ga.) Fire Rescue Squad, whose members had come to lend a hand. As the men searched for dead bodies amid the rubble, they applied a special ointment to their upper lip to mask the stench of decaying matter they encountered. Work stopped now and then when the men were overcome by emotion.

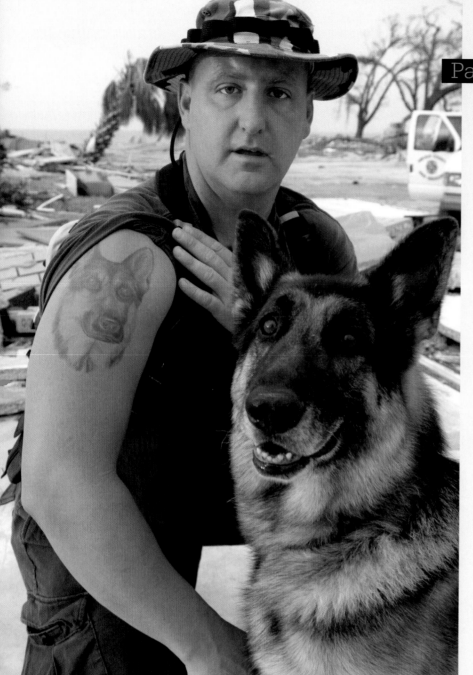

Partners

David Atkins, a member of the Dekalb County Fire Rescue Squad, poses for a picture with his co-worker Gunner, whose image adorns his handler's arm. The Dekalb team brought two recovery dogs with them to search for bodies; at one point, both of them "hit" on a location amid a wasteland of debris. As the men dug through the pile, their tools came up wet—the rubble had completely buried a large swimming pool. Atkins shared a regret with Usher: Gunner, 9 years old, will retire from service at the end of 2005.

"What the pictures can't show is the smell … everywhere, there was a brackish, garbagey smell—and that was the light stench. Every now and then, you'd catch a whiff of decaying matter that would make you start to retch."

Now What?

Chris Crounse, says photographer Usher, was one of the "haves": she owned a lovely Victorian home near the yacht club in Pass Christian, Miss. When the hurricane warnings were issued, she and her daughter Erin, left, evacuated to Kentucky; they returned days later to stay outside Pass Christian in the country cabin of a friend. Erin went back to find the Crounse home demolished. Although she had gone in hopes of retrieving some personal belongings, she could not bring herself to take the few scattered possessions she found. "It was a grave," she said.

Rest in Peace

Usher flew into New Orleans on the night of Sept. 4 with a helicopter pararescue unit. The chopper landed near the city's Museum of Art to rescue two elderly women. The scene, Usher reports, "was surreal, like a war zone ... it was just like Baghdad." He spotted a body nearby draped in a flag and took a picture of it with a night-vision camera. Several hours later, he flew over the same spot: the flag was still there, and he captured the scene by the dawn's early light.

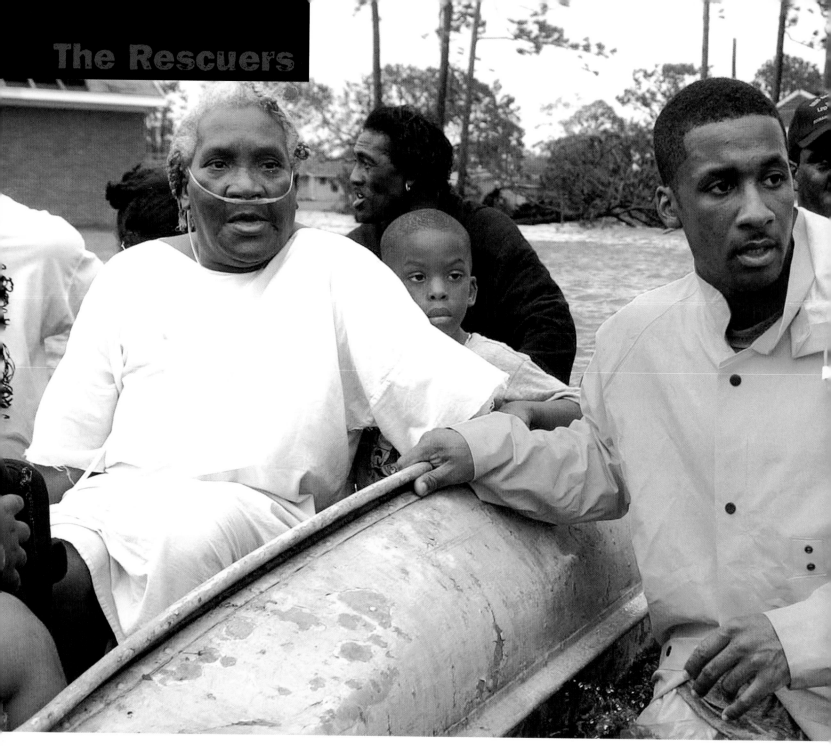

In Katrina's Wake, a Time for Heroes

When disaster strikes, volunteers, local agencies and the U.S. Coast Guard perform with distinction, but when outside assistance takes too long to arrive, the rescue effort becomes a race against time

The water was cold, and there was a strong current," remembers Terrence Gray, a 28-year-old maintenance supervisor for the Gulfport, Miss., police department. When Katrina's storm surges flooded the streets of his hometown, Gray (above, in the yellow slicker), took it upon himself to rescue more than 20 people who were trapped in their homes amid rising water. "The Forest Heights neighborhood has only one street in

and one out," he explains, "and there's a creek and a large pond inside. So it got hit really hard."

Gray parked his police truck on high ground near a railroad embankment and then commandeered an abandoned boat he saw floating nearby, which he dragged from house to house, offering a way out to the wounded, disabled, the elderly and small children. One of the women he rescued, Gray recalls, "kept crying that

Heights, before ending his day around midnight. "I'm one of the lucky ones," the modest hero says. "When I got home that night, the only damage to my house was a few missing shingles."

Terrence Gray's remarkable story of grace under pressure is only one of many spawned in the wake of Katrina, as an impromptu, unlikely corps of rescuers—volunteers, neighbors, emergency workers, local police and fire fighters and National Guard troops—fought to save hundreds of lives along the Gulf Coast.

In the days after Katrina struck, federal, state and city agencies stumbled and fumbled, while a great city sank into despair. But contrary to the picture that later formed in the public's mind, not every emergency office was overwhelmed by Katrina. An array of agencies in an arc spanning from Jacksonville, Fla., to Houston sprang into action even as Katrina was moving north, its winds dying down. The Coast Guard alone had more than 40 aircraft and 30 patrol

her grandmother was bed-bound and was going to drown if the water rose any higher. So after I got her out, I went directly to the house she told me about." There, Gray found a family of 17 people, including the grandmother, Lovie Mae Allen (at left in the boat). "She didn't want to leave at first," Gray recalls. "But I talked to her awhile and gained her trust. So she finally said she would go if her grandkids would come with her." During the 35-min. journey from her house to the railroad tracks, Gray recalls, "she didn't say much to me. She just prayed a lot." Gray made more than a dozen other trips into and out of Forest

GOOD SHEPHERD
Terence Gray guides Lovie Mae Allen to safety from her flooded home. At the time this picture was taken, Gray estimates he was battling a wind of about 45 m.p.h.; nearby, home-owners on roofs held up babies to get rescuers' attention

EVERYBODY OUT!
Below, Army chaplain Captain Thomas Holmes, left, and Specialist Jeffrey Madden offer a lift to an elderly New Orleans resident on Sept. 2, the day Mayor Ray Nagin issued a mandatory evacuation order

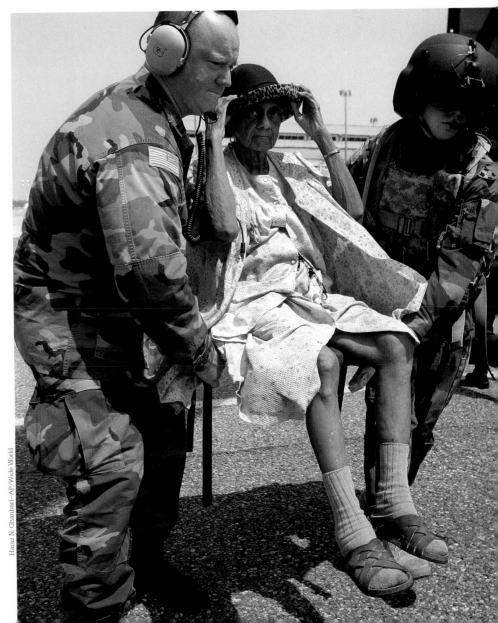

The Rescuers

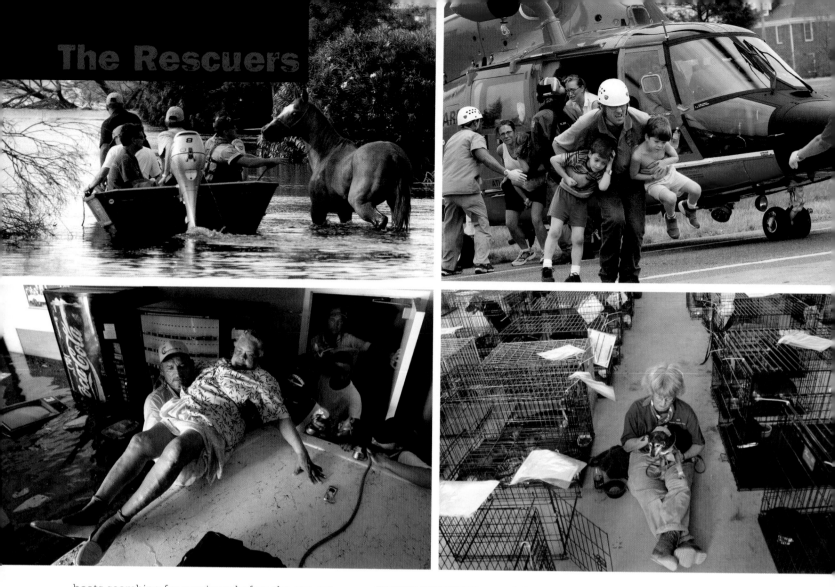

boats searching for survivors before the sun set on Aug. 29. In the confusing days that followed, the coastal service's effort was a model of organization, efficiency and effectiveness. Small wonder that when the Bush Administration realized too late it had bungled its response to the disaster, it put Coast Guard Vice Admiral Thad Allen in overall charge of the mission.

As Coast Guard helicopter rescue pilot Captain Jim Bjostad told National Public Radio the morning after the first day of rescue operations in Mississippi, his crew and dozens of others "worked through the night—in some cases chopping holes in roofs to get to people that were trapped inside out onto the roof, so they could hoist them into the helicopter. We had over 200 people at an unknown number of addresses ... And we're trying to prioritize them by the number of people and the severity of the situation that they're in." In all, Coast Guard helicopters retrieved hundreds of people stranded in Katrina's wake.

The epicenter of the rescue effort was New

TAKING THE REINS Not all of the rescued were human. Top left, workers from the Kentucky department of fish and wildlife save a stranded horse

SAVED! Top right, a Coast Guard helicopter ferries mothers and children to an evacuation center in New Orleans

PUPPY LOVE Bottom right, a volunteer from animal-rescue agency Noah's Wish comforts an evacuee

UPLIFTING Volunteer Mickey Monceaux, bottom left, lifts Vianna Dilbert, 86, onto a rescue boat at a senior citizens' complex in east New Orleans on Aug. 31

Orleans, converted by its breached levees into a flooded archipelago, where rooftop islands harbored stranded citizens. Rescue workers traveled from house to house in a bizarre armada of water craft—Everglades airboats and Ski-doos, rubber rafts and canoes—plucking out the living but leaving bodies behind for later recovery. Their ears were alert for muffled sounds: people who had been trapped in attics as the waters rose were pounding desperately on roofs from the inside; the lucky ones had already cut holes with knives and axes to reach the open air.

By Tuesday, Aug. 30, the day after Katrina struck, local authorities within Louisiana were marshaling workers unaccustomed to disaster relief and deputizing them to hunt for survivors. Sergeant Aaron Monceaux of the Louisiana state department of wildlife and fisheries came to New Orleans from the state's northern reaches and soon was gliding from the rooftop of one submerged house to another in the boat he uses to chase poachers through the bayou. "Y'all want a ride?" he called out to Donna Webber,

84

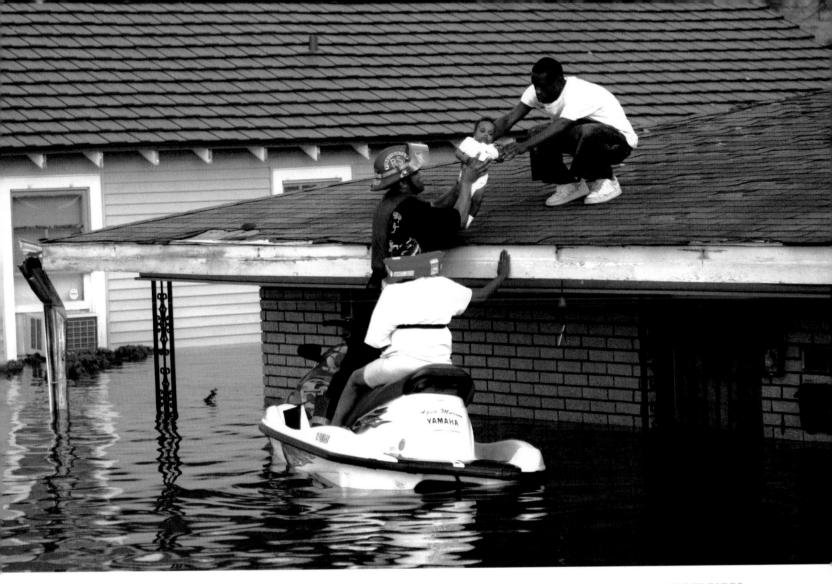

47, in the Mid-City neighborhood, after steering his boat over the roof of a submerged car and knocking on the side of her house. As the Associated Press reported, one of the women Monceaux picked up said, "There is a God. He answers prayers. All that material stuff, we can get back. We've got our life."

Amid the city's flooded streets, standard operating procedures, and the sense of decorum that traditionally accompanies rescue-and-recovery efforts, were abandoned. Police officers were told to leave human remains in the water as the search for survivors became increasingly desperate. National Guardsmen were told to ignore looters in some cases so that they could focus on the rescue mission.

Above, the skies buzzed with helicopters seeking the stranded. The potential for a disaster in the air was such that pilots told TIME reporter Adam Pitluk, who was embedded with them, to help scan the skies for stray news helicopters and sightseers in Cessnas among the flocks of military craft. "It was like a pickup game," according to Lieut. Commander

Bill Howey, a Navy helicopter pilot. "You got three or four different types of Army helicopters, same for the Navy. Then there's Customs, Coast Guard, Marines, and then there are the news helicopters." While rescuing a group of blind people who had been trapped for five days, a Marine helicopter pilot told TIME's Tim Padgett, "It's like flying into a hornet's nest."

Not all the rescuers wore uniforms. In Biloxi, Miss., the dozen members of the Bullard family cowered in the uppermost room of their home as Katrina's waters smashed through every window and door in the house. Seconds later, water started rising through cracks in the upper floor. As the adults panicked and babies screamed, Phillip Bullard, 13, got busy. He swam underwater to a submerged window, clearing debris in his path. Finding there was a way out, he returned for his sister Yoshico, 25, the only other member of the family who knew how to swim. Phillip, who says he has always wanted to be a doctor or a police officer, asked his sister to remain on the surface outside the window, while he swam

PRECIOUS CARGO
Marshall Martin, right, hands 3-month-old Christopher Collins to New Orleans fire rescue officer Jonathan Pajeaud on Aug. 29 in the flooded Seventh Ward of New Orleans. The child's grandmother Sheila Martin is seated on the back of the watercraft. The Martin family spent 10 hours stranded in their attic after Katrina struck

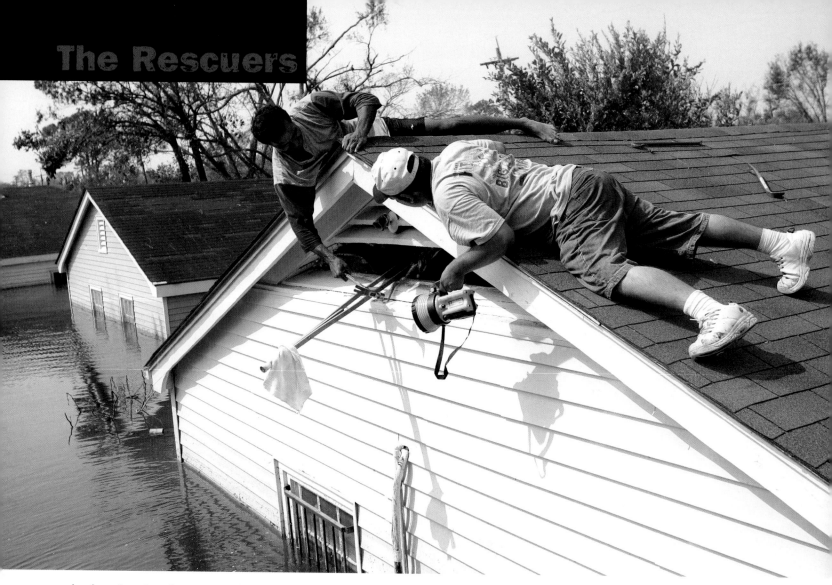

back and retrieved every member of his family, one by one.

Holding his hand over her mouth and nose, Phillip first saved his 1-year-old sister. He then returned and coaxed his mother Vanessa, 44, to swim underwater to the open window with him. Next, he guided his elderly grandmother to the window and up, where Yoshico led her to the surface outside the house. In all, Phillip swam back into the house seven times. The last to emerge was his twin sister, who was so frightened that she stubbornly refused to move, clinging to the eaves inside the attic before swimming to safety. Once the entire family was floating outside, Phillip and Yoshico found an abandoned rowboat floating nearby and began ferrying the other members of the family to high ground, using broomsticks and other debris as paddles.

Thanks to such examples of individual initiative, the first 48 hours of rescue-and-recovery work went reasonably well in many areas along the coast. One advantage: the emergency-response plans of most local agencies anticipate their having to work alone for up to 72 hours before outside help arrives. But when the cavalry hadn't sounded the bugle three days after the storm hit, local agencies, particularly in New Orleans, found themselves shy of resources, and their personnel exhausted.

The crunch hit hardest at the city's hospitals, where staff members fought to keep patients alive until rescue came, only to find, day after day, that rescue was not coming. Here, amid horror, medical heroes took a stand. At Charity Hospital, dark but for a lone generator and dimming flashlights, nurses who hadn't bathed in days tried to sterilize themselves with hand sanitizer. Caregivers wept when two patients died on the parking deck while waiting to be evacuated. "They'd been keeping these patients alive for a week with very little in terms of resources," said TIME contributor and CNN correspondent Dr. Sanjay Gupta, who was on the scene, "and to see them die on the deck—it really was very difficult."

After Gupta arrived by helicopter on Wed. Aug. 31,

TOO LATE Afredo Bonilla and José Vega break through a window leading into the attic of Bonilla's aunt's house on Sept. 5, a week after Katrina made landfall. A white flag attached to a crutch and poked through the window was a hopeful sign, but in this case, no rescue was made. When the men reached the inside of the home, Bonilla's aunt was dead

Ben Sklar–Magnum

taken care of us? Why did they forget us?'" The food supply was down to beans and a few raw vegetables; candy vending machines had long since been emptied. "One of the guys here has been trying to call FEMA, and all he gets is a busy signal or voice-mail," Gupta said. The stress was so severe that perhaps half a dozen hospital staff members had to be treated in the facility's psychiatric ward. The basement morgue was flooded, so the growing numbers of bodies were stacked in body bags in the stairwells.

It wasn't until Sunday, Sept. 4—as the last displaced people finally left the Superdome and the Convention Center, and all the city's hospitals had been emptied of stranded patients and staff—that it was safe to say that almost everyone in New Orleans who could be rescued had been. Sporadic missions to gather up stragglers and holdouts were still underway, but now the exhausted rescuers turned their attention to the next task: recovery, the grim duty of retrieving the remains of the dead. At the same time, a different sort of rescue mission was well under way—the Federal Government's effort to restore public confidence in the ability of those we trust to save us when we cannot save ourselves. ∎

hours passed before it was safe to ferry him through sniper fire and across a putrid moat into the hospital building. With a full evacuation still several days away, "people came to me and said, 'Why haven't they

DOG TAG Near left, on the day Katrina made landfall, Mississippi fire fighter Wade Hicks writes his name, birthday and an ID number on his hand in case he does not survive

HELP AT LAST Below, a soldier takes an infant for medical treatment at an emergency evacuation site beneath Interstate 10

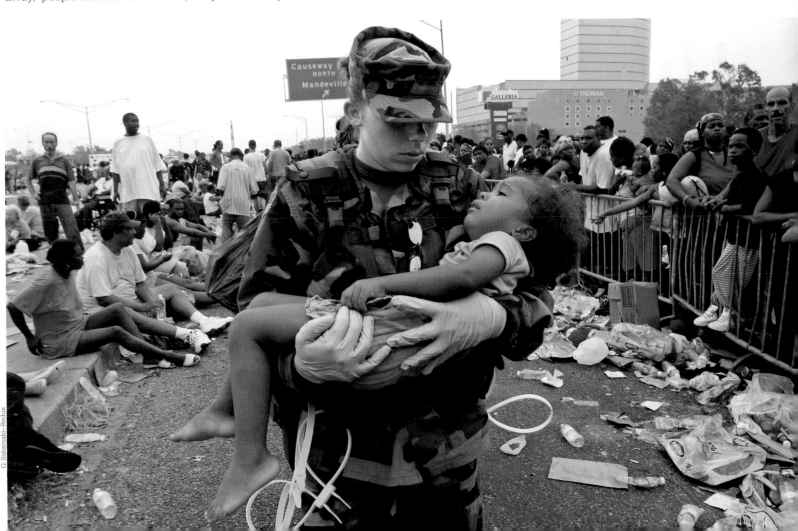

O. Sakamaki–Redux

POWER FAILURE

Local, state and federal authorities had plenty of warning that Katrina was coming: So why did all of them fail so drastically? An inside look at how and why the emergency response system broke down

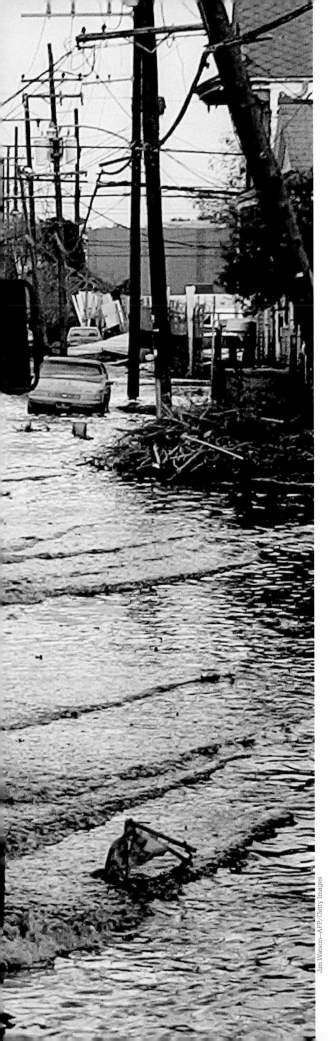

Jim Watson—AFP/Getty Images

As Hurricane Katrina moved steadily closer to New Orleans on Sunday, Aug. 28, state and city officials successfully executed a complex plan that reversed the flow of traffic on three Louisiana interstate highways, speeding the evacuation of tens of thousands of New Orleanians from the path of the storm. Only the year before, a similar scheme during Hurricane Ivan had ended in massive gridlock. For people of means, the plan worked beautifully. An estimated 80% of the population evacuated, most of them in cars, a major accomplishment in any city but especially in New Orleans, where residents have to travel at least 80 miles over a small number of arteries to get out of harm's way.

Sadly, that motorized exodus was one of the few things that officials did right. A few days later, the world watched in horror as government emergency agencies scrambled to rise to Katrina's challenge, only to bog down in missed communications, arguments over jurisdiction, and the effects of poor preparedness. The biggest problem, everyone seemed to realize too late, was the other 20%: the citizens who hadn't fled, most of them because they lacked the means or good health to do so. As middle-class citizens barreled out of town on those reverse-flow freeways, they left behind in Katrina's path the old, the feeble and the poor—in short, the very people whom government safety nets are designed to catch.

The images that resulted will haunt the American memory for years: women pushing their mothers in wheelchairs through flooded streets; rescuers desperately breaking through house roofs, seeking the stranded; the aged and infirm sitting outside the New Orleans Convention Center, day after day, waiting for someone—anyone—to get them out of there.

Katrina not only devastated the Gulf Coast; it also shattered the nation's self-esteem, threw George W. Bush's presidency off balance and shredded Americans' confidence in federal agencies such as the Department of Homeland Security and the Federal Emergency Management Agency. When TIME polled 1,000 adults nationwide the week after the

IN THE SAME BOAT
From left, Coast Guard Vice Admiral Thad Allen, Louisiana Governor Kathleen Blanco, President George W. Bush, New Orleans Mayor Ray Nagin and Lieut. General Russel Honoré, at right rear, assess the damage to New Orleans on the President's first visit to the stricken city on Sept. 2

disaster, 52% said that government at all levels had done a poor job preparing for Katrina. And 62% said that government agencies had responded too slowly to those hardest hit.

Who was to blame? New Orleans Mayor Ray Nagin, Louisiana Governor Kathleen Blanco and Senator Mary Landrieu pointed their fingers at FEMA Director Michael Brown and DHS Secretary Michael Chertoff, who pointed right back. The White House, spinning furiously, tried to brand the exercise as a "blame game" played by its political foes—who, for their part, insisted that the issue involved assigning accountability rather than blame.

The American people had a different idea: in TIME's poll they spread the responsibility for the debacle far and wide. And after the initial crisis period passed, many of those involved could agree on a few general lessons learned from the disaster.

> "Get people to higher ground and have the feds and the state airlift supplies to them —that was the plan, man."
> —Mayor Ray Nagin

DON'T FORGET THE NEEDY Before any disaster, the first responsibility of local responders is to evacuate hospitals, nursing homes and special-needs populations, as Billy Zwerchske, former president of the International Association of Emergency Managers and a consultant to the Department of Homeland Security (DHS), told TIME. Apparently, aside from some informal plans to rely on churches and neighbors to get such people out, New Orleans had not come up with a solution to that challenge in time for Katrina.

Despite all appearances to the contrary, New Orleans did have a plan. A week after the storm, Nagin summarized it for the *Wall Street Journal:* "Get people to higher ground and have the feds and the state airlift supplies to them—that was the plan, man." But in fact the plan was more substantial—and it estimated, correctly, that 100,000 residents would have no means of transport in case of an evacuation. The city's website advised people who needed a ride out of town to "try to go with a neighbor, friend or relative." The alternative: head for the Superdome, a shelter of last resort for people who couldn't escape. Never mind that the Superdome was first used as a refuge in 1998 during Hurricane Georges and served poorly, owing to a lack of preparation—and that seven years later, the city had still not stockpiled enough generator fuel, food and other supplies to handle the job. Those who had to go to the shel-

Brett Duke—Times-Picayune/Londov

C. Ray Nagin
Mayor of New Orleans

Rudolph Giuliani he isn't. After Katrina shut down his city, and many of his police officers didn't show up for work, Mayor Nagin seemed to devote as much time to ranting as leading: his "desperate SOS" message on Aug. 31 sent a needed jolt of electricity to the White House, but in many cases he crossed the line. On Oprah Winfrey's show, Nagin spoke of "hundreds of armed gang members" killing and raping people inside the Superdome—accounts that not only were grossly exaggerated but also fed public panic, rather than helping avert it. "The city of New Orleans will never be the same in this time," he told local radio station WWL-AM—not exactly a ringing call to rebuild. The city's problems, it seemed, belonged to anyone but him: FEMA, the feds and other authorities shared the blame.

Tall and debonair, Nagin, 49, is a former telecommunications executive who was elected in 2002 on the promise that he would purge the city of corruption—a large order. The mayor probably saved lives with his urgent appeal to evacuate before the storm hit, even if he didn't heed experts' pleas to make the exodus mandatory. "This is not a test. This is the real deal," he declared less than 48 hours before Katrina came ashore. Later, though, he lost his footing. No diplomat, in mid-September he squared off with the Katrina recovery chief, the highly capable Coast Guard Vice Admiral Thad Allen: when Nagin called on some 180,000 evacuees to return to dried-out districts, Allen, concerned about safety, called the idea "extremely problematic." Nagin quickly fired back that Allen was trying to be "the new crowned federal mayor of New Orleans." Hurricane Rita ended that debate, and the two patched things up, but if Nagin is going to lead the renaissance of New Orleans, he may have to learn to raise his profile by lowering his voice.

ters were advised to "eat a full meal before arriving." After Katrina, it is safe to say, no U.S. city will ever again construct an evacuation plan that doesn't address those with special needs.

COMMUNICATION IS PARAMOUNT Can we talk? Not if a hurricane is chewing on your phone line. In 2003 New Orleans received a $7 million federal grant for a communications system that would connect all the region's first responders. Yet when Katrina struck, the radios used by police, fire fighters and Nagin quickly drained their batteries. Then the batteries of their satellite phones would not recharge, and, of course, most land lines and cell phones were down. For two critical days, Nagin and his emergency team were cut off—holed up in the Hyatt Regency Hotel, fending off gangs of looters. It remains unclear why the mayor and his team chose not to use the city's Mobile Command Center— designed for just such a disaster—or join the other local officials at the emergency center in Baton Rouge. In Florida, by comparison, emergency officials across the state are linked by a system of more secure satellite telephones. And in Texas, ham operators have a place at the table in the emergency bunker in Austin.

Yet in the frightening hours and days after Katrina struck, communication failed in a more important way: local, state and federal officials seemed unclear about the lines of their responsibilities, although an extensive new plan addressed them. When he moved in to lead the Department of Homeland Security, Michael Chertoff inherited the *National Response Plan,* a 426-page report published in December 2004. Outlining detailed lines of authority in the event of calamity, the plan "ensures the seamless integration of the Federal Government when an incident exceeds local and state capability." The plan failed miserably, as even Chertoff admitted after the fact. The problem, said Jim Carafano, a homeland security expert at the Heritage Foundation, is that DHS's plans assumed that state and local authorities would be responsible in the first 72 hours after a catastrophe. "In this case," he says of New Orleans, "the state and local response was wiped out. There was no one to fill the 72-hour gap."

The boundary of power between state and local governments is a hazy, contentious subject, particularly in the South, where memories of Reconstruction run deep. In 1992 Florida Governor Lawton Chiles came under withering criticism for waiting three days after the destruction from Hurricane Andrew before making a written request for the federal troops that were standing by with food and tents. In like manner, it was not until Thursday, Sept. 1, that Blanco sent a detailed request for aid to the White House, asking for 40,000 troops; urban search-and-rescue teams; buses; amphibious personnel carriers; mobile morgues; trailers of water, ice and food;

Chris Usher for TIME

Kathleen Babineaux Blanco
Governor of Louisiana

Governor Blanco had big plans for Aug. 29, 2005: she was scheduled to attend the annual conference of the Southern Governors' Association in Georgia, where she was slated to be sworn in as the group's new chairwoman. Hurricane Katrina had other plans, handing the native of Port Iberia, La., the greatest crisis of her career. Blanco, 62, began her professional life as a school teacher, quit to raise six children, and later worked as a census taker: knocking on doors in backwoods Cajun country first made her think she might like politics. In 1983, with no money for television ads or media consultants, she ran her first campaign for the state legislature the same way, by connecting with voters face to face. Later, Blanco, a Democrat, served as the first woman on the state's Public Service Commission. In 2003 she became its first woman governor, and focused on controlling Louisiana's infamous corruption and attracting outside investment to the state.

Never an inspiring public speaker, Blanco cultivates a low-key personal style that dares political opponents to underestimate her. This approach may have worked against her in the hours after the storm hit. Bush Administration officials contend that her initial requests for federal assistance were vague and did not convey the full scope of the disaster. (One of Blanco's aides answers, "That's like telling a drowning man that you are not going to help him until he asks for a life preserver.")

This grandmother of seven is a woman of serious resolve. She did not hesitate to spar publicly with Mr. Bush and defiantly proclaimed, after some questioned the wisdom of spending billions to reconstruct New Orleans, a city that sits below sea level: "To anyone who even suggests that this great city should not be rebuilt, hear this and hear it well, 'We *will* rebuild!' "

Michael Chertoff
Secretary, Department of Homeland Security

When Chertoff, 53, a former federal judge, prosecutor and chief of the Justice Department's criminal division, took over from Tom Ridge as chief of the giant Homeland Security agency in February 2005, he gave up a lifetime appointment as an appellate judge to do so. He had strong reasons for his choice: he lost friends in the 9/11 terrorist attacks, and he felt a patriotic duty to protect the U.S. Yet in the first days of the crisis, the Secretary seemed less concerned with controlling Katrina's damage than with performing damage control for the Bush Administration. He waited until 36 hours after Katrina struck to declare the storm "an incident of national significance." On Aug. 31, all evidence to the contrary, he declared himself "extremely pleased" with the federal response to Katrina. In a conference call the next day with President Bush, Vice President Dick Cheney and five congressional leaders, while chaos and despair reigned in the Crescent City, he insisted things weren't going as badly as media reports suggested, adding that he had spoken to local law-enforcement officials in the past hour. "Not that bad?" asked Harry Reid, the Senate Democratic leader, according to congressional sources. "Turn on your TV!"

It was a reasonable suggestion since it came on the same day Chertoff first learned—from an NPR anchor in Washington—that there were thousands of people stranded, starving and in some cases dying in the New Orleans Convention Center, a story that had been all over the media that morning. "He's a great lawyer, very smart and extremely decent," the top aide to a G.O.P. Senator says of Chertoff. "But he's a lousy politician." Chertoff finally acted decisively when he removed FEMA chief Michael Brown from command of the federal response effort: it was one evacuation plan that performed up to expectations.

base camps; staging areas; temporary housing; and communications systems. Her aides confirm that she had unrealistic expectations of precisely what Washington was capable of doing. "She thought it would be more omniscient and more omnipresent and omnipowerful than it turned out to be," said one.

One example: early on, Blanco relied on FEMA's assurances that it would provide bus transportation out of the Superdome to evacuees. A day later, as situations there were rapidly deteriorating, she discovered those buses were still on the way from other states, and she had to order her staff to start rounding up local buses.

On the Friday after the hurricane, Blanco met with Bush aboard Air Force One at the New Orleans airport, and he asked a sensitive question: Would Blanco relinquish control of local law enforcement and the 13,268 National Guard troops from 29 states that were under her command to the Federal Government? State officials later said she considered this an odd request, given that federal control would not in itself guarantee that she would receive more troops, and the transfer would prohibit the Guard, under the Posse Comitatus Act of 1878, from acting as police. She feared the White House had a political motive: it would allow Washington to come in and claim credit for a relief operation that was finally beginning to show progress.

Blanco asked for 24 hours to consider the request, but as she was meeting with advisers at midnight that Friday, White House chief of staff Andrew Card called and told her to look for a fax. It was a letter and memorandum of understanding under which she would turn over control of her troops. Blanco refused to sign it. Her verdict: "We need to have a better communications network."

OVERHAUL FEMA If Katrina had an accomplice in destroying the Gulf Coast, in the American public's eye, at least, it was the Federal Emergency Management Agency and its underqualified director, Brown. How did FEMA bungle its job? Let us count the ways. Despite being warned by multiple hurricane experts that Katrina would be a catastrophic event, Brown waited until about five hours after the storm's landfall before he proposed sending 1,000 federal workers to deal with its aftermath. While people were dying in New Orleans, the U.S.S. *Bataan* steamed offshore, its six operating rooms, beds for 600 patients and most of its 1,200 sailors idle. Foreign nations—responding to urgent calls from Washington—readied rescue supplies, then were told to stand by for days until FEMA could figure out what to do with them. Florida airboaters complained that they had an armada ready for rescue work, but FEMA wouldn't let them into New Orleans. Fire fighters who had come from around the country to lend a hand after the storm hit were confined to a ballroom in an Atlanta hotel and told

they would be handing out public-relations materials for FEMA, rather than helping those in need.

Just when things seemed to be stabilizing, another FEMA fiasco would light up the news wires. On Friday, Sept. 9, thousands of evacuees stood for hours in the 93° heat outside the Astrodome in Houston, waiting for FEMA debit cards; after only 4,200 of them had been distributed FEMA officials declared they would end the program. Only two days earlier, Brown had heralded his agency's cards as a way to "empower" survivors. FEMA scrapped the plan, it said, because it would be more efficient for the government to deposit funds directly into evacuees' bank accounts.

For many disaster experts, FEMA's feeble response, just like the massive hurricane that triggered it, was woefully predictable. President Bush, an avowed foe of government waste, began emasculating the agency soon after taking office. Joe Allbaugh, his first FEMA chief, labeled federal disaster aid "an oversized entitlement program" four months before 9/11. A parking lot for political allies since its creation in 1979, FEMA had improved under the stewardship of James Lee Witt during the Clinton years. Staffed by experts in emergency response, it won bipartisan praise. Even Bush lauded Witt during a debate with Al Gore in 2000, applauding FEMA's skill at coordinating the resources Washington can bring to a disaster zone when adversity overwhelms local efforts.

> "You can't have a Mike Brown at FEMA unless you can guarantee that there isn't going to be a catastrophe."
> —a Washington lobbyist

But the agency's highest ranks began to fill with political chums again once Bush took over. Brown and FEMA's other two top officials had ties to Bush's campaign or to the White House's advance office, whose primary mission is to make the President look good. None had significant disaster experience. As TIME.com first reported, Brown appeared to have padded his own résumé to make himself seem to have some—any—preparation in the field of emergency response.

FEMA's effectiveness was dealt perhaps its worst blow after 9/11, when the newly created DHS swallowed the emergency agency whole. FEMA now became just one of 23 agencies folded into the massive new department, with its 181,000 employees and $30 billion annual budget. DHS aides insist the department has paid as much attention to preparing for natural disasters as terror-

Allen Fredrickson—Reuters/Corbis

Michael Brown
Ex-director, Federal Emergency Management Agency

To be fair to Michael Brown, he wasn't the first political ally with skimpy credentials to be appointed by George W. Bush to lead the Federal Emergency Management Agency. Brown, 50, is an old friend of Joe Allbaugh, who was Bush's chief of staff when he was Texas governor and his presidential campaign manager in 2000. When Allbaugh, who also had little experience in disaster management, was made FEMA's chief in 2001, he brought the Oklahoma lawyer along as general counsel. Brown was later promoted to serve as the agency's deputy director, and when Allbaugh left for the private sector in 2003, Brown got the top job. He earned the confidence of the White House as a loyal team player and oversaw the federal response to a number of emergencies; in most cases the agency he led performed ably enough to avoid lasting criticism.

None of those disasters measured up to Katrina. In the days after the storm struck, as FEMA stumbled, live on TV for all to see, Brown seemed to spend much of his time blaming victims for not evacuating, blaming local politicians for not preparing and blaming the media for its negative tone: things just weren't as bad as they appeared, he claimed. When it turned out that things *were* as bad as they appeared, DHS Secretary Chertoff sent Brown back to Washington, one day after TIME's website published a report highlighting Brown's scant background in emergency management, and suggesting the few credentials he claimed to possess may been exaggerated. Within days, Brown resigned. But his personal ordeal did not cure his political tin ear: called before a Congressional committee investigating the federal response to Katrina on Sept. 27, he admitted only two mistakes: not holding regular media briefings and failing to recognize "that Louisiana was dysfunctional."

ist attacks, but its allocation of resources suggests terrorism was the agency's paramount focus. Two months before Katrina, DHS Secretary Chertoff proposed that FEMA only respond to disasters, not prepare for them.

Chertoff, not Brown, was the man fully in charge of the federal response, and when he realized, belatedly, and perhaps with a bit of urging from the White House, that Brown wasn't getting the job done, he sent FEMA's chief back to Washington and handed the reins to Coast Guard Vice Admiral Thad Allen. Brown resigned the next day. But as Jane Bullock, a 22-year FEMA veteran told TIME, "The system is broken, and firing Mike Brown is not going to fix it." Like the country it is dedicated to protecting, FEMA may need to declare its independence—from the DHS.

"Don't confuse a plan with execution. A plan is good intentions. You don't win with good intentions."
—General Russel Honoré

BREAK THROUGH THE BUBBLE On Sept. 29, as Hurricane Katrina was shredding homes along the Gulf Coast, President Bush was joshing with Senator John McCain on the tarmac of an Air Force base in Arizona, posing with a melting birthday cake. Later he headed to a long-planned Medicare round table at a local country club, joking that he had "spiced up" his entourage by bringing the First Lady. Meanwhile, Blanco was desperately trying to get in touch with the President to seek more help; it took her six hours to get through to him. The next morning, just after 5 local time, Bush talked to an aide about the seriousness of the storm, then convened an emergency conference call of his top staff. He was scheduled to spend a few more nights of his five-week vacation at his Crawford, Texas, ranch, but instead he blurted out, "We're going back [to Washington]." After attending a V-J day anniversary celebration, he returned to the White House on Aug. 31, flying over a stricken, flooded New Orleans en route.

Yet in the days that followed, the President still seemed unable to grasp the seriousness of the situation along the coast, or the extent to which the halting federal response to the disaster was damaging his reputation. A TIME poll the week after the flood showed his overall approval rating had dropped to 42%, his lowest mark since taking office. And while 36% of respondents said they were satisfied with his explanation of why the government was

Lieut. Genreal Russel Honoré
Commander, Joint Task Force Katrina

Chris Usher for TIME

Critics who carped that the U.S. government didn't do anything right in the aftermath of Hurricane Katrina must have overlooked General Honoré. The lean, 6-ft. 2-in. Louisiana native arrived in the region on Aug. 31 to lead the U.S. military relief effort and proceeded to take names, kick butts and convince people that there was at least one adult on the scene: after watching the general in action, New Orleans Mayor Ray Nagin compared him to John Wayne. Seeming to pack two days into one, Honoré, 57, oversaw the military as it distributed 13.6 million meals, handed out 24.2 million liters of water, launched 24 ships and deployed more search-and-rescue helicopters than were flying in Iraq and Afghanistan combined. "Normally," he said, referring to the military, "we go in and break things. Here we're trying to fix things."

Honoré seemed uniquely qualified for his task: he was born in a Louisiana hurricane, the devastating storm of 1947 that killed 51 people. Until June 2004 he was the Standing Joint Force Headquarters—Homeland Security commander, responsible for studying a national response plan for terrorist attacks as well as for storms like Katrina. The office had conducted a study of what New Orleans should do after a direct hit by a massive hurricane. Of the city's evacuation plan, he said, "Don't confuse a plan with execution. A plan is good intentions. You don't win with good intentions." The second highest-ranking African American in the Army was not pleased to see troops in the streets of New Orleans. Their forays, he said, "just pissed off people inside the city," whom he found to be behaving well. "Imagine being rescued and having a fellow American point a gun at you. These are Americans. This is not Iraq." Here's a suggestion for a reborn New Orleans: a streetcar named Honoré.

not able to provide relief to hurricane victims sooner, 57% said they were dissatisfied—an ominous result for a politician who banks on his image as a straight shooter..

Why did Bush dither? One factor cited was the unusual absence of his top advisers when Katrina struck. Many of them were enjoying long Labor Day vacations: Vice President Dick Cheney was house hunting; Secretary of State Condoleezza Rice was visiting New York City; and master fixer Karl Rove was in the hospital, then confined to his home, battling kidney stones. Meanwhile, the public face of the government response on the scene was a political hack, FEMA Director Brown, an old buddy of Bush loyalist Joe Allbaugh, the president's first FEMA director.

Another factor was Bush's growing isolation. In his second term, the "bubble" around him has grown tighter; he is surrounded by advisers who offer skewed accounts of reality, aware of his inability to weather criticism well. "His inner circle takes pride in being able to tell him 'everything is under control,' when in this case it was not," a former aide told TIME. The result is a kind of echo chamber in which good news can prevail over bad—even when there is a surfeit of evidence to the contrary. Aides eventually became so concerned about Bush's ignorance of the miseries afflicting the Gulf Coast that they cobbled together a videotape of news reports for him to watch on Air Force One as he flew there on Friday, Sept. 2, four days after Katrina made landfall.

Finally, if the Bush team initially missed the significance of appearing to ignore the plight of a city with a majority black citizenry, it may be because he has organized his presidency around a different and far wealthier segment of the population, forgetting the needy. He addressed the subject directly in his speech from New Orleans on Sept. 15, saying, "There is deep, persistent poverty in this region ... And that poverty has roots in a history of racial discrimination, which cut off generations from the opportunity of America. We have a duty to confront this poverty with bold action."

After Katrina, bold steps indeed appear in order—even if creating a new, more efficient system for responding to disasters means spending more money and appointing more experts. That, says Clark Kent Ervin, a Republican and former inspector general for the DHS, would be a huge improvement. "I do think part of the problem is that we've tried to do Homeland Security on the cheap. We spend $400 billion on the Defense Department. It's telling that we're spending literally a tenth of that on Homeland Security." America may need to start thinking of homeland security the way we think of national security, Ervin and others argue. That would mean billions more. But it might mean a chain of command that made more sense. No one can say the military functions seamlessly, but there is, at least, someone in charge. ∎

Christopher Morris — VII-AP/Wide World

George W. Bush
President of the U.S.

When a TIME reporter asked President Bush to cite an example of a mistake he had made in office in a nationally televised news conference in April, 2004 the Chief Executive famously responded that he was unable to do so. But after his first fumbles on Katrina, the President finally embraced the act of contrition: "The results are not acceptable," he said on Sept. 2, before visiting the Gulf Coast for the first time. He was more explicit in his Sept. 15 prime-time address from the swamped city. "Americans have every right to expect a more effective response in a time of emergency," he said. "I as President am responsible for the problem, and for the solution."

Katrina's winds had a long reach: after shredding the Gulf, they tore the Teflon from Mr. Bush. The man many Americans regarded as a forceful, decisive leader suddenly seemed overmatched and out of step. His miscues on Katrina came at a crucial moment in his second term, when his top legislative priority at home, Social Security reform, was already on life support and the war in Iraq was becoming a mounting economic and political burden. It is already one of history's ironies that the man who scorned "nation building" in a 2000 debate with Al Gore has staked his presidency on difficult nation-building efforts in Iraq and Afghanistan. Now the man who said during his 2004 campaign that "government is limited in its capacity to heal and help" found himself standing in Jackson Square and proposing a veritable New Deal of federal aid to rebuild New Orleans. At the same time, he assured his conservative G.O.P. base that he wouldn't raise taxes to pay for it. Critics blamed Bush's foundering in the first days of the crisis on the "bubble" that isolates him. Katrina, the levee buster, may have been the bubble buster Mr. Bush needs.

No Direction Home: Katrina's Diaspora

The evacuation of the Gulf Coast may have been tardy and painful, but when the newly displaced residents of the hard-hit region arrived in unfamiliar surroundings, other Americans made them feel welcome

How does it feel? How does it feel to be on your own? With no direction home? Like a complete unknown? Like a rolling stone?" In the days after Hurricane Katrina swept through, hundreds of thousands of residents of the Gulf Coast found themselves living out the words of a song that turned 40 years old in 2005 yet suddenly seemed as fresh as the morning's headlines. Across America, an estimated 1.3 million people seeking shelter from the storm were on the move, wondering where they would live, where they would work, where their children would attend school and—most important—when, and if, they would ever find the direction home.

The response to Katrina was understandably chaotic and unfocused all along the heavily damaged shores of the Gulf. In contrast, the preparations in unaffected areas to receive those displaced by the storm were a model of efficiency and a testament to America's charitable spirit. In the early-morning hours of Wednesday, Aug. 31, fewer than 48 hours after Katrina slammed into the Gulf Coast and just as the magnitude of the disaster was coming into focus, Texas Governor Rick Perry answered a call for assistance from Louisiana Governor Kathleen Blanco by setting in motion plans to convert the abandoned Houston Astrodome into a giant refugee shelter. Fortunately, the city of Houston had aggressively refined

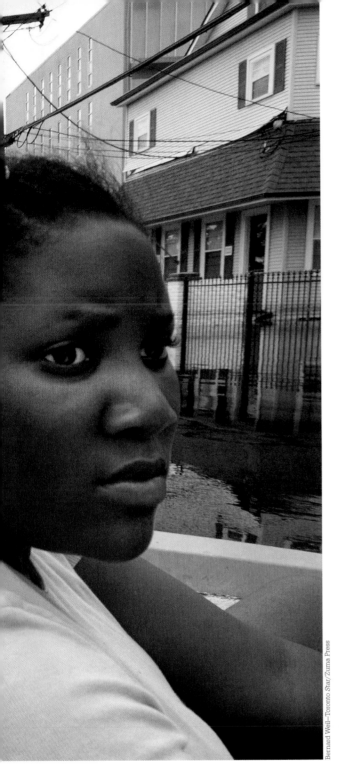

pulled into the Astrodome parking lot. Gibson had picked up more than 70 stranded people as he drove out of New Orleans, and they had pooled their money to buy gas, food and diapers for the babies in the group. "I don't care if I get blamed for it as long as I saved my people," Gibson said.

While Houston police tried to figure out whether to arrest Gibson or give him some sort of award (they eventually decided to do neither), his passengers and several thousand more Katrina survivors, who arrived just before midnight, were welcomed inside. In addition to air conditioning and electric lights (two amenities absent from the Superdome almost from the beginning), they found on each of the thousands of cots waiting in the Astrodome a "comfort kit" containing a toothbrush and toothpaste, a razor, a washcloth, a comb, tissues, soap and shampoo.

As the sun rose on Thursday morning, a breakfast of eggs, sausage, grits and rolls was served to thousands of people who had not eaten a hot meal—or, in

and rehearsed these plans after 2001's Tropical Storm Allison flooded 55,000 homes and caused $5 billion in damage. Stockpiles of cots, food and medicine were shipped to the Astrodome, while a network of more than 40,000 trained volunteers was activated. Before the day ended, the Astrodome was ready to receive its first guests.

But the first to arrive weren't the visitors Texas authorities had been expecting. Just after 9 p.m., hours ahead of the official convoy, a school bus stolen by New Orleans native Jabbar Gibson, 20,

DRIFTING Left, New Orleans resident Rochada Drummer looks back at her home perhaps for the last time as she leaves the swamped city; her two children are in the boat ahead of her. Their rescuers were agents sent by the South Carolina department of natural resources

AIRLIFT Sick and injured people are ready to be flown via a U.S. Air Force C-17 Globemaster from the New Orleans airport to Dobbins Air Force base in Georgia. The jumbo jet flew to the Gulf from McChord Air Force Base in Washington State to help the evacuation

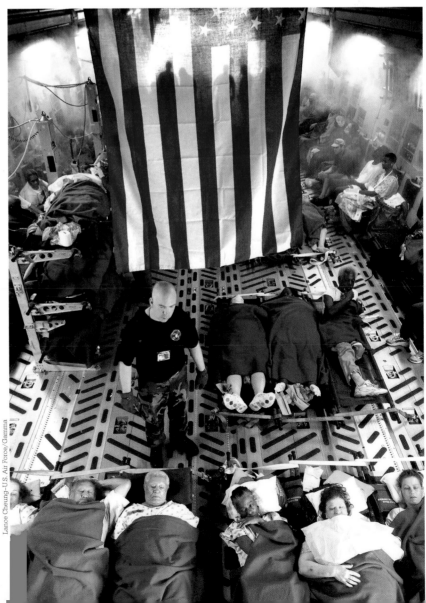

The Displaced

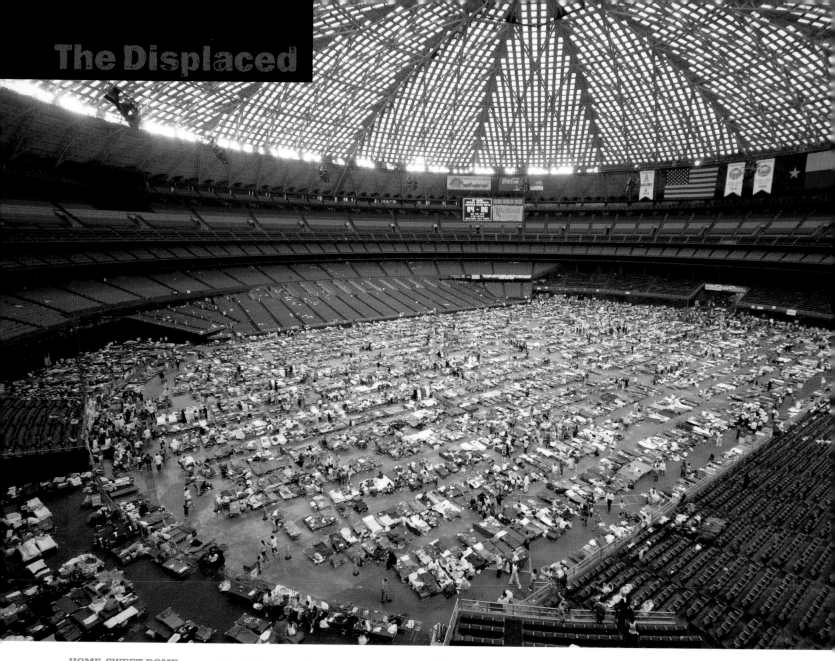

HOME, SWEET DOME
The Astrodome in Houston fills up with evacuees, primarily from New Orleans, on Sept. 4. Texas and Arkansas took in the highest numbers of those displaced by Katrina

some cases, any meal—in several days. Working bathrooms and showers, complete with an unlimited supply of clean towels, underscored the contrast with the Superdome, where chaos had reigned until the last (some officials at the New Orleans arena first heard about plans to ship evacuees to the Astrodome on Wednesday afternoon, when reporters on the scene asked them to comment on the plan).

If the creature comforts inside the Astrodome were instantly apparent, so was another crucial difference from the shelter most of these people had just left. There were always at least 200 Houston police officers within the complex, often more than 500, backed up by National Guard troops. Roy Harrison, 46, a New Orleans butcher, found the conspicuous presence of law enforcement reassuring but also a little unnerving. "Texas has capital punish-

ment," he told the Associated Press. "When you live in a city like New Orleans, where you are just about free to do anything you want, and then you come to a place where martial law is real every day, they [criminals] are not going to make it here."

Within 48 hours of welcoming its first guests, Houston's defunct sports arena had become a crowded but reasonably comfortable city. The Astrodome boasted its own own ZIP code and post office, several health-care clinics and a pharmacy, multiple telephone banks, an Internet-access kiosk and makeshift indoor "parks" where children could safely run and play. In a grim reminder, though, of the disaster that had driven the inhabitants of this emerging metropolis from their homes, the walls were covered with photographs and notes asking for information about family and friends still missing.

Although the operation at the Astrodome initially worked so smoothly as to seem miraculous, even this well-oiled machine threatened to seize up when pushed beyond its limits. Texas officials had originally predicted with confidence that they could handle 25,000 refugees. Within four days, they had received more than 10 times that number, and the Astrodome was filled to capacity less than 24 hours after its doors opened.

Local officials quickly duplicated at three more Houston venues the preparations they had earlier made at the Astrodome. By late Thursday evening, the Reliant Center, an exhibition hall; the Reliant Arena, a stadium next to the Astrodome; and the George R. Brown Convention Center all began taking on the overflow of Katrina survivors.

By the weekend, the lack of medical care emerged as a serious bottleneck. Fewer than 100 doctors were available to address the needs of more than 50,000 evacuees at the four large Houston shelters, with several thousand more arriving each hour. "We just need help," Dr. Steven Glorsky told the Associated Press. "We have a crisis in there." Like clockwork, more doctors soon arrived.

Texas took in more Katrina refugees than any other state. Dallas housed 25,000 evacuees in its Reunion Arena, and San Antonio took in approximately the same number at a former Air Force base now owned by the city. More than 100,000 additional refugees found space at hotels, in private homes or in shelters operated by charities like the Red Cross.

Across a wide swath of the nation's Southeast, other states reached out to welcome Katrina's dispossessed. Arkansas, the only state that borders both Texas and Louisiana, helped both its neighbors. More than 70,000 Katrina survivors arrived in the state, either directly from Louisiana or as part of a secondary migration from overcrowded Texas shelters. Many of the initial wave of evacuees lucky enough to make it out of New Orleans before the storm hit landed in Arkansas on Tuesday, Aug. 30. This first group of 9,000 was sent to Fort Chaffee, in Siloam Springs, which had been used 25 years earlier as a processing center for refugees from Cuba's Mariel boatlift.

Like Texas, Arkansas had learned from previous disasters. The state had vast supplies of cots, blankets and food rations in storage, waiting to be tapped. Unlike Texas, Arkansas planned from the beginning to use Fort Chaffee, its single largest shelter, only as a waystation. Most refugees were shuttled through Fort Chaffee and into a network of smaller camps and shelters, often operated by religious organizations and private charities, within 48 hours. Many of these sprang up spontaneously, in response to Katrina: in Charleston, Ark., locals worked around the clock to refurbish and open an abandoned nursing home to shelter 20 evacuees. Some towns, like rural Imboden, which took in more than 300 refugees, absorbed the equivalent of half their normal population.

"If you look back from where we came from and the ordeal we came through, this is a blessing," said John Cannon, a refugee of New Orleans who had been sent to Camp Aldersgate, a religious-retreat center in Little Rock, along with about 60 other refugees. The state as a whole saw its population swell 3%—meaning that, in proportional terms, it took in more people than Texas did.

Many of the state's guests were so delighted by their reception (and so traumatized by the ordeal they had left behind) that they were considering settling permanently in Arkansas. "I went from New Orleans, where I had nothing, to a place where I have something," reflected Louisiana native Orelius Caldwell. But some were less enchanted by their new surroundings, which could have been on a different planet from the urban sophistication of New Orleans. "I'm exhausted and confused," Christina Wheaton declared. "I just want to go back home." Fellow evacuee Delilah Carter agreed, "I'm tired, and I should have went home to my hometown by now."

Mother and Child Reunion

Here's a story of one displaced family with a very happy ending. When Katrina hit New Orleans, Stacy Nolan, right, was separated from her 7-month-old son, A'Mahd McGee, who was in the care of family friend and nanny Nicole Johnson. Flooded streets kept the mother and child from reuniting before Nolan, her two other children and several family members were evacuated and bused to Dallas on Aug. 30. "I can't sleep because I miss my baby so much," a weeping Nolan told Texas reporters. "I just lie beside the bed and pray. That's all I do. That's all I can do."

Nolan's prayers were answered on Sept. 6, when Johnson called her from Alexandria in central Louisiana, where she and A'Mahd had been sheltered after fleeing New Orleans. Members of Prestonwood Baptist Church in Dallas, who had been assisting the evacuees, had spread the word of Nolan's plight; somehow, the story reached Johnson. She and A'Mahd were flown to Dallas on a donated private jet for the joyous reunion below; A'Mahd's grandmother, Cynthia Henry is at right.

Top: Melanie Bruford–Dallas Morning News/Corbis; Bottom: Kim Ritzenthaler–Dallas Morning News/Corbis

BELLSOUTH®

REACHING OUT On Sept. 12, more than two weeks after the storm, evacuees use phones at a mobile communications center set up by FEMA and BellSouth

And that was the big question. The day when Wheaton, Carter and the other evacuees would return to their hometown remained unclear more than a month after Katrina made landfall. As of late September, the Red Cross was still caring for more than 142,000 storm victims at almost 500 shelters spread across 12 states. Other government and private aid organizations were hosts to an unknown number of additional refugees in at least 19 states.

And the homecoming that many refugees sought was delayed further at the end of September by Hurricane Rita, which wrought additional devastation on the Gulf Coast, reflooded parts of New Orleans and once again choked the aid network line with a new wave of evacuees.

For some of Katrina's survivors, especially those who were facing their fourth or fifth move since fleeing from their homes, enough was enough. "Just

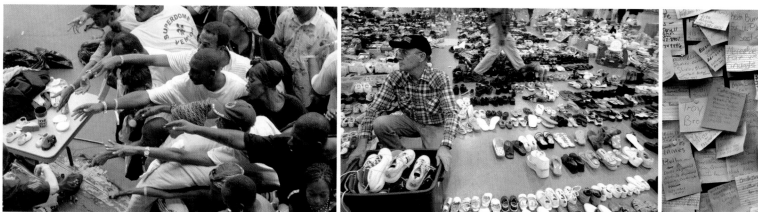

ASTRODOME Socks and underwear are popular giveaways

RELIANT CENTER Got sole? Donated shoes fill a room

Melanie Gomez—Gamma

when we get comfortable, they move us," lamented Naomi Gray, 55. "I'm tired of moving." Or, as New Orleans refugee Thomas Marquez, put it, "I'd like to be like everyone else—just have a home."

South Africans employ an evocative phrase for those displaced from their homeland by political and tribal strife: scatterlings. In the months and years to come, Katrina's scatterlings will find a direction home—whether that home is in a rebuilt New Orleans

or whether it is a new one in the towns where their diaspora leads them. They will join other groups whose wanderings have enriched the nation, including, perhaps, some of their own ancestors: More than two centuries ago, political exiles left their homes on the island of Haiti and in Canada's Acadian country and fled to French Louisiana, bringing gumbo, jambalaya and the Mardi Gras with them—and who today can imagine America without them? ∎

PRIVACY, PLEASE
Evacuees use cardboard boxes to create a personal space in the vast expanse of the Astrodome

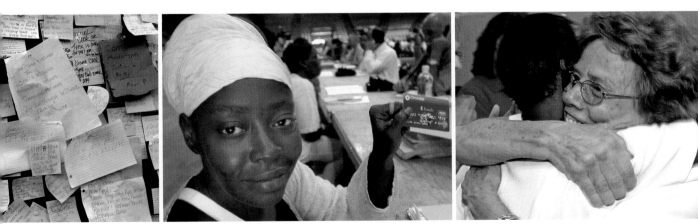

ASTRODOME A message board **HOUSTON** A FEMA debit card, soon obsolete **UTAH** Veronica Scott, left, exults in finding work at a job fair

"Interviewing folks while taking their picture was great, but it just about drove me crazy. Every time I turned a corner, I would see an amazing spectacle, but I hadn't been assigned to shoot those scenes. I could have shot until my cameras wore out."

Toby Clairmont

John Chiasson

The photographer, who has worked for TIME since the mid-1980s, is a native of Lafayette, La., so he felt a special bond with the Katrina victims he spoke with. TIME asked Chiasson to carry a tape recorder and interview Gulf Coasters whose lives had been changed by the storm, and he came back with a wealth of narratives as well as his portraits of the survivors. Chiasson enjoyed the work, saying: "I was trained as a photojournalist, but this time around, I felt a bit more like a journalist than a photographer."

Brian Molere

"I come from a family of swimmers," the Bay St. Louis, Miss., man told Chiasson; his great-grandmother had swum her way to survival through hurricane flood-waters, and his mother lived through Hurricane Camille. When Katrina struck, Molere and his Chihuahua Rocky fought the floodwaters for two hours and survived the ordeal. His mother, 80 and on a respirator, re-fused to leave the house she was in and was swept away. "I hope she went fast," Molere said.

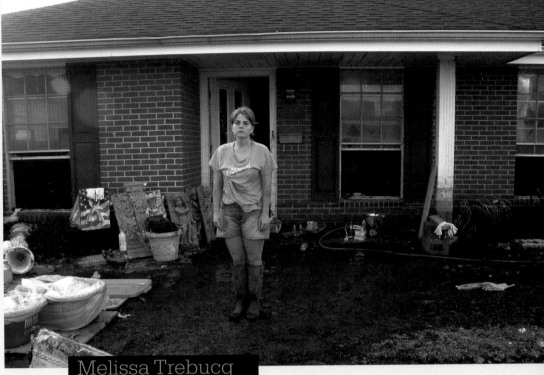

Melissa Trebucq

Chiasson found Trebucq busy scouring her home in Chalmette, La., which had been flooded by an oil spill from a nearby refinery. Trebucq explained the irony of the situation to Chiasson: she is employed at a plant that turns oil into coke.

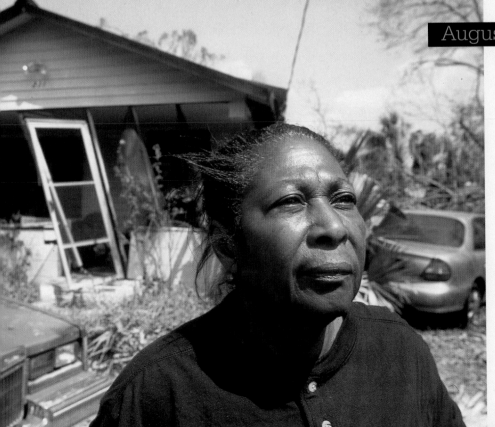

Augusta Acker

On the morning of the storm, Acker told Chiasson, she got out of bed in Bay St. Louis, Miss., and "I put my foot down and the floor was cold!" As the floodwaters rose, she and her daughter, who lives next door, held tightly to her son, Steven, as they fought the waves and tried to swim against the storm surge. Then, from around the corner of the house, a boat that had belonged to her late son—who died more than 20 years ago—suddenly appeared; it had been lifted off the blocks where it had been stored. The three climbed aboard and floated to safety.

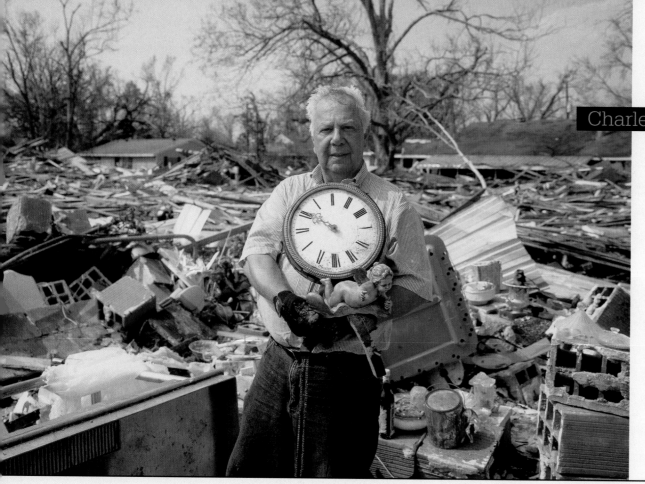

Charles Gray

The Hancock County Historical Society executive director told Chiasson, "I will not be whipped. I will be back and record the history of this storm." His home in Bay St. Louis, Miss., was filled with a collection of priceless antiques and paintings, which he had spent a lifetime collecting.

"At first, I found this assignment to be riveting. But after days of meeting people whose lives have been destroyed ... well, you have to put in some insulation ... any minute you might hear a story that will break your heart. It wears on you after a while."

The Ainsworths

Kirk, his wife Lyndi, baby Jack and daughter Mia, 3, evacuated New Orleans' Mid-City neighborhood before the storm. Heavily armed, the medical-device salesman and friends, including a former Navy SEAL, later returned in a skiff to do rescue work. Kirk Ainsworth told Chiasson, an old friend, that although he is not a New Orleans native, "I miss it already, everything about it."

Susan Ebel

Chiasson found Ebel, a private chef, outside her 150-year-old Garden District home, American flag flying in the breeze. She was one of the fortunate ones; her street, on high ground, barely flooded, and she "never lost a pane of glass." Ebel told Chiasson, "I do not feel threatened in my home by looters or anything like that." She had no plans to evacuate the city. "They'll have to take me kicking and screaming," she declared.

Robert Barnes

As storm surges engulfed his home, Barnes, a concrete finisher, scrambled to his roof; then he leaped to a nearby pine tree, strapped himself to it with his belt—and watched as his home was swept away. Later he found a neighbor's corpse. "Who lived here?" Chiasson asked Barnes, of the trailer where he was camping. "I don't know," Barnes said.

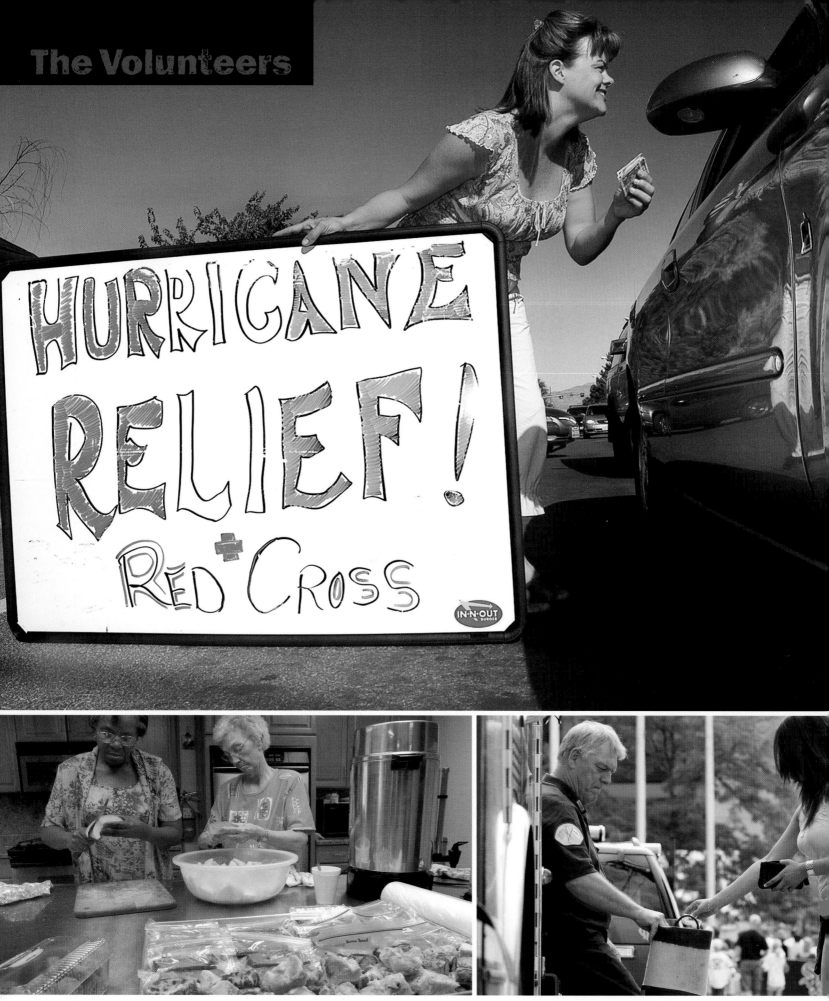

HURRICANE RELIEF! + RED CROSS

IN·N·OUT BURGER

TEXAS Cooking breakfast for evacuees

ILLINOIS A Chicago fire fighter collects funds

A Whirlwind of Generosity

Americans respond to Hurricane Katrina with an outpouring of charity, as schools, churches, families and businesses reach out to aid those stricken by the hurricane

As Gordon Vanscoy watched the images of Katrina's devastation on television, the 17-year-old was gripped by an urge to help the victims. Along with friend Shayna Stout, Vanscoy started an impromptu fund-raising drive at their school, Hempfield High in western Pennsylvania's Westmoreland County. Vanscoy's father Gordon, a professor of pharmaceutical sciences at the University of Pittsburgh, offered to match every dollar they raised with one of his own.

The two students assumed they would be lucky to raise something in the neighborhood of $3,500. As of the first week in October, they had passed the $30,000 mark, and money was still pouring in. School officials offered to allow the elder Vanscoy to cap his matching pledge at $10,000, but he declined. "By my trying to push their generosity," he explained, "they pushed back."

What's remarkable about Vanscoy and Stout's story is that it is not at all remarkable. Across the nation, in the days after Katrina made landfall, Americans united in ways large and small to help. In Charlotte, N.C., cousins Paulina Ashe-Reeder, 7, and Yahzmin Bolling, 10, raised $86 in their first day operating a lemonade stand. On the other side of the country, in Folsom Hills, Calif., fourth-graders Megan

Uhlig and Sarah Freese opened their own lemonade stand on Sept. 3 and raised $120 in their first three hours. In Lincoln, Neb., 300 motorcyclists staged a Hurricane Katrina Poker Run on Sept. 17 and raised $6,388. Elementary school students in the Copley-Fairlawn suburb of Dayton, Ohio, hired themselves out for household chores like walking dogs, washing cars and cleaning yards. They raised $5,178, which came to more than $15,000 after matching contributions from local businesses.

Even if America's public servants at every level fumbled the initial response to the hurricane, Americans themselves answered the crisis with an outpouring of generosity that dwarfed the nation's massive response to the 2004 Asian tsunami disaster and is expected to exceed the nation's answer to the terrorist attacks of Sept. 11, 2001. One month after the disaster, the American Red Cross, the organization designated by the Federal Government to head relief efforts in the private sector, was close to raising $1 billion, most of it in individual donations.

In Los Angeles, Mayor Antonio Villaraigosa stood in traffic outside city hall, brandishing a white bucket and collecting money from motorists. After persuading the occupants of each of the first seven cars he stopped to donate, Villaraigosa remarked, "I'm just

MUCH OBLIGED
Left, Jennifer Hart of Citadel Communications thanks a driver for donating to a relief drive in Reno, Nev., on Sept. 1

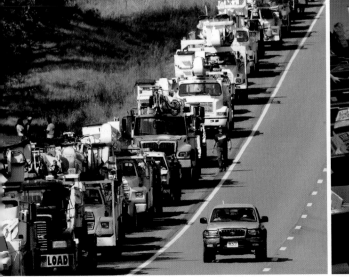

MISSISSIPPI Utility trucks from North Carolina arrive

MISSISSIPPI A Church of Christ Congregation collects donations

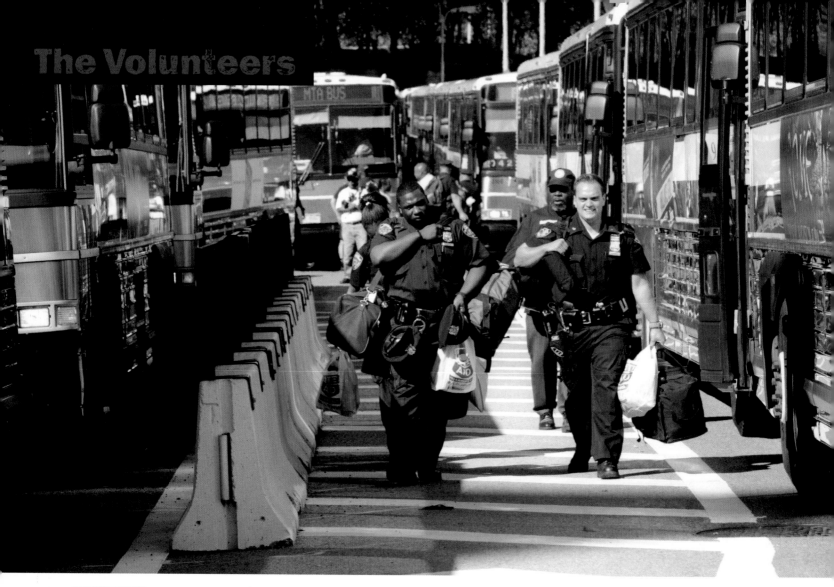

The Volunteers

SOUTHBOUND
On Sept. 3, 150 New York City police officers prepare to board buses that will take them to New Orleans. The 100 Metropolitan Transport Authority vehicles then carried evacuees to shelters in other states

amazed at the generosity. Kids are giving money. People are driving up, and you can tell they are not people of means, and they are giving $50 or $20." But many also gave in proportion to their incomes: in Los Angeles and around the country, owners of private jets directed their crews to fly into Louisiana and Mississippi and ferry out refugees.

American businesses also pitched in to help. In the first two weeks after the storm, according to the U.S. Chamber of Commerce, 145 companies had each pledged $1 million or more, and a total of 396 corporations had donated just over $409 million, along with another $138 million they had collected from their customers. Several heavyweights, including Wal-Mart, Office Depot and General Electric, each contributed in the range of $20 million.

While some Americans were reaching for their wallets, others were reaching for their car keys. In Beaver Falls, Pa., members of a local nonprofit group, U.S. Search, Rescue and Recovery, waited a week for FEMA to answer their offer to send trained emer-

gency responders to the Gulf region, then decided they'd waited long enough. Organizing a local benefit, they raised $15,000 and sent a team of 14 people to Waveland, Miss., for five days. Physicians from more than a dozen states also grabbed their medical bags and headed toward Katrina evacuation centers.

Some Americans who couldn't get to the scene of

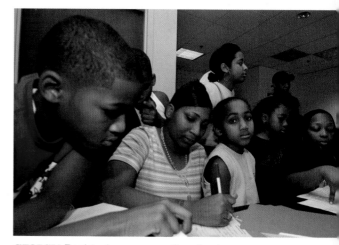

GEORGIA Registering evacuees for school

108

the disaster decided to bring the disaster's victims to them. By the hundreds of thousands, people who wanted to help opened their homes to those whose homes had been destroyed. Two of them were Forrest and Marie King, a Massachusetts couple whose house in Attleboro, southwest of Boston, had rooms to spare. But representatives of official agencies discouraged them, fearing friction might arise between the Kings and their houseguests.

After more days of watching wrenching hurricane coverage on their TV, the Kings decided that bureaucrats might not be the best judges of the situation. "The government failed," said Forrest. "The citizens have to stand up and say, 'Get out of the way. We'll take care of our own.'" So he began looking online and found *openyourhome.com,* started by Serena Howard, a mother of five in Fayetteville, Ark.

And that's how Forrest, a self-described "dyed-in-the-wool conservative," became host to Jan and Yolanda Meehan-Hoo, a lesbian couple, and three children, ages 5, 7 and 9. "The adults are same sex, and I don't care," Forrest said. "I don't care if they're purple and got horns coming out of their faces. They're Americans first." The Kings offered their home to the Meehan-Hoos indefinitely. Jan, who had a job at a nursing home in Louisiana, and Yolanda, a paramedic, hoped to find new jobs nearby.

Communal living provided learning experiences all around. "Marie asked how she should refer to us," says Jan. "She said, 'You gotta educate me.' I said, 'I call Yolanda my wife, and she calls me her wife.'" As Forrest recalled with a laugh, "The other day I heard them arguing with each other in the stairway. It proves to me that same-sex couples are just as miserable as the rest of us."

Across the nation, doors of all kids were swinging open to welcome Katrina's victims. Perhaps most critically, a tide of displaced children—as many as 372,000 by one estimate—flowed through the school doors of the states closest to the disaster. Texas schools alone had taken in 41,000 students by mid-September, with more arriving daily.

The influx of new faces had administrators doing math problems, and they soon realized that Katrina's exodus might just breach their tax levies. Houston Independent School District superintendent Abelardo Saavedra estimated that the long-term cost of serving the 4,700 student evacuees who poured into his district in just the first two weeks after Katrina struck, times an average estimated annual student cost of $7,500, would equal $35.2 million.

On Sept. 16 the Federal Government stepped in. Education Secretary Margaret Spellings announced that the Administration would request $2.6 billion from Congress to pay 90% of the average cost of educating each Katrina student—whether publicly or privately—up to a ceiling of $7,500 apiece. The news delighted school administrators but alarmed congressional Democrats, who charged that the Administration's intent to fund private schools along with public schools represented an unprecedented federal bankrolling of those institutions and their often overtly religious approach to education.

It's safe to say that political disagreements, like hurricanes, will always be with us. Another thing that's certain, however, is that the lives of everyone touched by the hurricane have been made far less disagreeable than they otherwise would have been, thanks to a storm surge of American generosity that surpassed even Katrina's floodwaters. ∎

MASSACHUSETTS The Meegan-Hoos settle in with the Kings

TEXAS New Orleans teacher Danyell Schulze meets her class

DIRTY WORK

What a mess! Surviving Katrina was tough enough, but after the hurricane reduced homes and buildings along the Gulf Coast into heaps of rubble, residents tackled a cleanup job of epic proportions

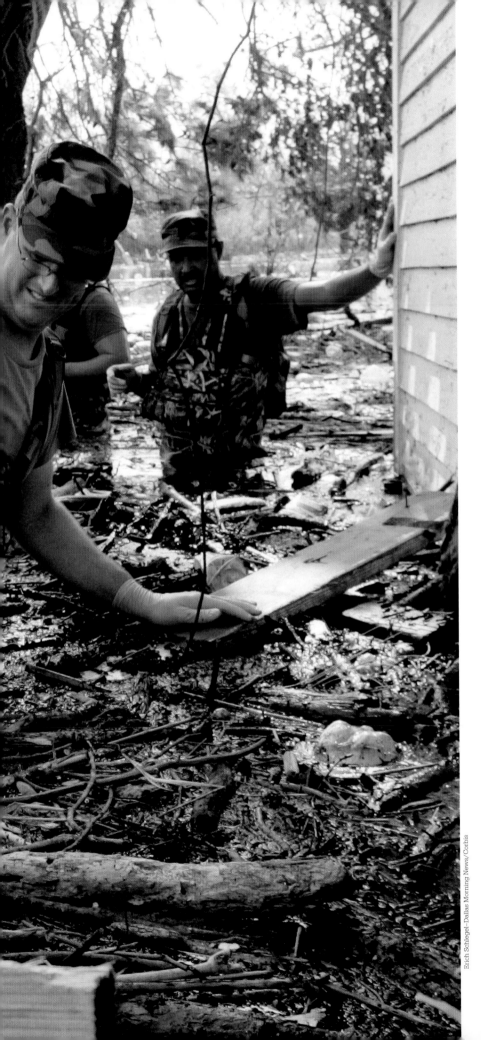

In the first frantic days after Hurricane Katrina devastated the Mississippi coast and flooded New Orleans, residents were too shattered to give much thought to the future. But as the days went by, and the extent of the storm's damage sank in, Gulf Coast residents realized they faced one of the greatest cleanup efforts in the nation's history. "I've heard reporters say the Gulf Coast looks like downtown Baghdad," Colonel Tony Vesay of the Army Corps of Engineers, the man charged with supervising the cleanup in Mississippi, told the Boston *Globe.* "Well, I've been to downtown Baghdad, and the Gulf Coast is in much worse shape."

Katrina painted its destruction across a huge canvas. All along the Gulf Coast—6,400 miles of twisting and turning shoreline and 140,000 sq. mi. of waterways and coastal zones—scientists, disaster specialists and recovery companies began taking inventory of the damage, creating a to-do list for the massive cleanup job to come. Coast Guard monitors assessed and photographed 400 damaged or sunken ships in Gulf waters off Mississippi and Alabama. In Louisiana alone, state officials estimated that some 150,000 to 200,000 cars and 50,000 to 75,000 boats would need to be removed from roads, canals, yards and bayous—not to mention 1,000 overturned railroad cars, some of which had been carrying hazardous materials.

In Alabama, the state least affected by Katrina, 73 public water systems were shut down and awaiting repair; more than 1,000 water systems were damaged in Louisiana and Mississippi. In the Gulf, some 140 oil and gas platforms were damaged, 43 severely. Some had been pulled from their pilings by Katrina's winds and storm surges; some sank; some floated away; one came to rest on an Alabama beach. Five major oil spills threatened the coastline's delicate ecology and the livelihoods of those who relied on it.

New Orleans, clasped in the brackish embrace of

YUCK! Two weeks after Katrina struck, New Mexico Army National Guard Sgt. 1st Class Chris Andrews slogs through the muck during a house-to-house status check in Port Sulphur in Louisiana's bayou country

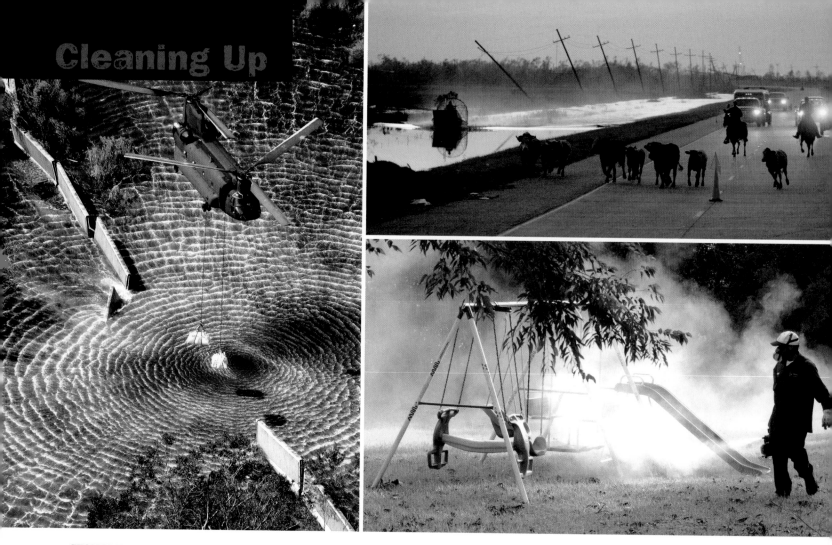

Cleaning Up

STONES IN THE STREAM Above, a military helicopter drops sandbags to repair one of the levees in New Orleans

HEAD 'EM UP Top right, cowboys on horseback and in airboats team up to wrangle stray cattle on Sept. 8 south of New Orleans near the mouth of the Mississippi. One local rancher lost 1,500 head in the storm

BIG BUG WOES Bottom right, health worker Andre Augustus sprays to control mosquitoes in the Riverbend subdivision of New Orleans on Sept. 6

Lake Pontchartrain, presented a special problem. Driving through the swamped city with an eight-vehicle convoy of Army Corps of Engineers personnel on Sept. 1, TIME writer John Cloud took in the scene. "Vast tracts of the city—not just shanties but mansions, not just the morgue but the Southern Yacht Club—aren't salvageable," he reported. "They all sit in what is called 'floodwater' but is really a solution of oil, feces, battery acid, human and animal rot, burst containers of bug spray and paint thinner and nail polish and antifreeze. The primary sensory experience of New Orleans now is the smell, a gagging foulness of the charnel, of the hundreds of bloated fish pooled in the 17th Street Canal and a million other nasty things floating everywhere. The masterless dogs are so hungry and delirious in the 92° heat that they drink this mix, at least a lap or two, and then stagger away. The city smells dead."

How to bring this dead city and dead region back to life? The task began with a grim chore, recovering the bodies of the deceased, that had been put off for too long as rescuers paddled through the streets of New Orleans or dug through the heaps of rubble along the Mississippi coast in hopes of finding survivors.

In New Orleans, the next step was to secure the levees and pump the floodwater out of the city. Once dry, the city's streets, buildings and houses—those that were salvageable—had to be thoroughly scoured, cleansed of the foul residue left behind. At the same time, cleanup crews in New Orleans began the task already started along the shoreline: hauling away mountains of debris.

Even as the rubble was being cleared, the next phase of the cleanup was beginning. In an effort that bore an uncanny resemblance to the sort of computer game in which simulated cities arise onscreen at the click of a mouse, the entire infrastructure of the Gulf Coast—electric power and natural gas lines, water and sewer systems, highways and bridges, phone lines—had to be either restored or built all over again from scratch.

DRYING OUT NEW ORLEANS In the Crescent City, Job One was restoring breached levees and pumping out flooded streets. The task fell to the Army Corps of Engineers, the people the Federal

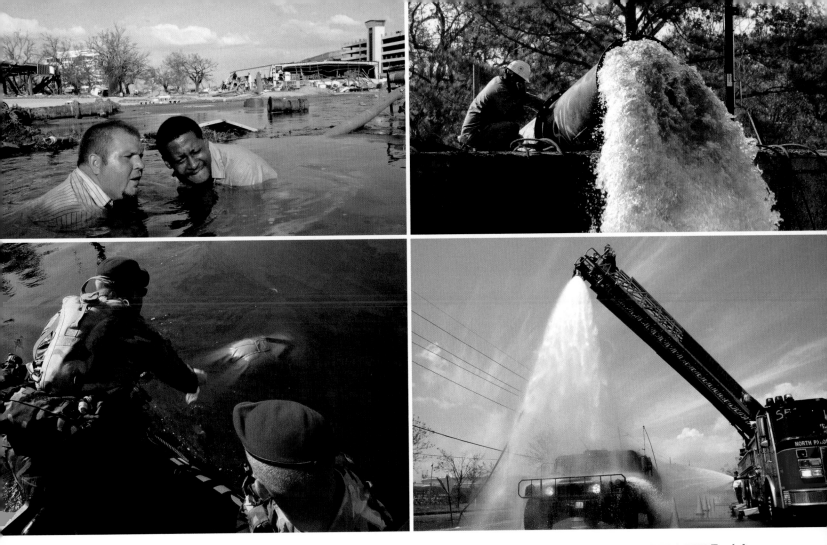

Arthur D. Lauck–Baton Rouge Advocate/WPN

Government calls when it wants to build something big. Some 1,580 of them came to the Gulf to fix what Katrina broke, and in the days soon after the storm, many of the Corps employees lived in conditions as bad as the city's residents. TIME's Cloud found they were sleeping no more than four hours a night, mostly on the floor of the Corps's New Orleans office, which had reeking bathrooms and no running water.

The simple immensity of the task before them astonished even the most experienced Corps engineers. When Colonel Richard Wagenaar, the Corps's New Orleans commander, first tried to approach the flooded 17th Street Canal as the storm was subsiding, he couldn't get within half a mile of it because of all the water and downed electrical lines.

Everything conspired against progress in those early days. "We're not so worried about the criminal element now, but the latest problem is the wild dogs," Susan Jean Jackson, the Corps's spokeswoman in New Orleans, told Cloud. "Poor things. Just starving. Yesterday one of our rangers had to pull a gun on one."

The Corps's first engineering challenge was plugging the London Avenue Canal, a long thin stretch of water leading south from Lake Pontchartrain toward the French Quarter. Both the levee and the floodwalls of the barrier had been damaged. (A levee is an earthen mound separating man from water; a floodwall is a concrete-and-steel wall that stands atop a levee or sometimes in place of one.) Two long sections of the floodwall, which is a foot thick and 14 ft. high, were shoved over as though they had been upright graham crackers. To fill the breach, the Corps commissioned an eight-chopper fleet of Black Hawks and Chinooks, three of them from Singapore, that dropped 7,000-lb. bags of sand, at a rate of roughly 50 bags an hour, where the floodwalls should have been. The force of the choppers' blades was so strong that it blew out the windows on at least two Corps SUVs parked nearby.

The Corps succeeded in plugging the London Avenue Canal on Sept. 6; all the critical damage to the city's levees was patched up by Sept. 10. Officials were careful to make no promises as to how serious a storm these hastily erected barriers, little more than thumbs in a dike, might withstand.

GET A GRIP Top left, workers Joe Dobson and Roderick Stapleton from the Gulfport, Miss., water and sewage department struggle to change a valve on a burst water line on Sept. 6

DRYING UP Top right, water flows from a pump in Metairie, La., on Sept. 6. The 30-in. pipe pumps out 27,000 gal. of water each minute

ONCE-OVER Bottom right, a fire truck cleanses each vehicle leaving Chalmette, La., to remove contaminants

GRIM TASK Bottom left, Army recovery workers in New Orleans use a grappling hook to retrieve a body

Sure enough, when Hurricane Rita drew near the Louisiana coast on Sept. 23, the Industrial Canal was breached again, and the streets of the Lower Ninth Ward filled with water. Fortunately, by this time the Corps had a handle on the situation, and the new floodwaters were pumped out quickly. Mayor Ray Nagin, in one of his more optimistic moments, estimated that Rita set back the clearance of the city's streets by no more than four days.

The Corps of Engineers originally estimated that the process of pumping the water out of the city would be completed by Oct. 18, but even given Rita's unexpected house call, the job was completed by Oct. 2; a few small puddles and swampy areas remained to be drained in the first week of October.

TAKING OUT THE TRASH How to clean up after a hurricane? In recent years, as monster storms have pounded America's coastline, the process has be-

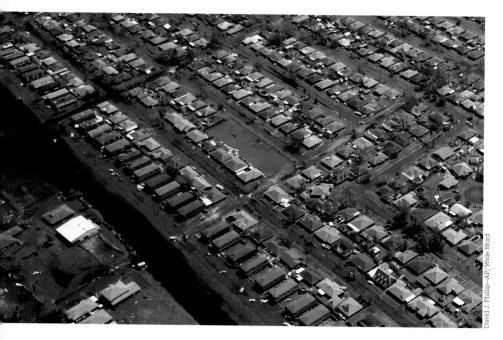

FOULED As the flood-waters recede from St. Bernard Parish in New Orleans on Sept. 8, a layer of mud and debris is exposed

David J. Phillip—AP/Wide World

come Big Business, with large corporations specializing in removing and treating waste. Shortly after the Katrina cleanup began, FEMA authorized the Corps to spend as much as $1.5 billion on the effort. This money was part of a larger pool of funds, from which more than $15 billion was committed to cleanup and infrastructure repair. The process caused a political firestorm; FEMA awarded more than 80% of its early contracts without bidding or

1 **Rain and floodwater flow** through underground culverts and canals to low points in the city, where pumping stations push them onward

Vertical centrifugal pumps

with very limited competition. Five of them were for $500 million or more.

Setting aside the politics of the situation, here's the cleanup drill. First, the rubble was gathered up by bulldozers and backhoes, dumped into trucks and hauled to "reduction sites," where most household debris—vinyl siding, wallboard, lumber, was separated. Then the individual raw materials, metal or lumber, for instance, were ground up together. Plastic and metal would become landfill; trees and brush were either burned or fed into a chopper to become wood chips and recycled someday for landscaping.

Refrigerators, air conditioners and other items that could contain hazardous materials such as coolants were set aside so that these substances could be removed. Simple light and appliance switches contain mercury; these had to be isolated before the materials could be chewed up.

On Sept. 21, federal and state officials told the Associated Press that workers had already removed almost 3 million cu. yds. of debris, enough to fill 30 football fields to a height of 50 ft. And the work had barely begun: the officials estimated that before the last load of debris was hauled away, they would have removed 80 million cu. yds. of debris, enough to build a pyramid 200 times the size of Egypt's Great Pyramid of Giza.

TURNING ON THE TAP Big cities have big thirsts: restoring clean, fresh water was one of the first chores of the cleanup teams. Utility workers succeeded in bringing most municipal water systems back online in the first week after the hurricane

Larger pumping stations then lift the water into open canals

3 **At some points in the city,** water flows to final pumping stations at the edge of Lake Pontchartrain, where pumps lift it over the levee

Horizontal screw pumps

Outflow canal to Lake Pontchartrain

Floodwall

DRYING OUT

Storm drains in nearly every city in the world work on the same principle: water flows downhill, usually to a river or a coast. But in New Orleans, the river and the coast are uphill. To get the water out, crews raced to restart the city's elaborate pumping system

Underground drainage canal

HOW LONG DID IT TAKE?
Working at full capacity, the city's pumps could drain an Olympic-size swimming pool in 1.9 sec. The Army Corps of Engineers finished the job on Oct. 2, well ahead of their first estimate, Oct. 18

Plug the holes, power the pumps …

As repair crews descended on the inundated city, the first step was to plug the breaches that let Lake Pontchartrain pour in. Less than two weeks after the storm, the major breaches had been filled, primarily with sandbags dropped from helicopters. Next, workers began getting power to the city's electric pumps

… and the water slowly recedes

At the height of the flood, about 80% of New Orleans was under water. By Sept. 10 it was about 60% under water. More than 30 of the city's 148 pumps were running at reduced capacity, pushing 90,000 gal. per sec. out of the city

Lake Pontchartrain

Approximate extent of highest flooding

Pump Station #6 (The city's largest)

38 portable pumps are also in use around the city

Levee

17th St. Canal

Orleans Ave. Canal

City Park

London Ave. Canal

#7

Audubon Park

N E W O R L E A N S

Shallowest flooding

Station #1

#4

Deepest flooding

Garden District

Downtown

#2

#3

French Quarter

#17

Interstate 10

#16

NORTH

#19

DRYING OUT
The highest point in New Orleans is the levee along the Mississippi River. The lowest parts are closest to Lake Pontchartrain. As more pumps came online, the water receded toward the northern parts of the city

Mississippi River

#5

#20

11.7 miles

Where levees breached

Sources: Army Corps of Engineers; National Register Evaluation of New Orleans Drainage System

TIME Graphic by Ed Gabel and Joe Lertola

Pumping stations in New Orleans
Size indicates normal pumping capacity
Proportion in operation as of Sept. 10

Gallons of water per second: 67,500 37,500 15,000 3,750 1,500 Capacity unknown

Cleaning Up

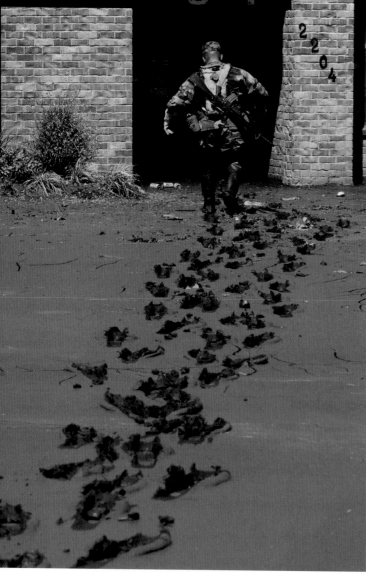

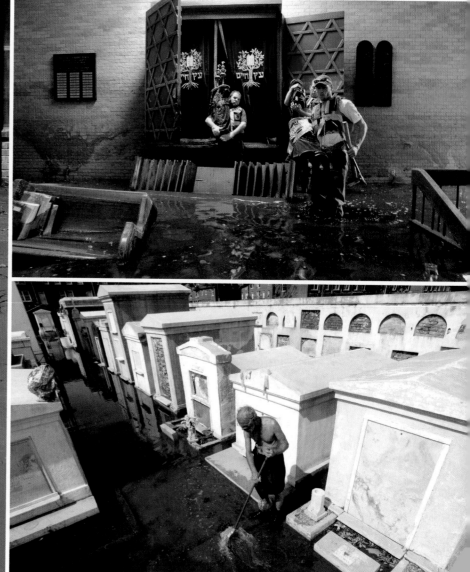

along the coast. But New Orleans faced water woes of a different sort: its streets were flooded by the messy goop that many began calling a "toxic gumbo." Mike McDaniel of the Louisiana department of environmental quality didn't cotton to that term. He told the Baton Rouge *Advocate* that the main problem with the water was bacteria rather than chemicals. Lead levels in some floodwater samples were much higher than normal drinking water standards, he admitted, but he doubted anyone would drink the stuff, forgetting the city's abandoned dogs and cats.

Officials at the U.S. Environmental Protection Agency, perhaps a bit more disinterested than McDaniel, said they had found levels of the pathogen *E. coli* as much as 20 times what is considered

healthy in the floodwaters. They also suspected that carcinogens like PCBs were present. Perhaps the greatest long-term danger was that contaminants would penetrate into the city's soil. "The fact is that the whole city is now a potential toxic dump or brownfield," Robert D. Bullard, a sociology professor and director of the Environmental Justice Resource Center at Clark Atlanta University in Georgia, told the New York *Times*.

FEMA officials hoped to have New Orleans' water system up and running within 90 days of Katrina's landfall, and the process, which might involve flushing, sanitizing and checking the safety of every single water pipe in the city, appeared to be roughly on schedule as of early October. However, as *USA Today* reported in late September, the waterlogged

MUDBATH Left, a Colorado National Guardsman makes tracks in St. Bernard Parish, Sept 8

SAVED Top right, Rabbi Isaac Leider carries a Torah scroll from the flooded Beit Israel synagogue in New Orleans, Sept. 13

CLEAN SWEEP Voodoo priest R. Gregory Walstrom clears debris from tombs in the flooded St. Louis Cemetery in New Orleans, Sept. 6

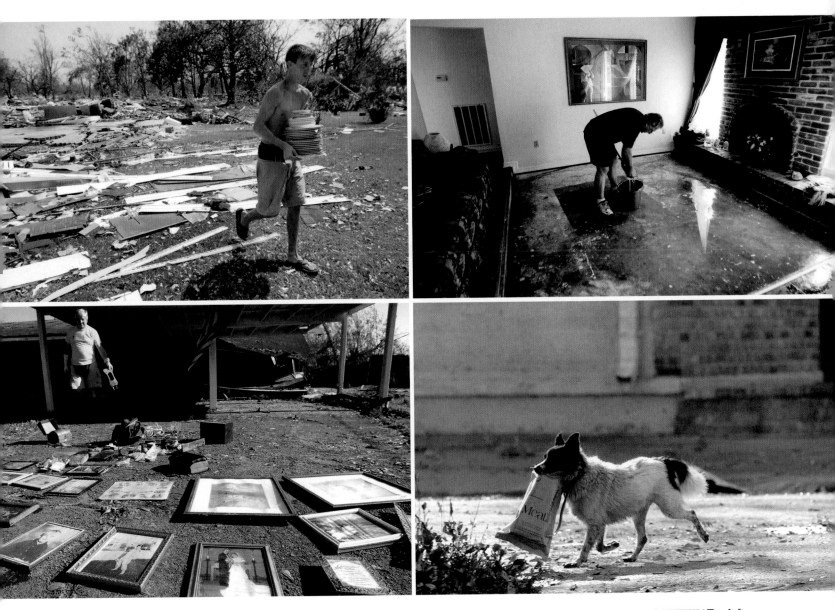

Armstrong—Getty Images; Willie J. Allen Jr.—St. Petersburg Times—WPN;
Spencer Platt—Getty Images

soil on which the city rests was so heavy it had caused hundreds of breaks in underground water pipes. Another chore on the water workers' list: draining, cleaning, vacuuming and pumping each of the city's storm drains. There are 55,000 of them.

POWERING UP Restoring electricity to the Gulf Coast was just as big a job: it involved not only patching up generators and turbines at power plants but also tracing every single line into every single home or building. Along those lines, transformers were soaked, clogged with brush and rubbish, and their electronic parts would have to be replaced.

The lights flickered on at different times across the battered shoreline. By Oct. 1, power was flowing to two-thirds of the districts in New Orleans; the num-

ber would have been higher if not for Hurricane Rita. Brigadier General Michael Fleming of the Florida National Guard, who was directing its massive force in New Orleans, noted that turning the power back on provides an instant major morale boost. "What we found in Florida [after the 2004 hurricanes] is that, all of a sudden, the mood improves significantly."

Hurricane Rita postponed the region's housekeeping chores. But storm-hardened residents largely took Rita in stride. As Mayor Nagin summed up the one-two punch that hit New Orleans, "Katrina was the wash cycle. Rita seems to be the rinse cycle. I'm hoping to get an opportunity to hang on the line and dry and not go through the spin cycle." It was good, for a change, to find Nagin speaking the language of Maytag rather than Mayday. ∎

CAREFUL! Top left, Michael Savarese hauls his grandma's dishes in Long Beach, Miss., Sept. 2

MR. CLEAN Top right, Larry Armstrong gets to work in Metairie, La., Sept. 5

CHOW TIME Bottom right, a dog in New Orleans has his chops on a military ration

IMAGES Bottom left, Charles Staehle saves memories in Bay St. Louis, Miss., Sept. 7

A New Dawn for the Crescent City?

Declaring that it's impossible to imagine America without New Orleans, President George W. Bush commits the Federal Government to a huge rebuilding plan—but a host of questions cloud the future

Standing in Jackson Square in a swamped, almost deserted New Orleans under harsh lights erected by his advance staff and with historic St. Louis Cathedral behind him, President George W. Bush made a very large commitment in his televised address to the nation on Sept. 15, 2005. "Tonight," he declared, "I also offer this pledge of the American people: throughout the area hit by the hurricane, we will do what it takes. We will stay as long as it takes to help citizens rebuild their communities and their lives. And all who question the future of the Crescent City need to know: there is no way to imagine America without New Orleans, and this great city will rise again."

It was a stirring call to action, equal to the grave crisis that spurred it. And it certainly reassured New Orleanians who firmly believed there was no place like home. But if there was no way to imagine America without New Orleans, it was also difficult to imagine what a restored New Orleans might look like—and even more difficult to reckon the price tag of a project so vast in scope.

One ironic hint as to the size of the task ahead could be found in the President's promise that New Orleans would rise again. For the essential problem with New Orleans is that it has been sinking, slowly and inexorably, for decades. The city was built on a rare strip of high ground that ran alongside the Mississippi River; its crescent shape gave the city one of its nicknames. By the mid-19th century, New Orleans, which commanded the shipping lanes into America's interior, was one of the richest cities in the land. But the amount of firm ground available for building was limited, and the city needed room to grow.

The answer: visionary engineers persuaded the city elders to erect a complex system of levees that would allow land lying well below sea level to be reclaimed for building purposes. The plan was not so far-fetched; thanks to a complex system of dams and barriers, the Dutch have built much of their nation on land reclaimed from the sea. And the scheme worked. As more and more territory was drained, New Orleans grew into a great port city and a worldwide magnet for tourists. But the system essentially held the city hostage to nature. Each year, the spongy soil on which some sections of the city were built slowly sank, in a process called subsidence.

Once the city had taken shape, nestled into what was essentially a lake bed, no one expected New Orleans to move someplace else. But there were several other options. Governments could have built stronger, higher levees and shored up the disintegrating coastline. As it was, the levees, overseen by the U.S. Army Corps of Engineers, were designed to handle storms as strong as Category 3, even though experts warned that worse storms were inevitable. Building levees capable of handing a Category 5 storm more would have been expensive—in the billions, most likely. But that is certainly less costly than the Katrina recovery will turn out to be.

A reborn New Orleans will also have to address the social and racial inequities built into the very street grid of the old city, where geography was destiny: well-to-do whites occupied the higher ground, while less fortunate blacks occupied the low-lying areas. The Lower Ninth Ward, site of the worst flood-

ing in the city, is 98% black. After seeing poor blacks stranded on rooftops, awaiting rescue, former FEMA Director Michael Brown said of the stranded: "They're appearing in places we didn't know they existed." It was one of the most telling sound bites to emerge from the Katrina saga.

The President addressed that problem squarely in

DRIFTING Workers make repairs on the Industrial Canal, which was breached by both Hurricanes Katrina and Rita

BIG PLANS "Here in New Orleans," the President said on Sept. 15, "the streetcars will once again rumble down St. Charles, and the passionate soul of a great city will return"

L.M. Otero—AP/Wide World

CHECKING IT TWICE
Engineer Ann Springston takes notes on damage to the Industrial Canal levee in the city's Ninth Ward, where streets were still flooded on Sept. 28

his speech from Jackson Square. "As all of us saw on television," he declared, "there is also some deep, persistent poverty in this region as well. And that poverty has roots in a history of racial discrimination, which cut off generations from the opportunity of America. We have a duty to confront this poverty with bold action. So let us restore all that we have cherished from yesterday, and let us rise above the legacy of inequality. When the streets are rebuilt, there should be many new businesses, including minority-owned businesses, along those streets. When the houses are rebuilt, more families should own, not rent, those houses."

The man who generally hews to the conservative philosophy that government's role in encouraging opportunity is limited went even further, speaking in bold terms about "one of the largest reconstruction efforts the world has ever seen," proposing a tax-advantaged Gulf Opportunity Zone to create jobs, worker-recovery accounts to help evacuees pay for job training and child care, and even an Urban Homesteading Act to let some low-income victims of Katrina build homes on cheap federal land. In short, this was George W. Bush's New Deal.

Even as Bush spoke, money was already flowing into New Orleans faster than water was being pumped out of it. By late September, it was safe to say the recovery from Hurricane Katrina had entered a new phase: the financial free-for-all. The President was careful not to get specific about what his plan might cost, but economists estimated that Katrina's final price tag could easily top $200 billion.

On Capitol Hill, both parties tried their best to harness the massive Katrina rebuilding effort to propel

their own ideological agendas. Democrats viewed it as a once-in-a-generation opportunity to try to alleviate poverty and racial inequality, touting more investment in public school construction and housing vouchers. But conservatives could see at least some of their handiwork in the Administration's initial proposals for job-training accounts and private- and parochial-school vouchers—as well as in the President's earlier, controversial decision to suspend rules requiring federal contractors to pay "prevailing wages" in the region.

On Sept. 30, Mayor Ray Nagin of New Orleans weighed in on the future of his city, appointing a panel of 17 civic leaders, heavily weighted with busi-

Bob Krist—Corbis

ness executives, to the Bring Back New Orleans Commission and charging them with creating a vision plan to rebuild the city. Commission co-chair Barbara Major, executive director of St. Thomas Health Services in the city, declared, "Part of my responsibility is to ensure that when this city is rebuilt—and not if, when this city is rebuilt—that it is rebuilt with the inclusiveness that it never had before, in terms of equity and access."

Not to be outdone by Nagin, the New Orleans city council quickly named its own blue-ribbon panel to consider the city's future. Clearly, the roux of renaissance was getting mighty thick. And no wonder: the notion of reconceiving and rebuilding an entire city is certainly enticing. But if those charged with restoring New Orleans needed a reality check, they had only to look to New York City. After the World Trade Center buildings were demolished on 9/11, federal, state and city officials rallied around to declare their intent to build a better Trade Center on the same site. Four years later, the process has barely begun; it has bogged down in quarrels over architecture, funding, security and a host of other concerns. One problem: too many cooks were deputized to stir the pot.

New Orleans will be rebuilt. But when that job will be done, what the new city will look like, and how much it will cost remain to be seen. Where are those ruby slippers when you need them? ∎

NEEDED: CLARITY
St. Louis Cathedral and Jackson Square in New Orleans embody the unique contribution of New Orleans to America's past. Is there a place for them in the nation's future?

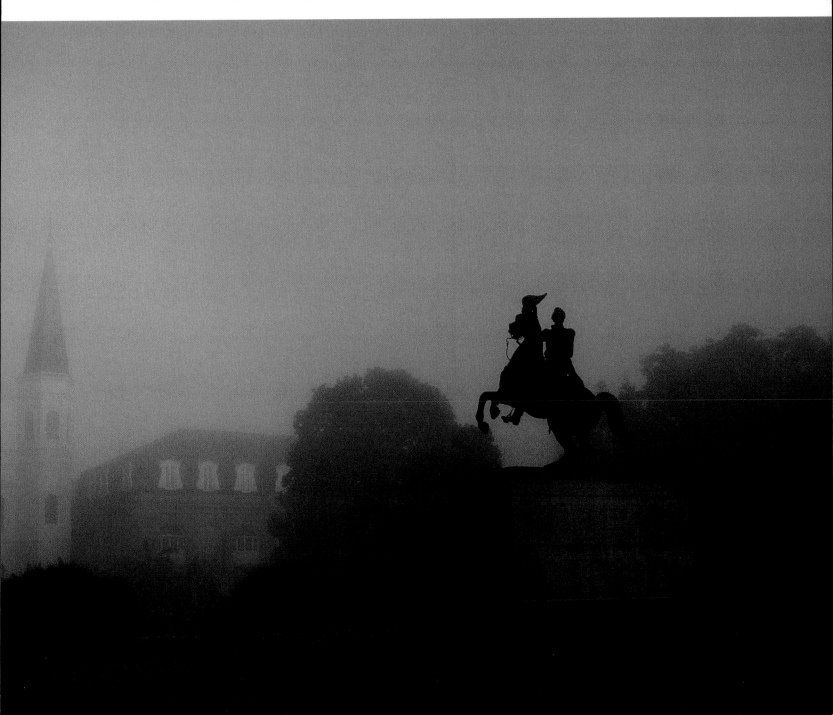

" In general, the local people were wonderful. Often the subjects I shoot aren't happy about having their picture taken, but these folks were saying, 'Thank God you're here … you're the only reason people are paying attention to us.' "

Domestic Tranquillity

When Robert Stolarik photographed this street in the Elysian Fields district on the day after Katrina hit, he was surprised to find that the residents were taking the situation in stride. "That attitude would change later in the week," he recalls, "but in the first day or two after the storm, some people were actually enjoying themselves. Kids were playing in the flood-water or in toppled trees. I guess there's a reason they call New Orleans the Big Easy."

Timothy Fadek·Polaris

Robert Stolarik

Based in New York City, the photographer took a roundabout path to his profession; he studied philosophy in college, explored painting and worked as a chef. But, he says, "from the moment I began shooting in 1993, I determined that this was what I was going to do with my life, regardless of how little money I might make." As a working photojournalist, he has specialized in shooting conflicts and policial upheaval in hot spots from the Balkans to Venezuela. A painterly eye clearly informs his photographs.

" 'Most people were wonderful, but by the end of the week, when the National Guard rolled in, the tension ratcheted up between the residents and the troops. People on the streets were screaming, 'You come here with no food and water, and put guns in our faces?' **"**

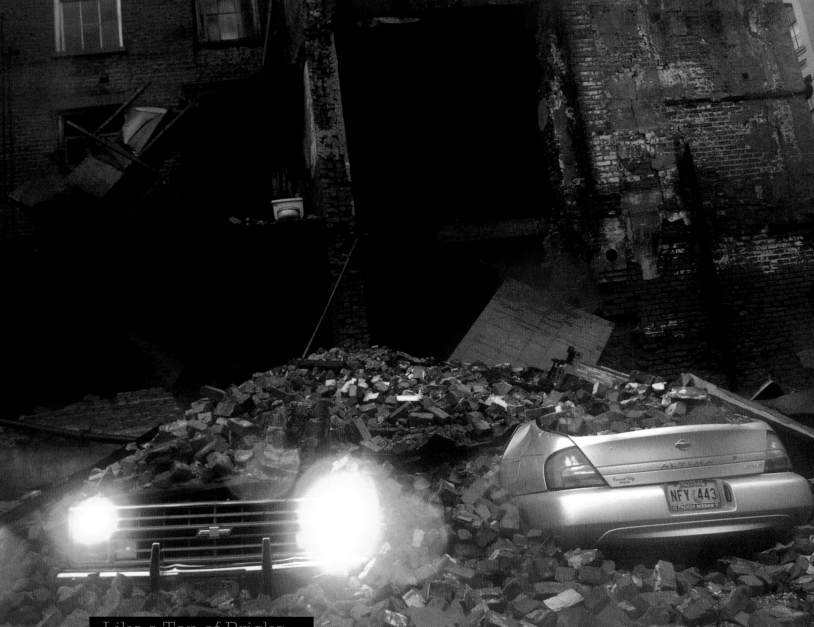

Like a Ton of Bricks

On Monday, Sept. 29, the day Katrina made landfall, Stolarik came across two vehicles buried under an abandoned building that had collapsed near a hotel. Since their lights were on, he feared that people might be inside them. Just then a woman drove up in a truck, hopped out and said, "That's my car! I paid $30 to have it valet-parked inside, and they put it out outside … now it's ruined!"

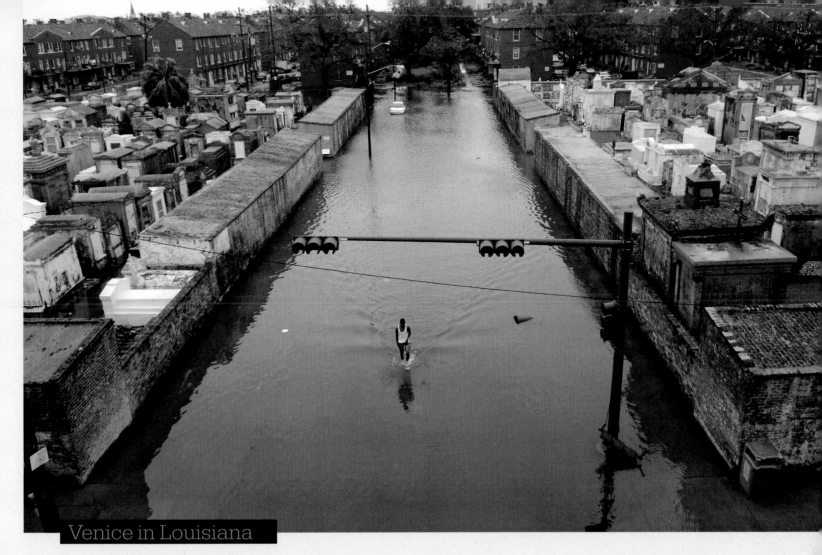

Venice in Louisiana

A street between two cemeteries becomes a canal in this evocative picture. Stolarik recalls: "As stranded people began to be rescued, they looked around in wonder, as if to say, 'So, this really did happen.' Many of them had been confined to their homes without any contact with the outside world; they didn't seem to take in the scale of the crisis until they saw entire districts flooded, not just their familiar streets."

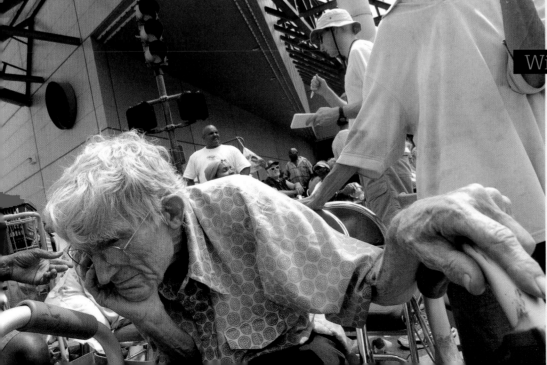

Wit's End

By Friday, Sept. 2, the mood outside the Convention Center was ugly; people had been stranded for days in horrible conditions. "The National Guard troops were trying to help this old gentleman get settled," Stolarik says, "but he seemed to have lost the will to respond. He simply sat there, slumped over and silent."

In the Swim

Stolarik: "This young woman was paddling down the street on an inflatable pool raft, and she actually seemed to be enjoying herself. She said to me, 'I've been blessed!' Many other people in those early days told me the same thing—they were just happy to be alive. I went into the floodwater myself the first day or two, and it wasn't so bad; by later in the week the waters had become incredibly foul. Sure enough, by the end of the week, I had a rash on my leg."

"At times I felt like we journalists were the liaison between the lawmen and the people. Both the troops and the locals felt better when we were around ... it seemed to ease the tension."

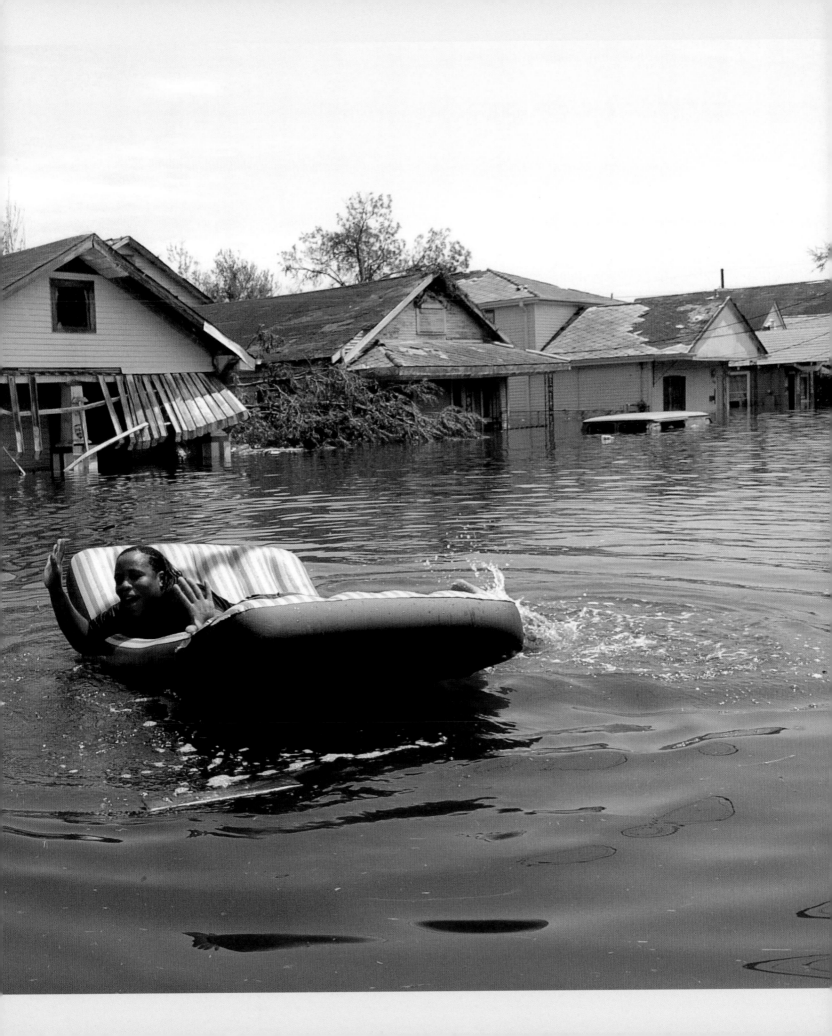

PATHS OF DESTRUCTION

Hard on the heels of Katrina, Hurricane Rita roared across the Gulf and ripped into the coast along the Texas-Louisiana border. This time, however, the coast was prepared

GALVESTON
Fires from downed power lines and damage from heavy winds were the worst of Rita's ravages—much less than the city had feared

LOUISIANA

MISSISSIPPI

TEXAS

Baton Rouge

REFINERIES
Twenty-three percent of U.S. refining capacity was in or near Rita's path. In addition to the four refineries still shut down since Katrina, 16 more refineries were shut down in preparation for Rita—a loss in refinery capacity amounting to 4 million bbl. a day

CHRIS HONDROS—GETTY

MEXICO

Saturday, Sept. 24
Hurricane Rita makes landfall rated as **Category 3**

PATH OF KATRINA

PATH OF RITA

Maximum extent of hurricane-force winds

Maximum extent of tropical-storm-force winds

OFFSHORE OPERATIONS
Because most of the facilities crowding the Gulf were vulnerable to Rita's onslaught, 605 platforms and 87 rigs were evacuated ahead of the storm, with a production loss of 1.4 million bbl. of oil and 6 billion cu. ft. of gas each day

ADAM ROUNTREE—GAMMA

Offshore oil facilities and pipelines
Oil refineries

Strength of Rita

5	4	3	2	1	Tropical storm	Tropical depression
Hurricane category						

Population per square mile, 2003
- 100 to 1,000
- 1,001 to 2,000
- More than 2,000

Sources: MDA Federal Inc./EarthSat; Earth Science Associates; LandScan/UT-Battelle; U.S. Geological Survey; NOAA; AP; EIA; DOE; Platts Power Maps; Minerals Management Service; Weather Underground

TIME Graphic by Missy Adams, Joe Lertola and Ed Gabel

150 miles
150 km

WHAT THE CATEGORIES MEAN
The Saffir-Simpson scale is a rating system that helps project a hurricane's potential damage as it hits a coast

CATEGORY 1
74- to 95-m.p.h. sustained winds
Some damage to trees, mobile homes and other unanchored structures

CATEGORY 2
96- to 110-m.p.h. sustained winds
Roof, door and window damage as well as damage to larger trees. Light coastal flooding

RITA'S FALLOUT

NEW ORLEANS
Several newly repaired levees were again breached by Rita's heavy rains and an 8-ft. tidal storm surge, submerging many of the areas flooded earlier. This time the city was considered lucky: the rain was much less than expected and most residents were already out

HOUSTON
As millions of residents heeded the warning to evacuate, the gridlock on highways out of town caused more deaths and injuries than the hurricane itself. Rita's path doglegged to the north, leaving Houston out of harm's way

TEXAS-LOUISIANA STATE LINE
Rita inflicted its heaviest damage on the coastal areas, then weakened to a Category 1 storm with top winds at 75 m.p.h. and a 15-ft. storm surge as it made its way inland. Moving farther north toward Arkansas, Rita spawned torrential rains, high winds, tornadoes and inland flooding

LAKE CHARLES
The city was empty of residents by early Saturday morning when Rita, at Category 3 strength, hit head-on with 120-m.p.h. winds and driving rains, causing heavy flooding

ALABAMA
GEORGIA
TEXAS
LOUISIANA
Lafayette
Abbeville
Beaumont
Port Arthur
Galveston
PATH OF RITA
Maximum extent of hurricane-force winds
75 km
75 miles

Gulf of Mexico

FLORIDA

Wednesday, Sept. 21
Hurricane Rita
reaches maximum
Category 5 severity

Tuesday, Sept. 20
Tropical Storm Rita
is upgraded to a
Category 1 hurricane

CUBA

HAITI

HOW RITA GREW
Like Katrina, Hurricane Rita started as an unnamed tropical depression in the Caribbean with winds of about 25 m.p.h. It gathered strength, and by the time it swept by the Florida Keys, it was a full-fledged hurricane. Rita steadily intensified, becoming a Category 5 monster over the warm waters of the Gulf of Mexico, with peak winds reaching 175 m.p.h.

CATEGORY 3
111- to 130-m.p.h. sustained winds
Mobile homes destroyed, roof failure, trees downed. Flooding along the shore and inland

CATEGORY 4
131- to 155-m.p.h. sustained winds
Extensive damage to building exteriors and to lower floors near shore. Flooding farther inland

CATEGORY 5
More than 155-m.p.h. sustained winds
Flood damage to lower floors of buildings near shore. Many buildings flattened by wind

Hurricane Rita: Déjà Vu All Over Again

Heeding the lessons of Hurricane Katrina, Americans flee a second big storm, and although the evacuation becomes an ordeal, the Gulf Coast escapes an instant-replay disaster

SURF'S UP: On Sept. 20, four days before it will make landfall on the Gulf Coast, Rita smashes into the Florida coastline

Sunday, Sept. 18: across the nation, as if in a single collective voice, Americans whisper the words "Not again."

Sadly, Mother Nature didn't appear to be listening. For that afternoon, just as the litany of horrors left in Hurricane Katrina's wake seemed at last poised to subside, meteorologists noted that an unnamed tropical depression east of the Bahamas was generating sustained winds in excess of 40 m.p.h. At that moment, the 17th named storm of the season was born and christened Rita. Within hours, a hurricane watch was posted in the Florida Keys and Governor Jeb Bush declared a state of emergency

This time around, it seemed, no one was going to be caught by surprise. The following day, a mandatory evacuation was ordered for the Florida Keys. By Tuesday, Rita (now a Category 2 storm) was churning up winds faster than 100 m.p.h. And then, a stroke of luck: the storm passed by the island chain, inflicting minimal damage. The Keys were spared.

But it was far too soon to stand down. On Wednesday, Sept. 21, Americans had their answer, "Yes, again." Hovering over the Gulf of Mexico, sponging energy from the warm water, Rita was upgraded to a Category 3 hurricane—and then, later in the same day, meteorologists at the National Hurricane Center in Miami jumped it up two more notches. Now Rita was at Category 5, with winds of 175 m.p.h.—the rank Katrina attained the day before it made landfall as a Category 4 storm, after its wind speed slightly lessened. Category 5 is the strongest kind of hurricane, and Rita was now one of only three ever tracked in the Atlantic.

New Orleans Mayor Ray Nagin, who had only two days before given his blessing to the return of some New Orleans evacuees to the city, now had to reverse himself and once again order everyone out. "People are just going to be thinking, 'What's the damn point if this is going to keep happening?'" said a New Orleans police officer, giving voice to the weary frustration of an entire region, which had barely begun to heal from the first deluge. Watching Rita hover offshore, the Army Corps of Engineers was worried that the levees of New Orleans could not withstand another blow. The pumps were still operating at only 40%, and while the city was basically dry, everyone knew that could change in a matter of hours. But New

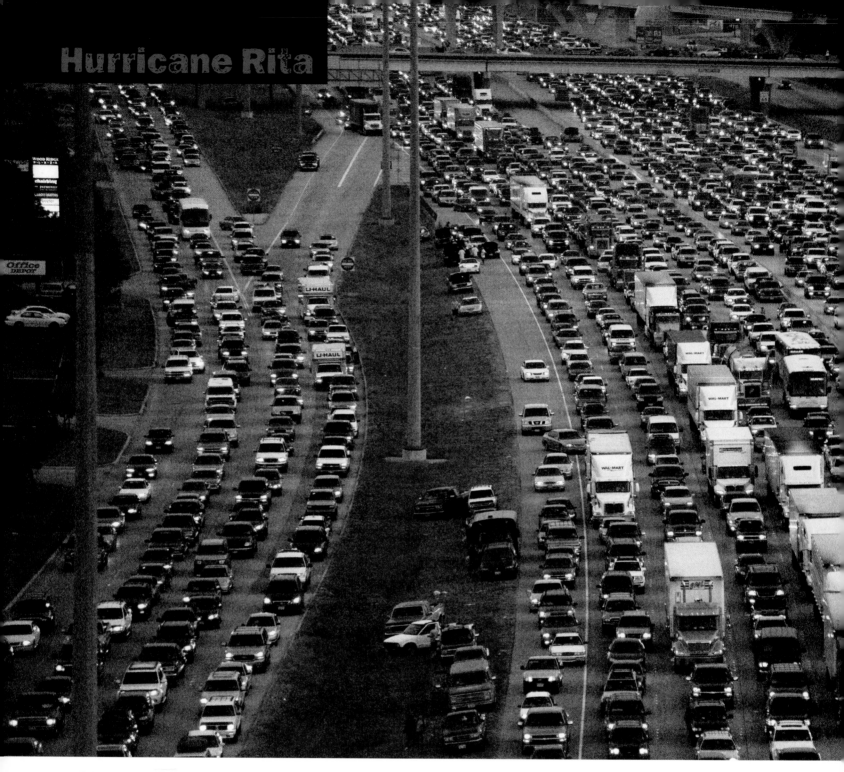

Orleans was determined to get it right this time. Buses were waiting at the Convention Center, along with half a million meals and a field hospital, in case the city endured a replay. A new $4.5 million communications system employing military satellite technology was ready in case the phones went out again. And if the city, state and federal officials were wiser, so were the people: they weren't counting on anyone else to save them this time. In the French Quarter the Déjà Vu strip club (ominously accurate moniker and all) was open for business, but just about everything else was closed, and everyone was gone, except for a now familiar cast of characters: cops, soldiers, reporters and a few die-hard looters.

On Thursday, Hurricane Rita eased slightly to a Category 4—less destructive, perhaps, but still the same strength with which Katrina devastated the Gulf Coast. That day, President George W. Bush declared a national emergency, FEMA dispatched more than 1,000 medical and rescue personnel to Texas, and the Pentagon stood by to send 2,500 hospital beds to communities within Rita's projected

TEXODUS Although both its sides were eventually opened to evacuees, Houston's I-45 became a long parking lot. Traffic was moving at about 1 m.p.h., as Rita drew near at 9 m.p.h.

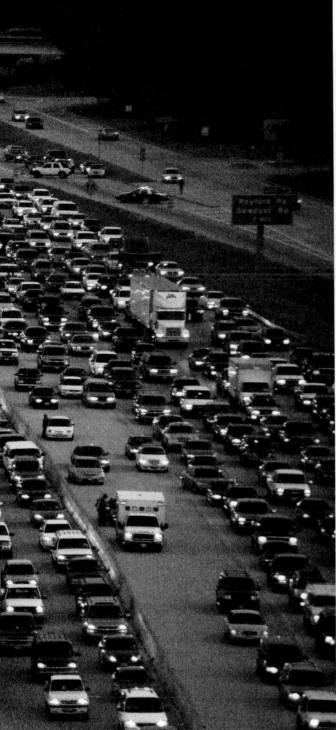

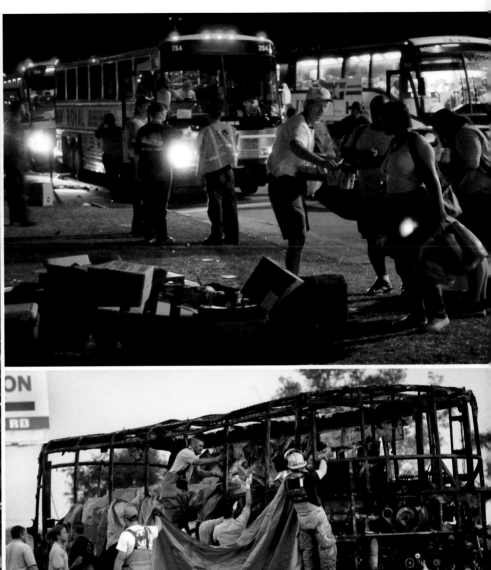

path. Storm watchers predicted landfall somewhere on the Texas-Louisiana coastline for late Friday or early Saturday. Meanwhile, hundreds of thousands of those who had watched the misery in New Orleans made solemn vows to get out of Rita's way while the getting was good. Official orders to evacuate soon followed. Forecasters couldn't say for sure where the hurricane was headed, and Governors Kathleen Blanco of Louisiana and Rick Perry of Texas weren't in any mood to take chances.

But if Katrina taught Americans about the dangers of staying behind, Rita would instruct us in the challenges of leaving. All told, some 1.8 million people—more than the populations of 15 states—were ordered to ship out from endangered areas of Texas and Louisiana, all at the same time.

In Texas alone, the plan called for some 1 million people to move out of harm's way. The reality was that 2½ times as many hit the roads. The Texodus came in waves, first from Galveston, the barrier-island city of 57,000 that history has taught to take hurricanes seriously, then thousands more from

NIGHT JOURNEY
Evacuation continued around the clock in Houston, where people boarded buses late into the night

HIGHWAY TRAGEDY
A bus evacuating seniors from a nursing home burned on the way out of Houston, killing 24

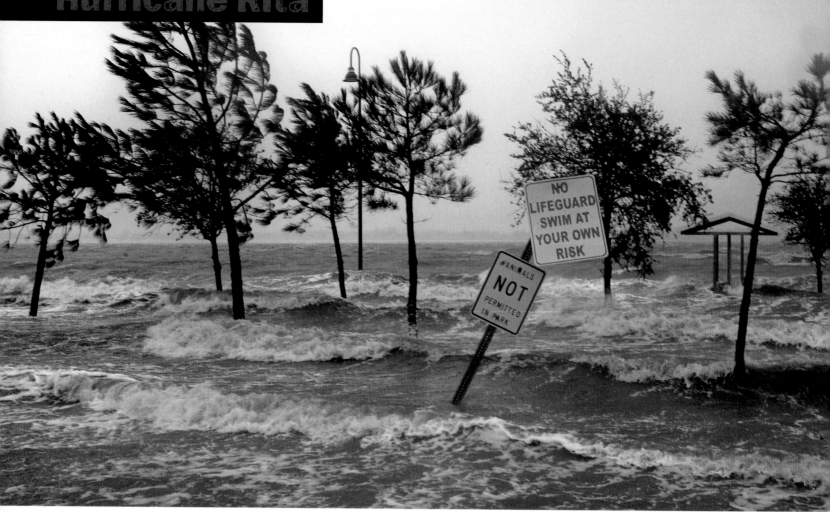

coastal towns and hundreds of thousands more from Houston, where Mayor Bill White urged residents of low-lying areas to get out immediately. "Don't wait," he said. "The time for warnings is over."

It is no small thing to evacuate a city like Houston, the fourth largest in the U.S. Shepherding out the willing and able would be difficult enough—and that doesn't take into account the old, the sick, the stubborn, women in labor, babies in incubators, criminals in prisons. White called what followed the largest mass evacuation in U.S. history. It was also at times the slowest. By Thursday, Rita was moving toward land at about 9 m.p.h., but this was faster than East Texans could run away.

Fleeing families were lucky to move a mile in an hour. Soon dead cars lined the roadsides, and the tanker trucks meant to revive them were themselves stuck in traffic or else had the wrong nozzles to fit civilian cars. "They're saying if you have one-eighth of a tank of gas or less, to get off the roads and let other people escape," said Mary Sieger, 62. "But

where should people go if they do pull off? There's no gas in the entire city. They can't get home."

Somehow state and city officials could not seem to reverse the southbound lanes until midday, and even that was remarkable because there was no master scheme for doing it at all. "Contraflow was never in the plan," White told TIME. "We improvised it." One city official said that was only because TV images showed packed lanes next to empty ones. "They

NO DAY AT THE BEACH Signs offer apt advice as Rita hits Lake Charles, La., on Sept. 24

WATER, WATER EVERYWHERE A house is stranded amid the floodwaters in Johnson Bayou, La., on Sept. 25

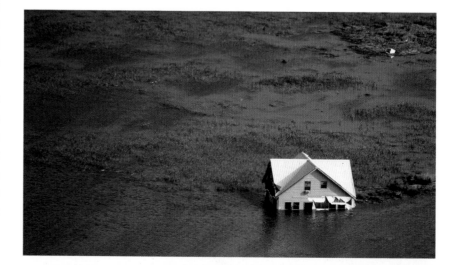

[state officials] were not going to do it," the official says. "It was never part of the plan because they believed that the roads could accommodate the traffic." But that's barely true during a normal day's rush hour, much less during a sudden spasm of survivalism. Perry acknowledged that being stuck in traffic for 12 or 15 hours was bad, but "it sure beats being plucked off a roof by a helicopter." It was a line he was to repeat all day. He was right to wince. For once, the tables were turned between Texas and Louisiana: New Orleans had pulled off an efficient reverse-flow traffic plan as Katrina approached.

As the evacuation proceeded, Friday brought hopeful news: Rita was downgraded once again, this time to a Category 3 hurricane, with winds of 125 m.p.h. But the day was also marred by a grisly tragedy reminiscent of Katrina's carnage: a bus carrying elderly evacuees from a Houston nursing home caught fire outside Dallas and exploded in flames, killing 24 of the people aboard.

On Saturday, Rita finally came ashore at 3:30 am, crossing the coastline a few miles east of Sabine Pass, on the Texas-Louisiana border, packing winds of 120 m.p.h. Within hours, the Louisiana coast was devastated all over again. Trees were pulled from the ground, roofs torn from buildings, and floodwaters quickly rose above the first-floor ceilings of many buildings. Before the sun rose on Saturday, exploding transformers and downed power lines left more than 1 million people without electricity. In New Orleans, the haunting sense of instant replay was underscored as a recently repaired levee broke once more

BREACH! Left, floodwaters pour through the just-patched Industrial Canal on Sept. 23, allowing the Ninth Ward in New Orleans to fill with the waters from Lake Pontchartrain a second time

RITA'S FLAMES
Below, fire fighters battle to control blazes in three buildings in downtown Galveston that burned to the ground late on the night of Sept. 23

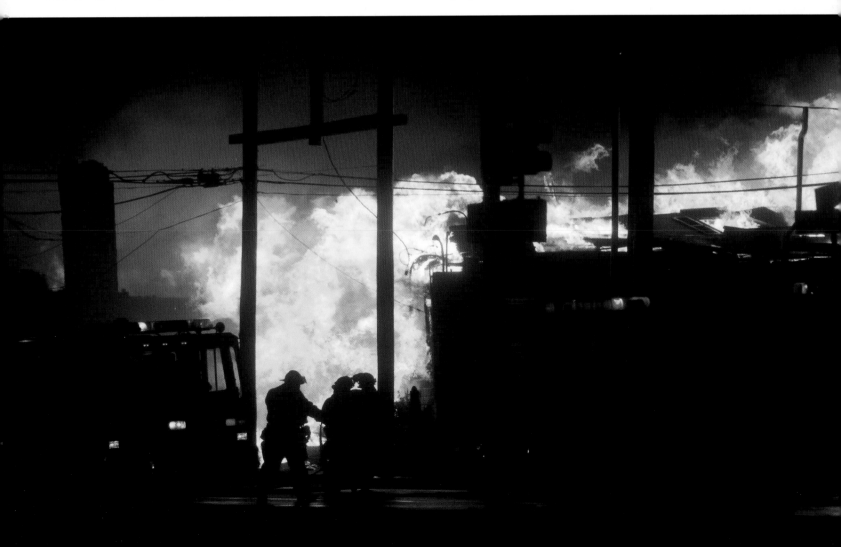

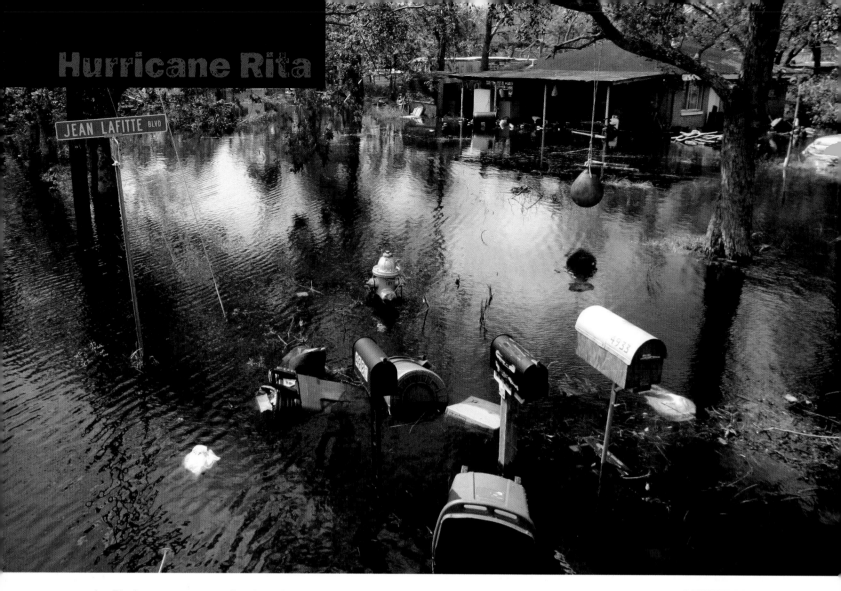

under Rita's storm surge, reflooding the city's low-lying Ninth Ward.

The good news, if it can be called that, was that Rita veered eastward in its last hours before hitting the coast, somehow steering between the major urban centers, managing to avoid most refineries and concentrating its punch in sparsely populated rural areas. But even if Houston and other large cities dodged the bullet, Rita was so big and slow, she still caused trouble hundreds of miles in every direction, including in Katrina's old stomping grounds along the battered western shores of Louisiana.

In Beaumont, Texas, police patrolled the blacked-out streets in cruisers and on the backs of dump trucks, shotguns at the ready for looters who never appeared. "It was really whipping through here last night," said resident Bill Dode. "It was extremely loud, and the house was creaking." Tree branches were poking through some car windows and some homes' walls. At one house, a goat was standing on top of a patio table, braying at a window.

But when the trees stopped shaking, there was a sense of relief. Nearly everywhere, not least within New Orleans, there was the sense that Rita could have been much worse. If New Orleans had been a vast urban sacrifice to greater knowledge, at least a lesson had been learned at every level. President Bush, determined to do better this time around, monitored federal assistance efforts from the headquar-

LAFITTE, LA.
Rita's storm surges in the bayou country reached 15 ft.

HIGH WATER
Barbara Harrison of Port Arthur, Texas, surveys the flooded streets of her home town

ALL IN THE FAMILY Left, Bell Vaugn is evacuated from Erath, La., by her grandson Jon Erick Miletello on Sept. 25

SWAMPED Classic cars get a mudbath in Abbeville, La.

STILL THERE Below, Rita's winds pound Lake Charles, La.

ters of U.S. Northern Command in Colorado.

In the Texas state operations center, emergency chief Jack Colley presided over a series of conference calls with Bush, Homeland Security Secretary Michael Chertoff and a succession of local officials whose concerns were minor: One sheriff wanted to know whether he would be reimbursed for the gasoline he provided to federal agencies. Another said he was overwhelmed with evacuees and was worried about security along the roadways where, he re-

ported, "people with knives are fighting over gas."

The hard lessons of Hurricane Katrina—and the preparations they had inspired at every level—had clearly paid off. Among the biggest problems remaining was how to stage an orderly migration back into Houston, Galveston and other large cities. For the short run, though, it was déjà vu all over again, as, echoing their collective whisper of the week before, Americans everywhere exhaled and said with one voice, "Thank God." ∎

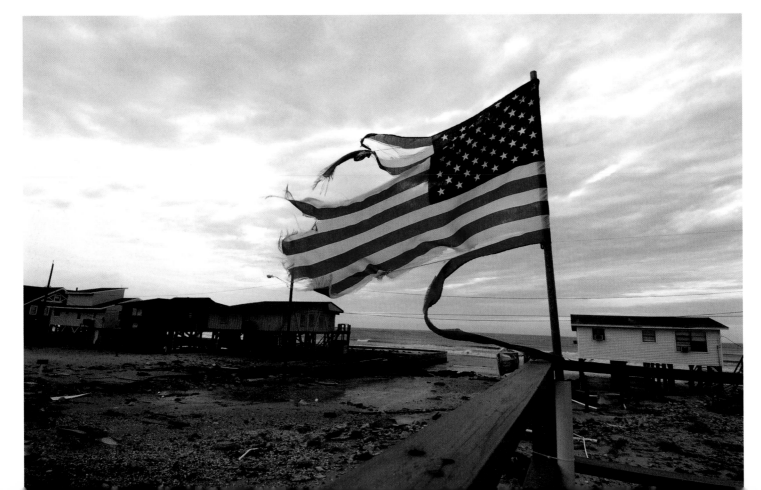